CEZANNE and his art

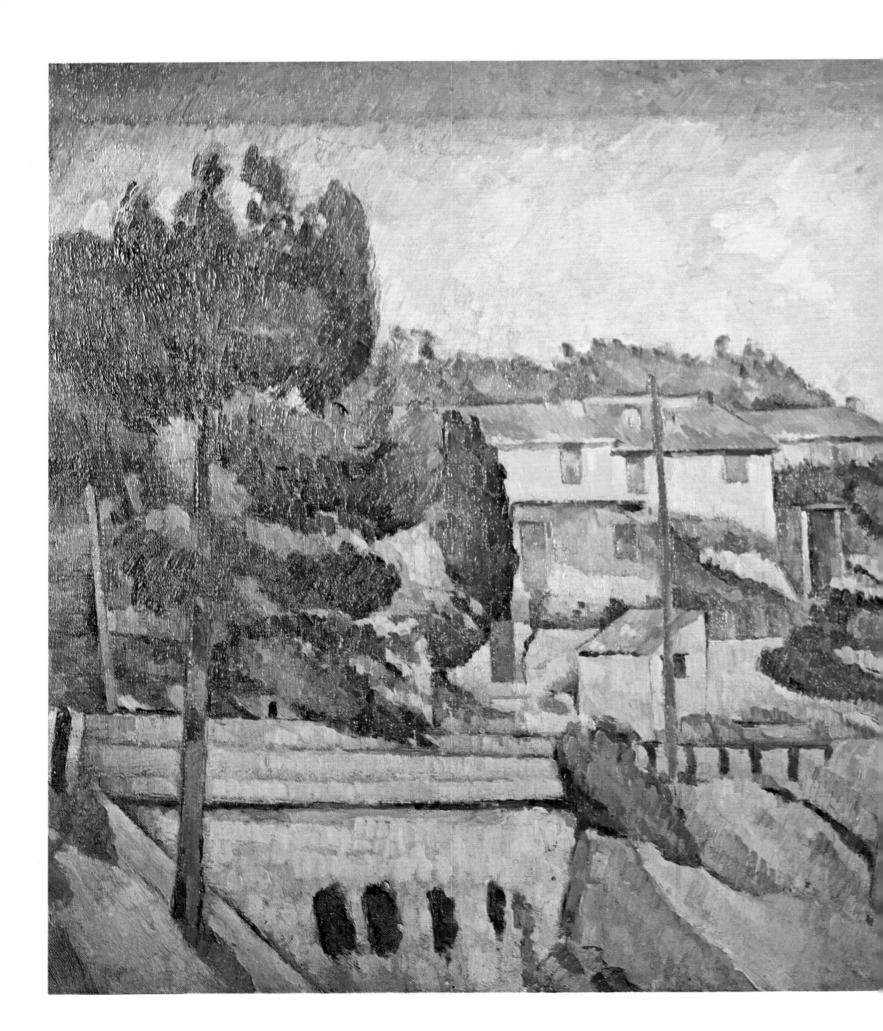

CEZANNE and his art

Nicholas Wadley

Plate I The Viaduct at l'Estaque 1882-85 oil on canvas $21\frac{1}{4} \times 25\frac{5}{8}$ in $(54 \times 65$ cm) V402 Art Museum of the Ateneum, Helsinki

Published by Galahad Books a division of A & W Promotional Books Corporation 95 Madison Avenue, New York, NY 10016 Library of Congress Catalog Card No. 74–78016 ISBN 0–88365–248–X

© Copyright The Hamlyn Publishing Group Limited 1975

Phototypeset in England by Filmtype Services Limited, Scarborough Printed in Spain by Mateu Cromo Artes Gráficas S.A., Madrid

All rights reserved. No part of this book may be reproduced or utilized in any form or by any means, electronic or mechanical, including photocopying, recording or by any information storage and retrieval system, without permission in writing from the Publishers. Inquiries should be addressed to The Hamlyn Publishing Group Limited, Astronaut House, Feltham, Middlesex, England.

Contents

Cézanne and his art 6 Extracts from Cézanne's letters 88 Cézanne in contemporary writings 113 Acknowledgments 126 Bibliography 126 Index 127

Cézanne and his art

Landscape painting is a very solitary activity. The painter is alone with the enormity and shifting complexity of nature as his motif; supported only by what familiarity or expertise he has with the tools of his medium and by his heritage as an artist.

It was never more so than in the later 19th century. No-one before the great landscape painters of this era had attempted to make this simple confrontation the exclusive context and content of their art. Of them, perhaps only Monet and Cézanne really survived the ordeal. Only they stood their ground without compromise, maintained the discipline and painted their way out of the problems (problems that threw many contemporaries) to a point of resolution. These resolutions rank among the major achievements in the greatest century of French painting. What is more, they left a set of standards and resources for the subsequent course of modern painting.

There was still rather more of the landscape left in 19th-century France. By comparison with the rest of Europe, France had lagged reluctantly behind the massive urbanisation and population-increase that were transforming the rest of the continent in the wake of the industrial revolution. Even so, these changes—suburban sprawl, the building of factories, the growth of the railways and later of the car, the appearance of electric lighting and so on—were deeply enough felt in 19th-century France to give the landscape and nature at large a new and poignant meaning.

As early as the 1850s we find the Barbizon painters lamenting change—'Everything I wanted to paint has been destroyed... trees cut down, no more water in the river, houses demolished' (Daubigny, 1854)—and seeing nature as the only true dependable basis of the thinking man's environment—'Trees are for me great history that will never change. If I could speak their language, I would be using the tongue of all ages' (Théodore Rousseau). Later, Cézanne was to write in a similar vein: 'I remember perfectly well the Establon and the once so picturesque banks of l'Estaque. Unfortunately what we call progress is nothing but the invasion of bipeds who do not rest until they have transformed

¹Translation from Robert L. Herbert, *Barbizon Revisited*, Boston, 1962.

everything into hideous quais with gas lamps-and, what is still worse-with electric light. What times we live in!' (to his niece, 1st September 1902).

In the 1860s and 1870s the Impressionists are painting landscape images of outer suburbia and the rural surroundings very much from the townsman's viewpoint: the town-dweller's escape, the day in the country. By the end of the century, the situation is more extreme. In the town we find Seurat painting and drawing industrial suburbs loaded with melancholy and Degas, ageing and nearly blind, cursing the inventions of telephone and taxi-cab. The landscape motifs have become wilder, more remote, more exotic. Monet is in voluntary exile in his watergarden, Cézanne—and Van Gogh until his death—alone in the depths of rugged Provence. The most extreme case was Gauguin. A successful modern townsman who had been seduced by the delights of nature-painting into an escapist mysticism, he abandons civilised modern Europe altogether for the more natural state of the South Sea islands.

This sense of stability and permanence in nature, this pantheistic faith in face of change and of modern concepts of progress, flavoured all 19th-century landscape painting, just as it colours our own reactions to the 19th-century heritage and the almost universal appeal of the Impressionist image of nature.

Cézanne's youth was full of this mood. Unlike most of the Impressionist generation, he was born and grew up in the heart of rural France: not among the atmospheric mists of the Ile de France, but in the Mediterranean climate of Aix-en-Provence. Much of his adolescence was spent in a romantic celebration of the rural environment, shared with schoolfriends who included Emile Zola. The following reminiscence by Zola gives the flavour of their shared experiences (the other friend referred to was Baptistin Baille):

'It was about 1856; I was sixteen . . . We were three friends, three scamps still wearing out trousers on school benches. On holidays, on days we could escape from study, we would run away on wild chases cross-country. We had a need of fresh air, of sunshine, of paths lost at the bottom of ravines and of which we took possession as conquerors . . . In the winter we adored the cold, the ground hardened by frost which rang gaily, and we went to eat omelettes in neighbouring villages . . . In the summer all our meetings took place at the river bank, for then we were possessed by the water . . . In the autumn, our passion changed, we became hunters; oh! very innocuous hunters, for the hunt was only an excuse for us to take long strolls . . . The hunt always ended in the

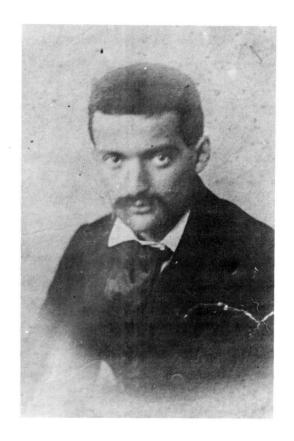

Plate 2 Photograph of Cézanne in 1861

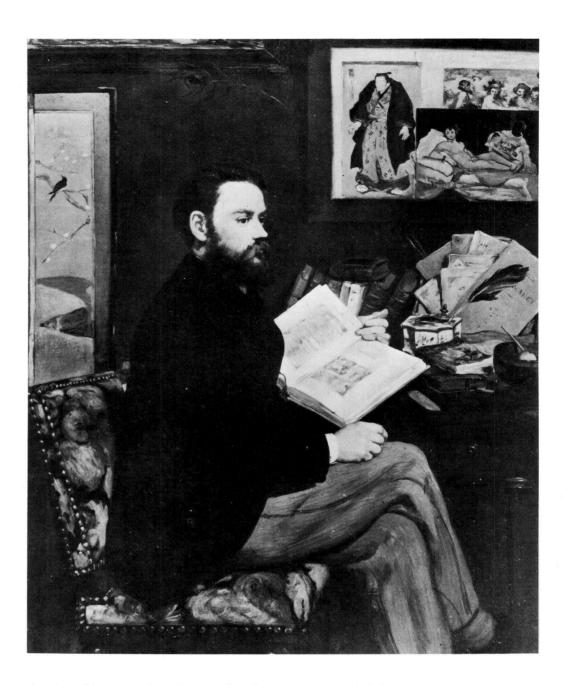

Plate 3 Edouard Manet **Portrait of Emile Zola** 1867–68 oil on canvas 57 × 43 \frac{5}{8} in (145 × 111 cm) Louvre, Paris

shade of a tree, the three of us lying on our backs with our noses in the air, talking freely about our loves.

'And our loves, at that time, were above all the poets. We did not stroll alone. We had books in our pockets or in our game-bags. For a year, Victor Hugo reigned over us an absolute monarch. He had conquered us by his powerful demeanour of a giant, he delighted us with his forceful rhetoric. We knew entire poems by heart and when we returned home, in the evening by twilight, our gait kept pace with the cadence of his verses, sonorous as the blasts of a trumpet . . .

'Victor Hugo's dramas haunted us like magnificent visions. When we came out of classes with our memories frozen by the classical tirades which we had to learn by heart, we experienced an orgy replete with thrills and ecstasy when we warmed ourselves

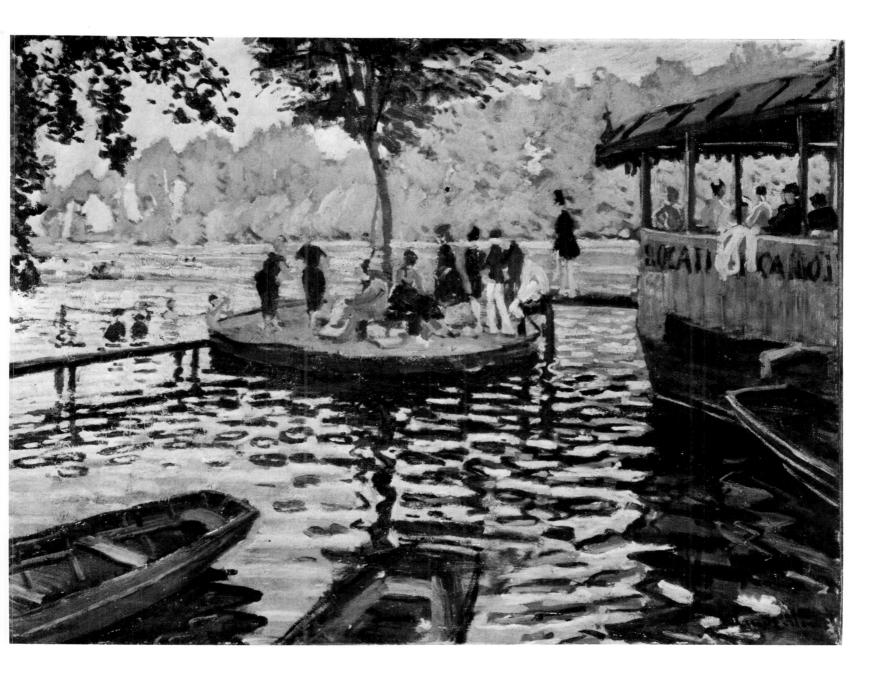

by memorising scenes from *Hernani* and *Ruy Blas*. How often, after a long swim, the two or three of us performed whole acts on the bank of the little river!

'Then, one morning, one of us brought a volume of de Musset . . . Reading de Musset was for us the awakening of our own heart. We trembled . . . Our cult of Victor Hugo received a terrible blow; little by little we felt ourselves grow chilled, and his verses escaped our memories . . . Alfred de Musset alone reigned in our game-bags . . . He became our religion. Over and above his laughter and school-boy buffoonery, his tears won us over; and he only became completely our poet when we wept on reading him.' 1

There are two important points here. The fact that their forays into the countryside—half minstrel-like, half bacchanalian—are described here as a fusion of sensual and literary experiences sets an

Plate 4
Claude Monet
La Grenouillère
1869
oil on canvas $29\frac{7}{8} \times 39\frac{1}{4}$ in (74.6 × 99.7 cm)
The Metropolitan Museum of Art, New York
(Bequest of Mrs H.O. Havemeyer, 1929,
H.O. Havemeyer Collection)

¹Translation reprinted by permission of the publishers from John Rewald, *Paul Cézanne* (© 1948 John Rewald), Simon & Schuster and J. M. Dent & Sons Ltd, pp. 4–5, quoting from Zola, *Oeuvres Complètes*, Paris, 1928.

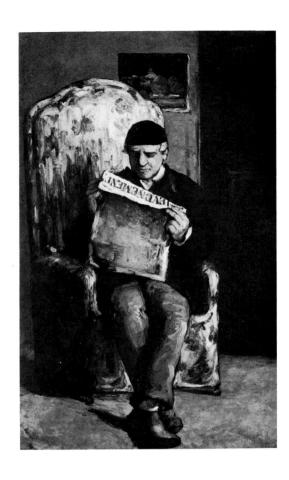

Plate 5
Portrait of the Artist's Father Reading 'L'Evènement'

1866–68
oil on canvas
78\frac{1}{8} \times 47 in (198 \times 119 cm)
V91\frac{1}{1}
National Gallery of Art, Washington, DC
(Collection of Mr and Mrs Paul Mellon)

¹ These reference numbers in the captions are to the two catalogues of Cézanne's works by Venturi ('V') and Chappuis ('C'). For details, see the Bibliography on page 126.

important precedent for the whole of Cézanne's working life. A deep sense of history and of his cultural heritage pervades all of his career as a painter. Within this heritage, his taste was centred on the most opulent, romantic and sensual faces of European culture (in the field of music he was a Wagner enthusiast). Face to face with the landscape later on he was not alone, in the sense that he carried with him a rich cumulative awareness of all that art had been. This served as both inspiration and discipline. It gave him his sense of identity as an artist, a working framework within which to operate and against which to measure his evolving responses to nature.

All of this may seem obvious and normal. But seen against the background of Impressionism and the general mood of the 19thcentury avant-garde, it is not so. The academic tradition had fallen into disrepute by virtue of a mindless inflexibility. The younger painter was often not a revolutionary by instinct, but became so after fruitless confrontation with the rigid conservatism of the academic art establishment, backed by a relatively uncultured artpublic. The head-on collisions with that establishment of their elders, figures like Courbet, Daumier and Manet, set a precedent. Increasingly the onus fell on the younger painter to define for himself his terms of reference. Increasingly often, this resulted in a rejection of accumulated traditions and an antipathy towards style. Instead the artist turned outwards toward nature and measured his art against nature's reality, not against other art. 'Paint only what you see', 'Forget all that has gone before you'-again and again this kind of maxim is repeated through the history of 19th-century avant-garde painting. Realism was the new ideal.

Impressionism stood for the extreme point of this history. Monet describes the only valid objective of the landscape painter as 'your own naive impression of the scene before you'. Implicit in this was the education of the painter by nature *alone*, by the eye's contact with nature, and the rejection of any interference with this contact by preconceived ideals. Of course it is arguable whether or not Monet's art as a whole is as innocent as this. For him it felt like that; it was important for it to be stated as strongly as that, and—above all—it seemed to his contemporaries that he was taking art away from traditional precepts to this extreme degree.

Cézanne from the start considered such an objective as an impoverishment. Many of his own best-known statements of intent refer to it: 'to make of Impressionism something more solid and durable, like the art of the museums'; 'to re-do Poussin after nature'; 'to become classical again through nature'. The definition of art that he felt compelled to take account of included

his contemporaries and immediate ancestors (Monet, Pissarro, Manet, Courbet, Delacroix), but also the great heritage of the past: of French, Venetian and Spanish painting, of Renaissance sculpture. The riches of this whole culture were to be harnessed to a feeling for nature at least as intensely immediate and particular as Monet's.

So his adolescent world-in which a game-bag full of Hugo and de Musset as well as of shotgun cartridges, salad, cheese, bread and no doubt wine, was a vital part of 'the healthy debauchery of the fields and of long walks'-closely foretold the scale and breadth and vigour of his ambition as a mature artist.

The second important point of comparison between his formative years and his mature life is one of contrast. The contrast is between the very close friendship and identity-sharing that we see in his youthful associations and the suspicious and uncertain solitariness of the grown man. Even as a youth he was given to

Plate 6

Jas de Bouffan 1882-85oil on canvas $23\frac{3}{4} \times 28\frac{3}{4}$ in (60.5 × 73.5 cm)

V460

National Gallery, Prague

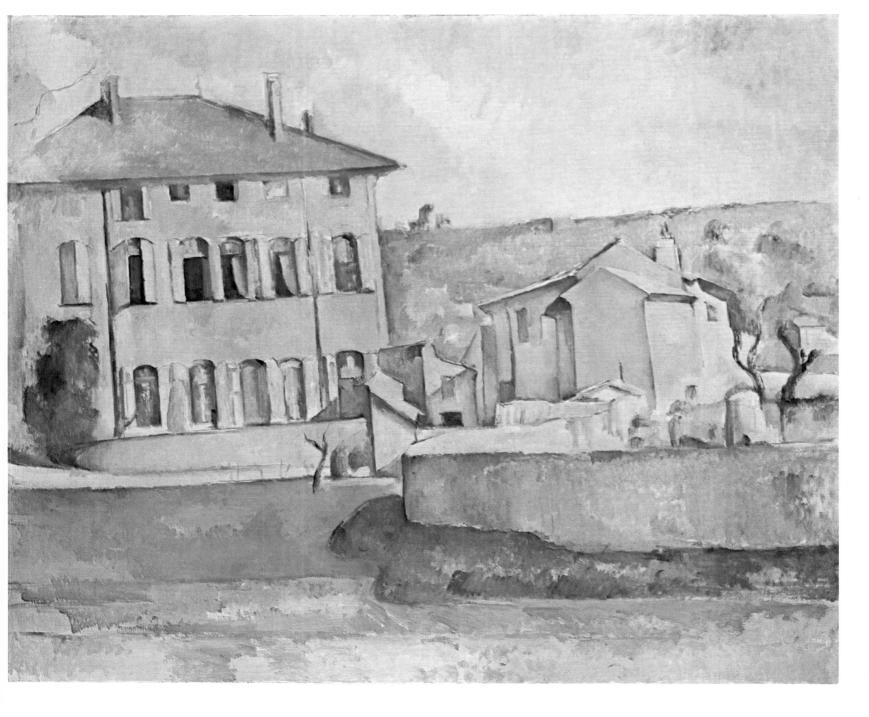

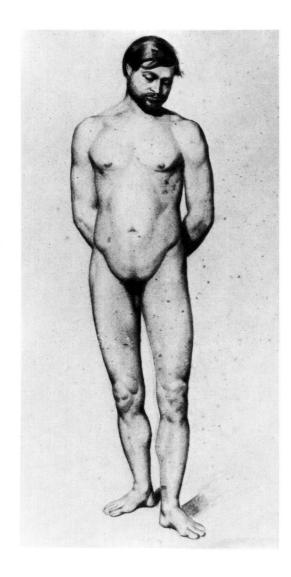

Plate 7

Académie: Male Nude
verso signed and dated 1862
pencil and black crayon
24 × 18½ in (61 × 47 cm)
V1162, C76

Musée Granet, Aix-en-Provence

occasional violent outbreaks of temper and anti-social depression. Zola advises their mutual friend Baptistin Baille: 'When he hurts you, you must not blame his heart, but rather the evil demon which beclouds his thought.'

His family background suggests some reason for this. There is more than a touch of the social outcast about his family's local standing. His father, Louis-Auguste Cézanne, had come to Aix in the 1820s and made good as a dealer and exporter of hats; well enough to buy, in 1848, the only bank in Aix, which further magnified his wealth and influence. Louis-Auguste had two illegitimate children by one of his employees (the first, Paul, on 19th January 1839) before he married her in 1844. In 1859 he bought a large and ostentatious manor house (the Jas de Bouffan, formerly the district Governor's residence) with an enormous estate. Local attitudes seem to have combined suspicious hostility with grudging respect, all this within a fairly tight-minded, respectable provincial community.

Within the family the dominant presence of Louis-Auguste was all-pervasive. A successful, satisfied, self-made man, the shadow of his massive personality, and particularly of his uncomprehending opposition to his son's liberty and ambitious instincts, falls repeatedly across the path of Cézanne's life. The violent see-saw struggle surrounding Cézanne's early ambition to be a painter rather than banker or lawyer; the father's jealous suspicion of Zola's influence; the furtive secrecy over more than a decade of Cézanne's love affair with Hortense Fiquet and the birth of their son (1871); their subsequent marriage in 1886 without love but with parental approval (and possibly pressure?)—all of these lend support to our linking of the tyrannical father with Zola's 'evil demon which beclouds his thought'.

Cézanne begins a letter to Pissarro: 'Here I am with my family with the most disgusting people in the world, those who compose my family stinking more than any. Let us say no more about it' (23rd October 1866). There were long periods of tense silence, total lack of communication between father and son, the only two men in the household. The mother and two daughters acted as hesitant intermediaries. All letters in the household were opened by the father: Cézanne often resorted to using Zola as a poste restante address.

Only after his father's death (1886) does he speak of him with any real warmth and respect, and then it seems, only because the wealth accumulated by his father enabled him to organise his own life as he wished ('My father was a man of genius: he left me an income of 25,000 francs'). He could provide a house and living for

his wife and son, without necessarily having to live with them; he could devote his own life to his painting. The marriage to Hortense seems to have been little more than an obligatory gesture towards orthodoxy. He felt real warmth and responsibility and, in the later years, personal respect for his son Paul, but of his wife he says, 'She likes only Switzerland and lemonade.' The year before their marriage there are glimpses—an incomplete draft of a love-letter (quoted on page 98) and another request to Zola to act as a forwarding address—of a passionate secret affair with a woman he met in Aix.

The long-standing relationship with Zola broke down in 1886, apparently as the direct, abrupt result of publication of Zola's novel L'Oeuvre. A curt letter of thanks for the book signed 'ever yours under the impulse of past times' (4th April 1886) was the last Cézanne wrote to him. One of Zola's Rougon-Macquart series, the novel depicts the artistic life of Paris. The hero, Claude Lantier, is a passionate, romantic painter who dreams of moving from Impressionism to lead a great revival of monumental painting, but who in fact flounders in frustration and inability, 'drowns in the heroic folly of art' and passes from madness to suicide. That the young Cézanne was the model for the character's early aspirations is as clear to us now as it must have been to Cézanne himself (it has long since been substantiated from Zola's own notes for the book). The implicit criticism of the mature Cézanne, the implied abortive end to all of his ambitions and potential, was a betraval of their mutual respect and faith. That it did in fact represent a major change of Zola's attitude to Cézanne's art was borne out in reported and published statements by Zola in the 1890s. We read of Cézanne's tears and grief at news of Zola's death in 1902, but there was no further contact between them, and enough evidence exists that this was by tacit mutual consent.

This loss of almost the only permanent, stable ally in his intimate life must have confirmed in him a need for privacy and a mistrust of the value of external relationships. The seeds of both had been sown by the ruthless exclusion of meaningful communication under his father's home rule. There were some other meaningful relationships: the friendship and support of the collector Victor Chocquet; the lifelong faith in him of his mother within her limitations; the intermittent contact with Pissarro, Renoir, Monet, the dealer Père Tanguy; and, at the end, the admiring attention of younger painters like Emile Bernard. But for the most part Cézanne in middle and old age kept very much to himself. He was not by nature unfriendly or unsociable, but the periodic neurotic outbursts of mistrust, the sudden rejections and

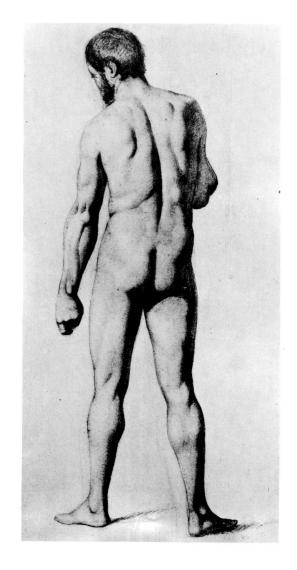

Académie: Male Nude, Back View signed and dated 1862 pencil and black crayon 23\frac{3}{4} \times 15\frac{3}{4} \times (60.3 \times 39 cm) V1627, C78
Private collection

Plate 9

Male Nude 1863-66charcoal heightened with white $19\frac{1}{4} \times 12\frac{1}{4}$ in $(49 \times 31$ cm)
C99

Fitzwilliam Museum, Cambridge

Plate 10

Male Nude

study for 'The Autopsy'
about 1865
charcoal and wash

12\frac{1}{4} \times 18\frac{3}{4} \times 18\frac{3}{4} \times 1600

CIIO

Art Institute, Chicago
(Margaret Day Blake Collection)

Plate 11

Uncle Dominique
(The Man in the Blue Cap)
about 1865–66
oil on canvas
31×25¼ in (79.7×64.1 cm)
V73

Metropolitan Museum of Art, New York
(Wolfe Fund, 1951, from the Museum of Modern Art, Lizzie P. Bliss Collection)

accusations of insincere flattery or double-entendre that are witnessed from time to time by all of his acquaintances suggest that he had learned to defend himself against expressing his natural disposition (see Pissarro's letters of 1896, pages 116–120). In defence, he appeared to resent any interference. 'If only I had an indifferent family,' he regrets to Zola, 'everything would have been for the best' (25th August 1885).

Perhaps his conversion to Catholicism in the early 1890s, surprising in the light of a rabidly anti-clerical attitude earlier in life, is also accountable in terms of support in this struggle for a private self-sufficiency.

What sustained him above all and what he, like Van Gogh, substituted for vital human relationships was his work as an artist. This, he told Zola, was, 'in spite of all alternatives, the only refuge where one finds true contentment in oneself' (20th May 1881). He writes elsewhere of an earlier decision 'to work in silence until the day when I shall feel able to defend in theory the results of my efforts' (27th November 1889, to Octave Maus); and finally to Joachim Gasquet: '... I thought that one could do good painting without attracting attention to one's private life. Certainly, an artist wishes to raise himself intellectually as much as possible, but the man must remain obscure. Pleasure must be found in the work. If it had been given to me to realise my aim, I should have remained in my corner with the few studio companions with whom we used to go out for a drink' (30th April 1896).

So the picture that emerges of Cézanne the man is of a big

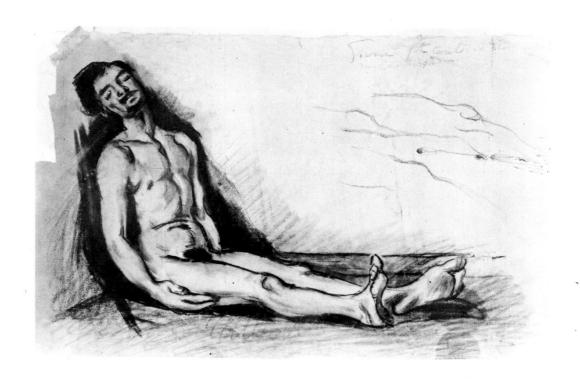

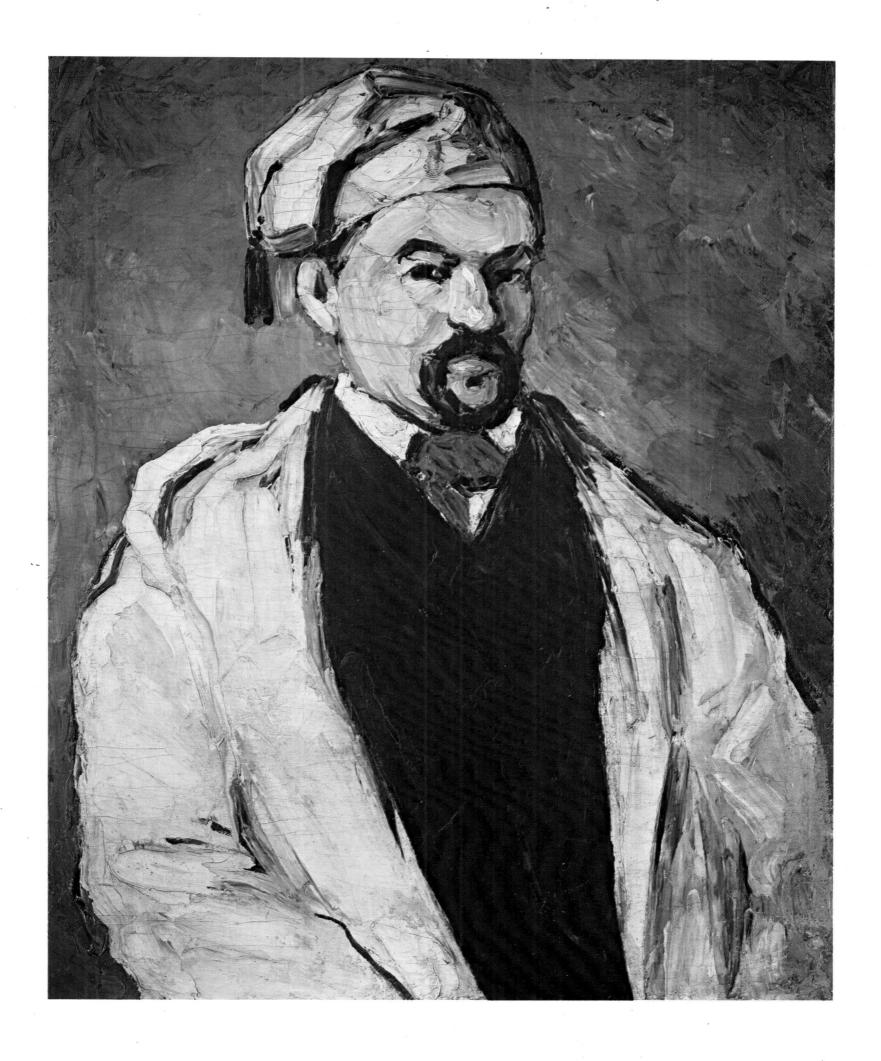

exuberant personality. Friends describe him in the early years as 'the poetic, fantastic, jovial, erotic, antique, physical, geometrical friend of ours' (Baille, July 1858), and 'his exterior is if anything more beautiful, his hair is long, his face exhales health and his very dress causes a sensation' (Guillemet, 2nd November 1866). He had a rough, peasant-like energy, which he exaggerated somewhat in face of the disconcertingly suave Parisian manners, but he was a more than capable scholar and by no means without faith in his own abilities and values (see page 96). This large-scale personality, extravagant but erratic in imagination, ambition and emotion seems to have been persuaded by successive external encounters to withdraw as a person, to channel his energies and identities into his creative activity as a painter. For this to be enough, for it to be an adequate working environment for his temperament, the struggle to gain control of his painting necessarily became that much more intense, almost a matter of life and death. The further this process went, with so much at stake, and the more complex the protective fabric became, the more inevitable it was that there would be increased dread of invasion of his personality.

In a sense all artists, poets and painters alike, enjoy the privilege and indulgence—as well as the discipline and isolation—of escapist retreat, of withdrawing from life into an empire where they alone command the terms of reference. In a sense it is like every man's world of his private thoughts and fantasies, but becomes more substantial than that. More substantial, first, because it is the major part of that person's existence, to which all or most of his positive energies are devoted; second, because it is expressed in real terms: documented in the written word of the poet, the score and performance of the composer, the painted image. As a painter he is responsible to the limitations of his medium, but beyond that responsible only to self–generated criteria.

Because Cézanne withdrew into that private world to sort out his destiny there, rather than conduct the sort of public dialogue as artist that, for example, Courbet, Gauguin or Whistler did, because he chose to remain relatively silent as a man and speak only through his painting for so much of his life, we get, paradoxically, a much simpler view of both man and painting. We can follow the exposed vulnerability and life-force of the late adolescent; the bending to other influences; the withdrawal; the resurgence in maturity of his innate strength, expressed now as discipline; and the fulfilment of his last years, when his empire felt secure enough to expand gently back into the public arena.

Looking at much of his earliest work, the paintings and drawings of the 1860s, it is difficult not to feel like an intruder into

a private world, a world of adolescent inhibitions, neuroses, violence and fantasy.

The background to his early work consists of the years of struggle with his father and to some extent with himself, about whether or not he was to be a painter. From 1859 to 1861 he was studying law at Aix University and at the same time working at the town's Drawing Academy. Zola worked hard to maintain Cézanne's confidence to cope: 'You must satisfy your father by carrying on your law studies as assiduously as possible. But you must also work with firmness and energy on your drawings'; 'Your father is becoming humanised; be firm without being disrespectful.

Plate 12

Portrait of Marie Cézanne
about 1867-69oil on canvas $21\frac{5}{8} \times 15$ in $(55 \times 38$ cm)

V89

St Louis Art Museum, St Louis, Missouri

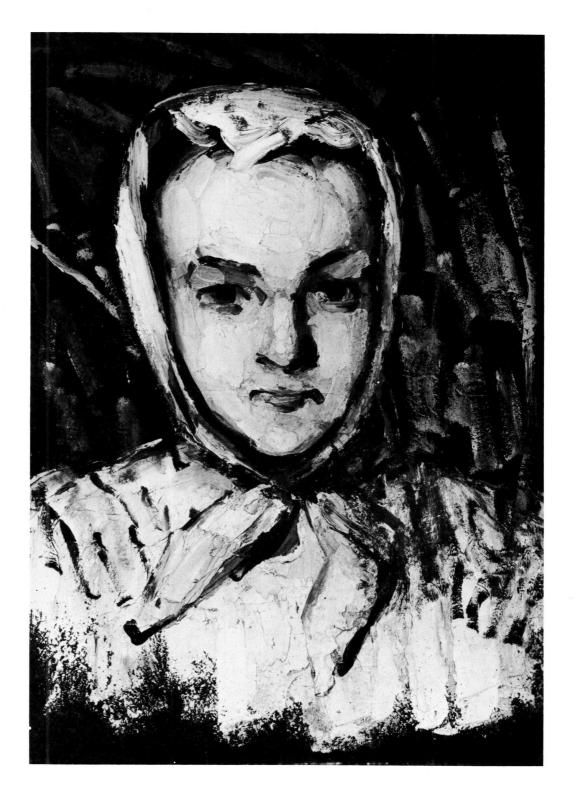

Remember that it is your future that is at stake and that your happiness depends on it' (letters of March and April 1860).

His first stay in Paris (April-autumn 1861) ended in discouragement, and he returned to take a post in his father's bank, again working at the Academy in his spare time. By the following summer he had recouped enough confidence to leave the bank and resume painting. His return to Paris in November 1862 did not mark the end of his own uncertainty, nor of parental opposition, but the decision to be a painter was effectively made then.

Much of his working time in Paris was spent at the Atelier Suisse, an open studio where, for a nominal fee, anyone could come and draw or paint from the model. It was here that he made his first contacts with Pissarro and other painters of the Impressionist generation. In some of the drawings made there and/or in the Aix Academy, we can see how much he was willing to conform at this stage (plate 8). In a series of drawings from the male nude, possibly made in connection with his unsuccessful application for entry into the Ecole des Beaux Arts in Paris, he submerges his own personality beneath the anonymous style of contemporary academic draughtsmanship.

Considering the antipathetic distance between these and his natural manner, the degree of submission is remarkable. It is a measure of how much he personally was prepared to accept and live with the established status quo, whether or not it reflects his father's wish for a respectable art education if any at all. The same impression emerges from his contact with and repeated submissions to the annual Salon, the only official exhibition to which an artist could submit work, gain official recognition and win public patronage. He was not predisposed to be a rebel *per se* any more than the Impressionists were, and it was only after repeated experience of concerted inflexibility and rebuff, hostility and ridicule, that they resorted to independent exhibitions and that Cézanne subsequently retreated from the public arena.

The académies are not great drawings. The restraint of the academic style lies uneasily on his shoulders. The regular restrained shading within a closed silhouette is meek, competent obedience to a formula. Compare this style with the relatively styleless immediacy of other drawings from the model. There, decisions about the means of execution stem from the activity of looking and recording: producing an image that is about the splay of the feet, sagging torso muscles, the droop of the head (plate 10); or which accentuates the twist of a pose, the dramatic fall of a shadow across a flexed hip (plate 9). The simplified oppositions of light to dark reflect the influence of Manet's painting (which he admired

Edouard Manet

Head of Victorine Meurend

1862

101 on canvas

17 × 17 in (43.2 × 43.2 cm)

Museum of Fine Arts, Boston, Massachusetts

Gift of R.C. Paine, in memory of his father

R.T. Paine II)

Plate 13

greatly at this time), but more important is that we see a first glimpse here of the working basis of his mature art. The artist is in front of the model marshalling his technical means to arrive at the most powerful visual expression of his motif.

Early paintings from the model-portraits and still-lifes-show something of the same aggressive originality. We do not know which paintings he submitted (and had rejected) at the annual Salons in the early 1860s, nor which featured in the notorious 1863 Salon des Refusés. If they resembled the palette knife paintings of 1865-67 (plates 11, 12, 97), their rejection is easily understood. 'Every time he paints a portrait,' a friend wrote in 1866, 'he seems to avenge himself for some hidden injury.' In this first positive indication of a personal manner of painting, the quality of violence predominates. Inspired in part by Courbet's heavyweight, crusty paint as well as by Manet's directness of execution, the physical gestures of putting paint to canvas are left exposed, raw, undiluted by any conventional sense of finish.

Cézanne and his friends discussed Manet's work at this time in terms of its 'brutality'. This might seem odd applied to the cool suaveness of Manet's 1860s paintings (plates 3, 13). It probably

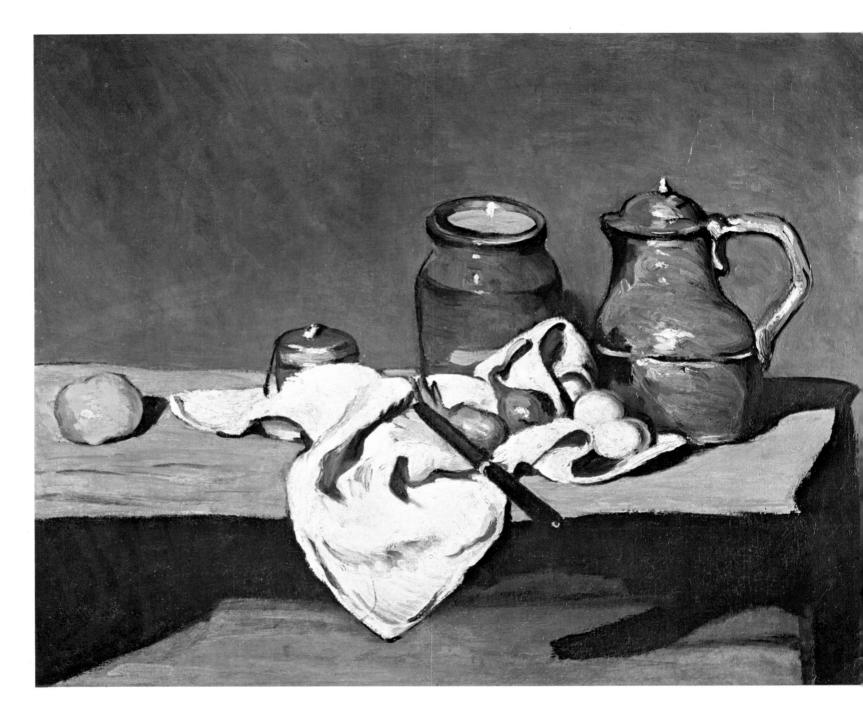

Plate 14 Still-Life with Jar and Coffee-Pot about 1870 oil on canvas $24\frac{7}{8} \times 31\frac{1}{2}$ in $(63 \times 80 \text{ cm})$ V70 Louvre, Paris

refers both to Manet's disdain of convention and to his very direct oppositions of light and dark tones. Cézanne's touch is not as cool and elegant, but in the simple colour scales (a lot of black, grey, off-white) and in the opaque density of the colours and tones we can see the affinity. They both propose a very simple and direct form of painting, uncluttered by the elaborate processes and subtle illusionism of current academic art.

The cool grey-green still-life in Paris (plate 14) is among the most Manet-like paintings by anyone other than Manet. Simply and directly painted, it has an extraordinarily physical presence and monumentality. The weight and inertia are as of a lead relief. The *Achille Empéraire* (plate 15) has the same qualities. Remote from

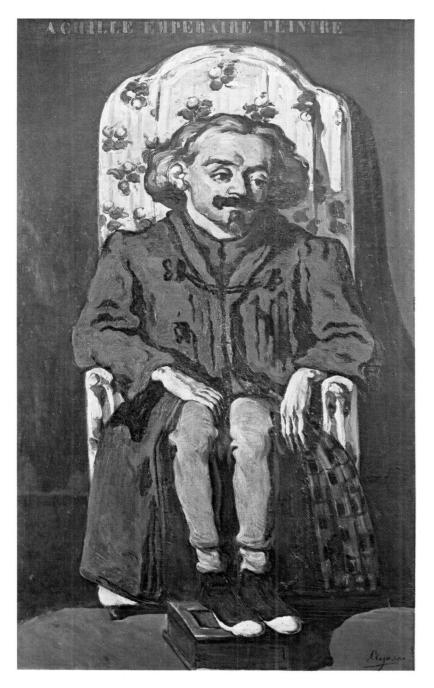

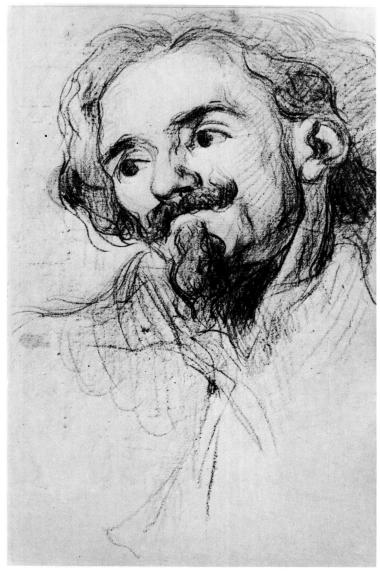

illusionism, the throne-like chair and the figure merge into a great heraldic emblem against a neutral ground. The stencilled inscription above echoes and underlines the flat frontality of image. Compare the way the floral pattern of the same chair is deliberately played down in his father's portrait (plate 5), whereas here it is emphatic and flattening.

A very conscious measuring against Manet is evident, too, from some of the subjects painted: particularly the theme of the picnic. But for Cézanne the image was not a relaxed middle class taking of lunch on the grass. It was part of his adolescent fantasy-world, and his pastorales and picnics were painted alongside scenes of orgy, rape and murder. In this great outpouring of violent images,

Plate 15

Portrait of Achille Empéraire
1868
oil on canvas
78\frac{3}{4} \times 48 in (200 \times 122 cm)
V88

Louvre, Paris

Plate 16

Portrait of Achille Empéraire
1867-70
charcoal and pencil heightened with white
19\(\frac{1}{4} \times 12\frac{1}{4}\) in (49 \times 31 cm)
C230
Cabinet des Dessins, Louvre, Paris

Plate 17 **Woman Taken by Surprise** about 1870–73 pencil $4\frac{7}{8} \times 8\frac{1}{2}$ in (12.4 × 21.7 cm) C289

Art Institute, Chicago

Plate 18

The Orgy
about 1864-68oil on canvas $51 \times 31\frac{3}{4}$ in $(129.5 \times 80.6 \text{ cm})$ V92
Private collection

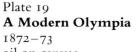

oil on canvas 18 × 21 in (46 × 55 cm) V225 Louvre Paris

Louvre, Paris

Plate 20 **The Temptation of St Anthony**

1869-70oil on canvas $22\frac{1}{2} \times 30$ in $(57 \times 76$ cm)
V 103
Bührle Collection, Zürich

often openly erotic and with an oppressive sensuality, we sense something of the tension as well as of the scale of his early imagination.

It is a very private adolescent world. Its autobiographical nature is confirmed by his own presence as spectator in many of the images (plates 19, 21). In a sense it was meaningful *only* to himself.

In L'Oeuvre, Zola describes his youthful hero, with Cézanne in mind: '. . . chaste as he was, he had a passion for the physical beauty of women, an insane love of nudity desired but never possessed, but was powerless to satisfy himself or to create enough of the beauty of which he dreamed. The women he hustled out of his studio, he adored in his pictures. He caressed them, outraged them even, and shed tears of despair over his failures to make them sufficiently beautiful, sufficiently alive.'

Cézanne's letters of the period are littered with frustrated admirations, with ambitious designs inhibited by clumsiness and a sense of inferiority (see pages 90–91). His drawings and writings have the same character, dwelling on voyeurish subject-matter and a morbid sensuality. In a poem called *Une Terrible Histoire*, the whole nightmare fantasy concludes with the narrator at last confronting the most beautiful woman he has ever seen. As his lips touch her breast, she is transformed, to the accompaniment of a death-rattle, into a cold corpse. Skulls and raw meat feature prominently in still-lifes of the period, and the sense of a compulsive working-out of inner frustrations and neuroses is expressed in the frenzied execution of many of the drawings (plates 17, 82). His hand trembles violently. There is a furious, desperate assault of pencil on paper. The images are a violent disarray of action. A few of the paintings, too, have this frenetic, super-

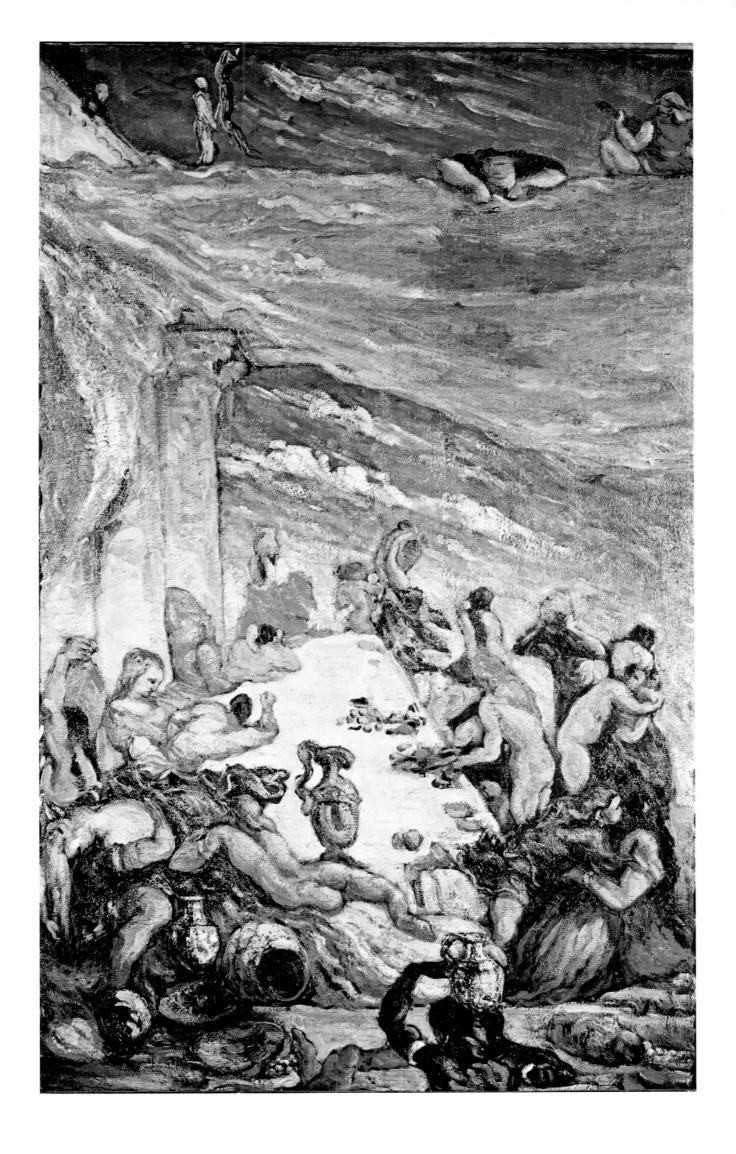

Plate 19 A Modern Olympia see page 22

Baroque tremulousness of handling. In *The Orgy* and another Manet subject *The Modern Olympia*, it is heightened by an extreme use of strong colour and a rather theatrical type of composition (plates 18, 19).

Most of the paintings carry this content through heavyweight paint and a very sombre palette, dominated by dense blacks and black-based greens. Good examples of this are *The Temptation of St Anthony* and *The Picnic* (plates 20, 21). Great screens of greenish black form a curtain-wall, against which the massively sensual action takes place. A shallow space is crowded out with physical presence.

Naive? raw? uncontrolled? immature? yes, all of these things at times, but Cézanne's early work is not merely the adolescent mental block it was once dismissed as. Nor is it as irrelevant to his mature work as this suggests. Firstly we learn from it of the generous energy and imagination, the scale of the man, that is present behind all of his oeuvre. Second, we see what a born painter he is. That the compositions do not fall apart, that for the most part he can hold and organise the welter of energies within his canvas, is a not inconsiderable pointer to the achievements ahead.

Other artists that he admired at this time-Delacroix, Caravaggio, Rubens, the great Venetians from Titian to Veronese -nourished his early aspirations towards grand-manner Romantic images, ebullient in character, rich in colour and a sense of

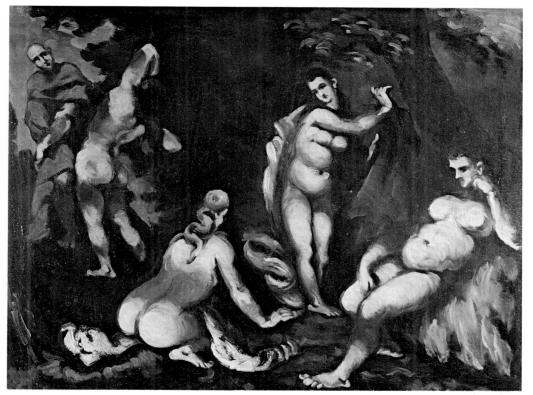

Plate 20 The Temptation of St Anthony see page 22

theatre. In other words, they would seem to emphasise a distance between the youthful Cézanne and the objective discipline of his mature nature-painting. But in fact these artists remained high in his private pantheon of heroes. He makes drawings after Rubens throughout his career; Delacroix is a lifelong yardstick of greatness in painting, and in 1904, two years before his death, Cézanne still writes of the Venetians and Spaniards as 'the true colourists'.

Despite all of this, the major reorientation in his painting in the early 1870s remains the most extraordinary 'conversion' in the history of 19th-century painting.

Plate 21 **The Picnic**about 1869
oil on canvas $23\frac{5}{8} \times 31\frac{7}{8}$ in (60 × 81 cm)
V107

Private collection

As early as 1866, Cézanne had written to Zola: '. . . all pictures painted inside, in the studio, will never be as good as those done outside. When out-of-doors scenes are represented, the contrast between the figures and the ground is astounding and the landscape is magnificent. I see some superb things and I shall have to make up my mind only to do things out-of-doors' (October 1866). In

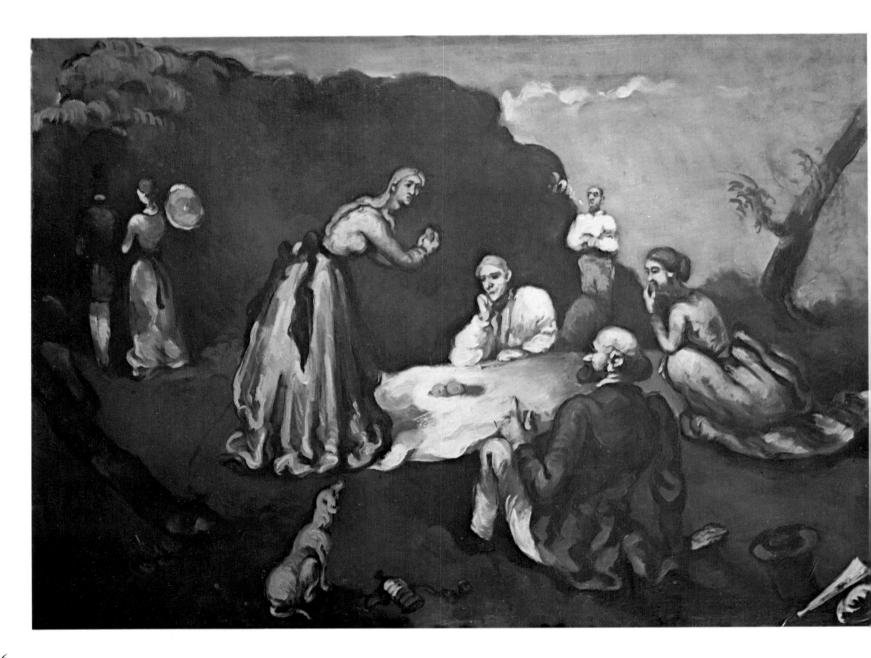

itself this is unexceptional avant-garde talk in the 1860s, but it is remarkable coming from Cézanne, in view of the main tenor of his own work at the time.

Even in works of around 1870, like *The Black Clock* or *Melting Snow at l'Estaque*, where he is treating ostensibly objective themes, a duality is apparent between his own romantic temperament and current concepts of objectivity. Both images seem loaded and ominous. *The Black Clock* (plate 22) has great structural strength as a painting, with a massively simple black-and-white tonality and an exposed rectilinear framework. In this sombre context, the lurid gash of a mouth on the shell evokes the same mood of hostile sensuality prevalent in the 1860s figure paintings.

The l'Estaque painting (plate 23) is coherent enough as an image from the real world, but again it is alive with a familiar nervous, tremulous handling and a fairly murky, ominous palette.

Cézanne was at l'Estaque (1870-71), living in secret with his mistress Hortense Fiquet, firstly to escape his father's attention and

Plate 22 **The Black Clock**about 1869-71oil on canvas $21\frac{3}{4} \times 29\frac{1}{4}$ in $(54 \times 73 \text{ cm})$ V69
Collection of Mr Stavros S. Niarchos

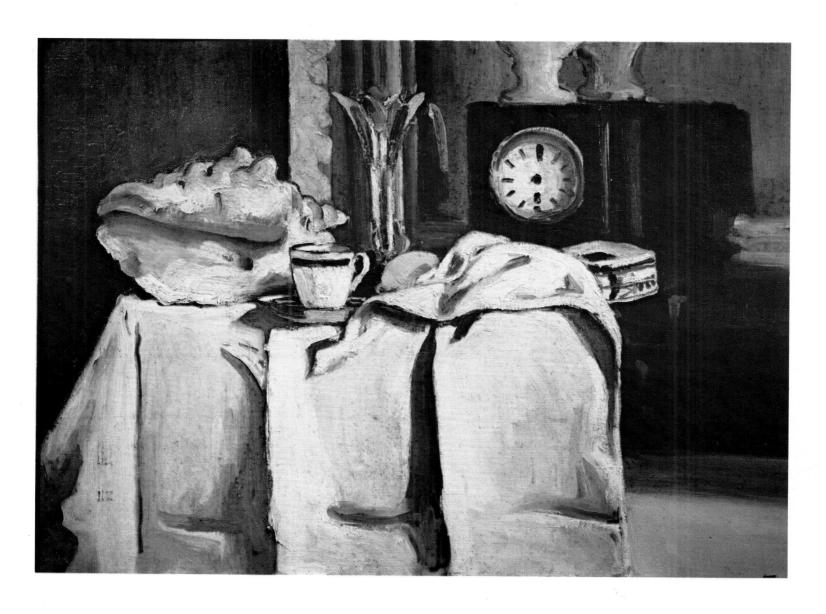

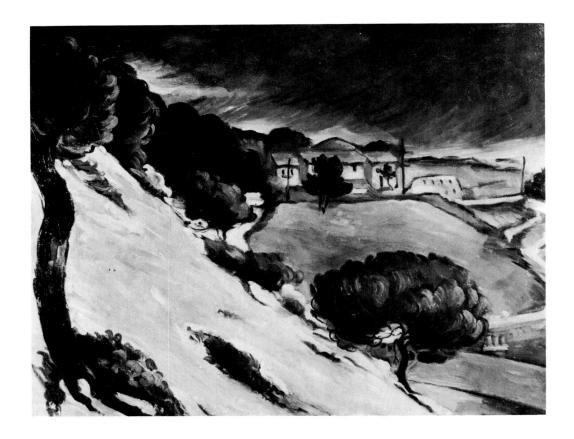

Plate 23

Melting Snow at l'Estaque about 1870–71
oil on canvas $28\frac{3}{4} \times 36\frac{1}{4}$ in $(73 \times 92 \text{ cm})$ V51

Private collection

secondly to evade conscription during the Franco-Prussian war.

In the 1860s he had been in intermittent contact with the young Impressionists and their ideas. In one of several surviving early letters to Pissarro he writes: 'You are perfectly right to speak of grey, for grey alone reigns in nature, but it is terrifyingly hard to catch' (23rd October 1866). But during the period when he was perhaps least in touch with Impressionist painting (1869–72) it was undergoing its most dramatic early developments: clarifying its concept of the transient, of the first impression, and developing its characteristic technique of small, clearly separated brushmarks and clear, more or less atonal colour.

So when he returned to Paris, late in 1871, Impressionism must have come as something of a shock to him. The effect of this, coupled with his enduring respect for 'the humble and colossal Pissarro', prompted the new direction he undertook. In later years it was always this moment in Impressionism's history that he singled out. At this point he was a great admirer of Monet. He retained this respect and enjoyed a lasting friendship with Monet, but the famous tribute, 'Only an eye but, my God, what an eye!', almost certainly refers to the intensity of perception exposed in early Monet (plate 4). 'Monet is the most prodigious eye since there have been painters.'

Of Pissarro's painting he felt the same: 'If he'd continued to paint as he did in 1870, he would now be the strongest of us all.'

Plate 24

Landscape at l'Estaque

1870-72

pencil

9½ × 125/8 in (24 × 32 cm)

C121

Art Institute, Chicago

(Given by Mr J.K. Thannhauser)

Shortly after the birth of his son (January 1872), Cézanne took his family to live at Pontoise and then at Auvers-sur-Oise, working closely with Pissarro until 1874. Considering that 'to prove something to Cézanne would be like trying to persuade the towers of Notre Dame to dance' (Zola, 1861), his acceptance of Pissarro as master is that much more extraordinary. He copied one of Pissarro's paintings; he stood side-by-side with him painting the same motif. This contact was the turning-point between the romantic, rather chaotic might of his early oeuvre and the dignity and discipline of his mature work.

The conversion to Impressionist principles served a sort of laxative role, a release from the stormy introversion of his adolescence. From here on he works directly from the motif, on the spot, concentrating his energies outwards. He adopts a clear palette, abandoning tonal construction and his bituminous palette (Pissarro told him to 'use only the three primaries and their derivatives'). Finally he adopts the broken technique of Impressionism.

But from the start there were significant differences in each of these three respects.

Firstly, in his attitude to the motif: he sat in front of the motif and-like the Impressionists-painted what he saw. He shared their devotion to the particular in nature: to light, nuances of colour, the vibrancy of motifs. But from very early on, the instinct to

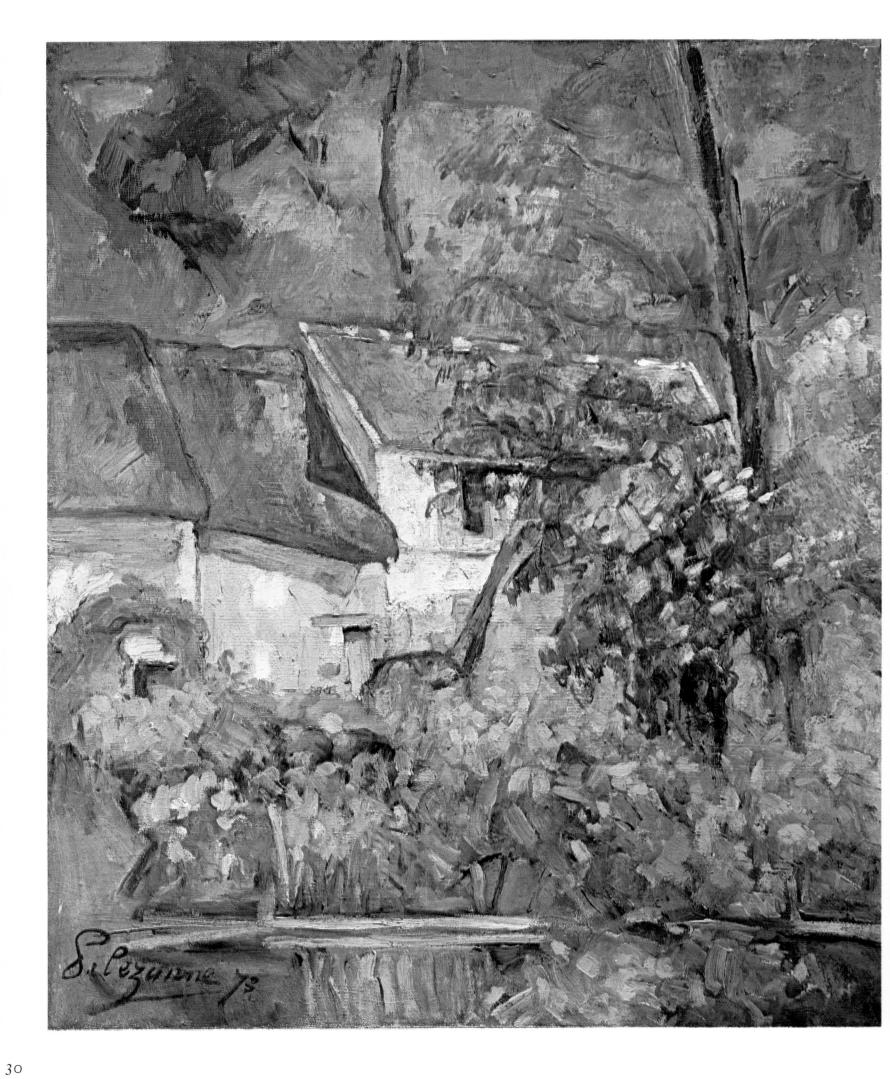

Plate 25 House of Père Lacroix

1873 oil on canvas $24\frac{1}{2} \times 20$ in $(62.2 \times 50.8 \text{ cm})$ V 138 National Gallery of Art, Washington, DC (Chester Dale Collection)

construct that we have already seen in his early work, to make monumental compositions, gives his landscape painting a character quite distinct from Impressionism generally. Whereas to Monet it had become a matter of principle to make each painting not a composite, complete thing, but rather an instantaneous fragmentary moment of perception, for Cézanne painting was a matter of a great series of perceptions being organised into a whole.

This distinction lies behind all of his later comments about Impressionism: '[it] is only a way of seeing'; 'I want to make of Impressionism something more solid and durable, like the art of the museums.' In the earliest Auvers paintings the canvas surface is laden with the robust ordered relief of pigment that we saw in *The Black Clock*. There is a sense of timeless permanence at odds with 'the first impression': no transience.

The brightening of his palette is the most evident change of these years. Until now black and white dominants had been all-important. Monet recalls Cézanne putting a black hat and a white handkerchief next to the model at the Académie Suisse, to judge values. Now black is virtually abandoned. At this point, though, Cézanne is far more conscious of local colour values than the Impressionists. Monet, Pissarro, Renoir, Sisley, during the 1870s, became more and more concerned with atmospheric greys, with the dissolving effects of light–almost to the point of discarding local colours.

It is important in this connection to remember that Cézanne came from the South of France. Here the hard and clear Mediterranean light intensifies colours, defies distance, draws no veils of mist across the water. Cézanne's eye had been educated differently. Down at l'Estaque in 1876, he writes to Pissarro that the effect of the light is to silhouette colours and flatten the landscape 'like a playing-card' (see page 96). In his drawings and paintings there—even in some before this date—you can see the effect at work. The definition of the distant horizon is insistent; it does not melt into atmospheric haze. The shapes of trees and houses make up bizarre silhouettes.

When he was painting with Pissarro at Auvers the same thing happens. Blue rooftops and red chimneys are sought out and make a succession of colour-accents across the composition. The contrast of red roof and green foliage is intensified, not dissolved.

Generally speaking this remains a constant characteristic of his painting. It needs some qualification in respect of the late work, but generally a greater value obtains in Cézanne's painting from one colour being tied to one object. It is especially evident in his painting of still-lifes. He learnt it from looking at nature and

Plate 26 View of the Village of Auvers

1873-75oil on canvas $25\frac{1}{2} \times 31\frac{3}{4}$ in $(65 \times 81 \text{ cm})$ V 150 Art Institute, Chicago (Mr and Mrs Lewis L. Coburn Memorial Collection)

Plate 27 **The Hermitage, Pontoise**

1875–77 oil on canvas $14\frac{1}{4}\times21\frac{1}{8}\text{ in }(44\times54\text{ cm})$ V176 Von der Heydt Museum, Wuppertal

Plate 28

Group of Houses at l'Estaque

about 1876 pencil $4\frac{7}{8} \times 8\frac{5}{8}$ in (12.4 × 21.7 cm) C790 Art Institute, Chicago

Plate 29

Self-Portrait

about 1875-77 black crayon 6×5 in $(15.2 \times 12.7 \text{ cm})$ C400 Private collection

Plate 30

Self-Portrait

1875–76 pencil $8\frac{5}{8} \times 4\frac{7}{8}$ in (21.7 × 12.4 cm) C402 Art Institute, Chicago

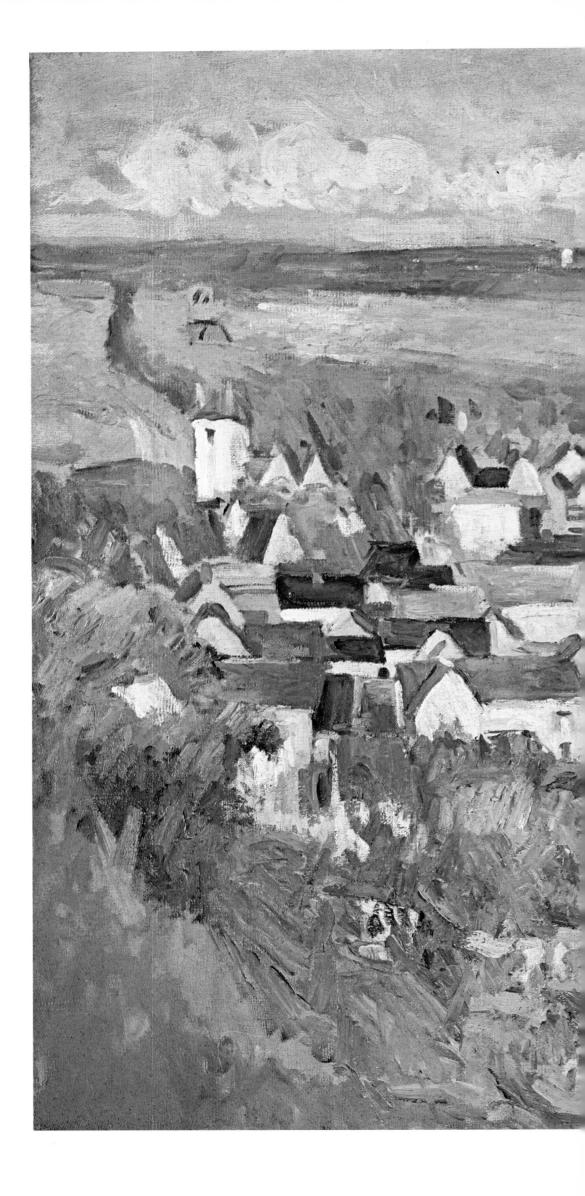

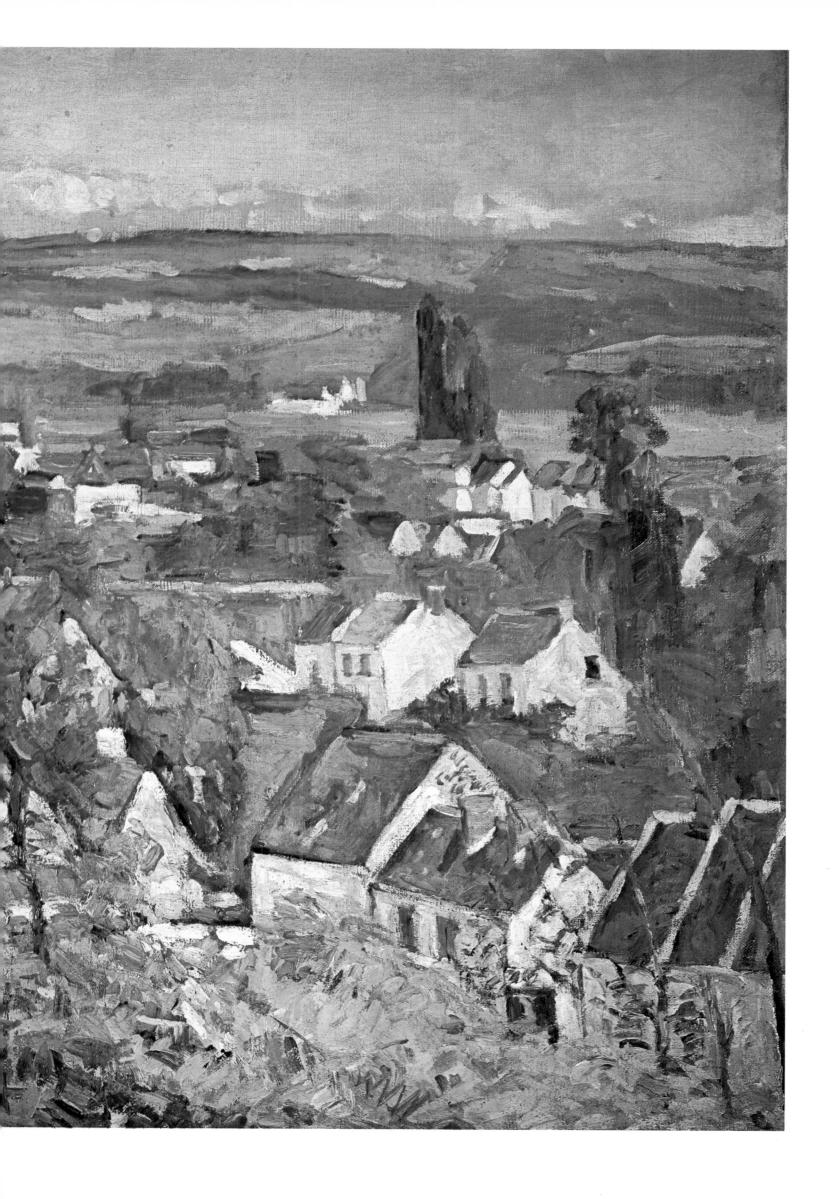

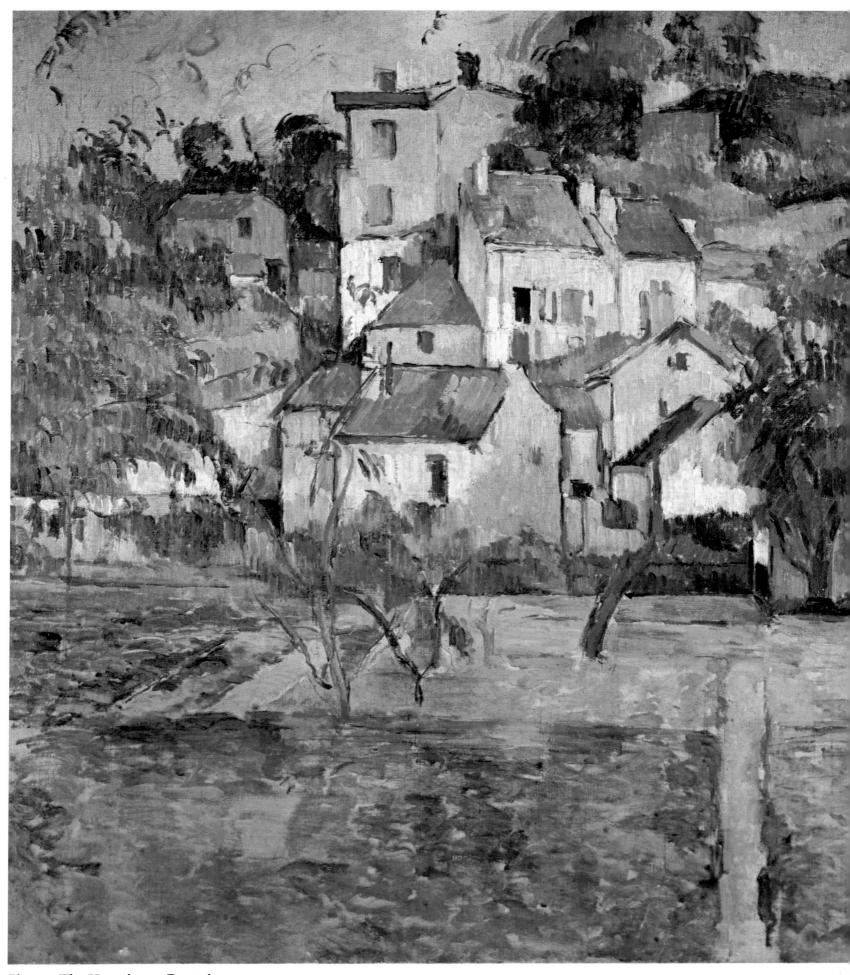

Plate 27 The Hermitage, Pontoise see page 32

found confirmation from looking at art. 'All painting lies in this dilemma,' he wrote later, 'whether to give way to the atmosphere or to resist it. To give way to it is to deny local values; to resist it is to give local values their full force and variety. Titian and all the Venetians worked with local values; this is what makes all true colourists' (quoted by Emile Bernard, 1920).

Finally, the Impressionist technique of broken brushwork: whereas, in the broad sense, the technique seemed a revolutionary throwing off of inhibiting conventions, for Cézanne it was more of a discipline, a means to control. He regularised it into a more systematic procedure. In his painting it becomes a more self-consciously organised fabric of marks. The repeated direction of the mark in the great Pontoise landscape (plate 27) holds the surface intact like a fine mesh. Against this mainly horizontal/vertical fabric, the curve of a tree-trunk or the steep angle of a pitched roof are dramatic incidents (rich in 'local values'). The fabric is both the language for Impressionist sensations of light and colour and a structural language in its own right.

His landscape drawings, too, develop the same sort of methodical plotting, building of relationships. In his sketchbooks of the 1870s, Cézanne became the first artist to consciously evolve a mode of drawing out of the Impressionist mode of painting (plate 28).

While this major reorientation was taking shape within his art, Cézanne's public image as an artist was if anything going from bad to worse. His work continued to be rejected at the Salons. His contributions to two of the independent Impressionist exhibitions (1874 and 1877) prompted some of the fiercest reaction from hostile critics and public. A Modern Olympia achieved a succès de scandale in 1874 almost as great as had the Manet masterpiece it

Plate 28 Group of Houses at l'Estaque see page 32

Plate 29 Self-Portrait see page 32

Plate 31 **Self-Portrait** about 1877–79 oil on canvas $21\frac{3}{4} \times 18\frac{1}{2}$ in $(55 \times 46$ cm) V284 Neue Pinakothek, Munich

Plate 32
Self-Portrait
about 1880
eil on canvas
13\frac{1}{4} \times 10\frac{1}{4} \times (33.6 \times 26 cm)
V365
National Gallery, London

Plate 30 Self-Portrait see page 32

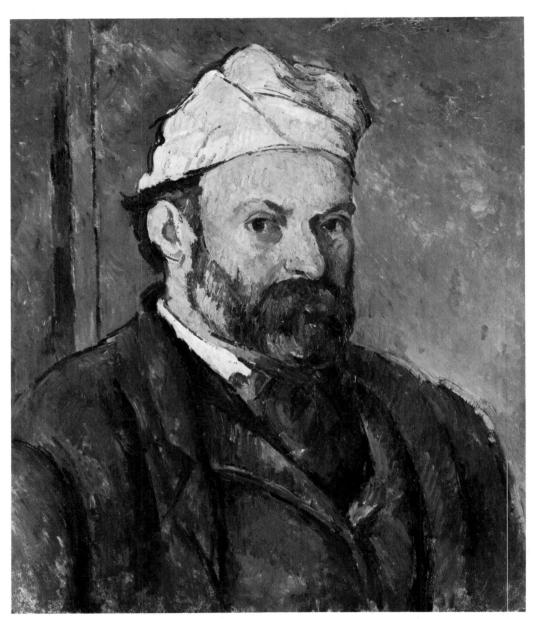

parodies. One critic wrote that 'Cézanne merely gives the impression of being a sort of madman who paints in delirium tremens.'

He then had misgivings about the value of group exhibitions and decided not to show in 1876. He regarded the third show (1877), in which he showed sixteen works, as a failure. All the works he showed were listed in the catalogue as 'studies after nature'. They included the portrait head of Chocquet (plate 90).

It was at this point that he withdrew from the Parisian arena, 'to work in silence until the day when I shall feel able to defend in theory the results of my efforts'. Although he stubbornly continued to submit paintings to the Salon in face of repeated rejection (only once did a friend's support bring about an

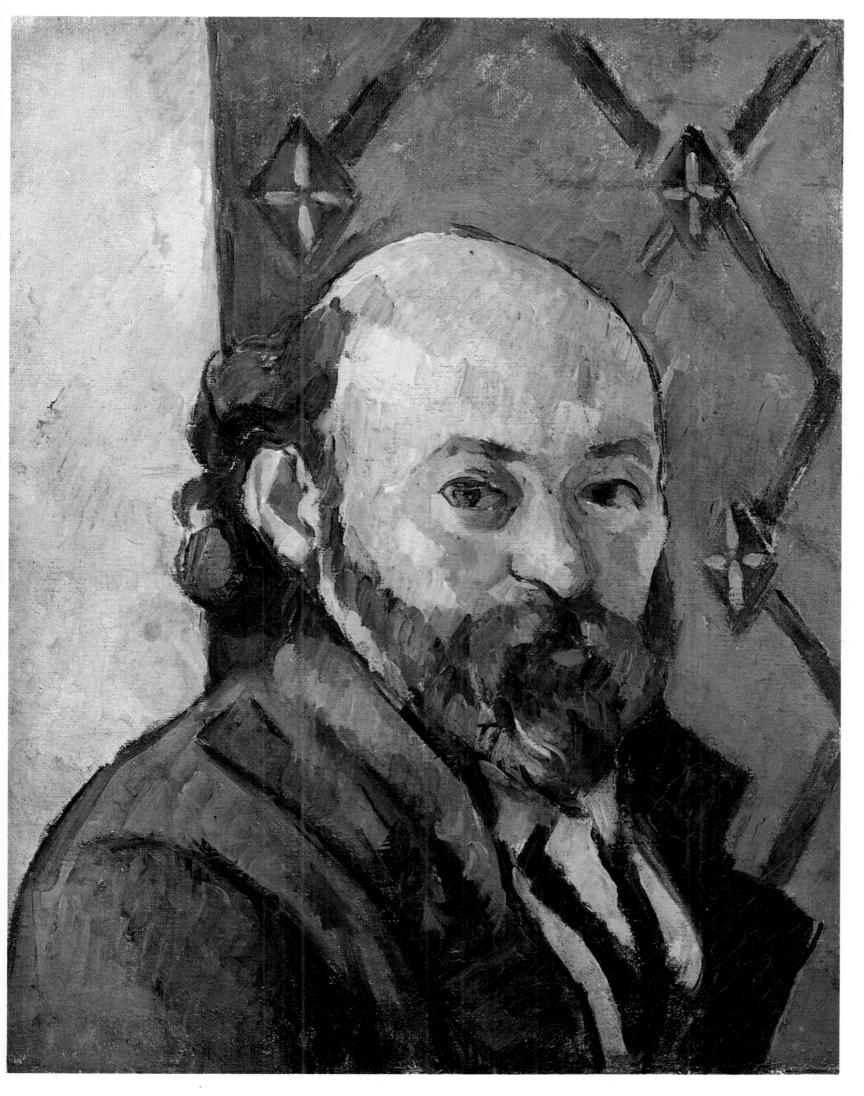

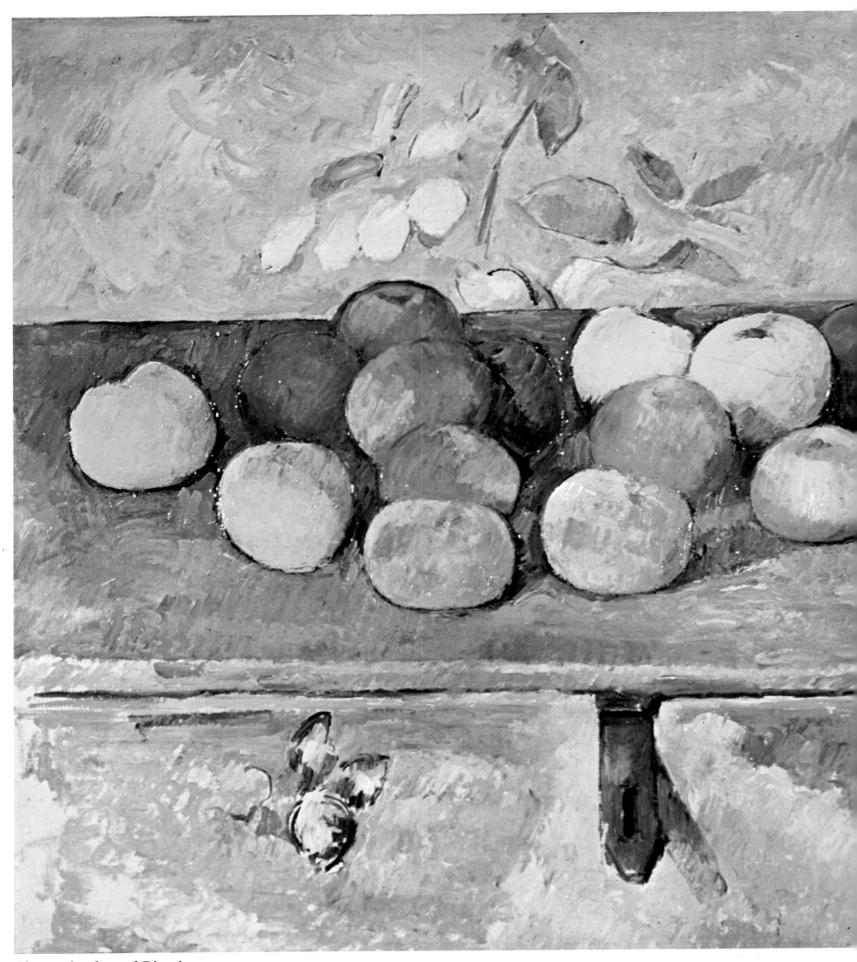

Plate 33 Apples and Biscuits see page 40

acceptance), he virtually did not exhibit again in Paris for almost twenty years. A few paintings could always be seen at Père Tanguy's shop, but not by a wide public.

It was a moment of great importance to him. His feelings in these years swing violently between stormy self-confidence and uncertain self-doubt. He wrote to his mother in 1874: 'I am beginning to consider myself stronger than all those around me, and you know that the good opinion I have of myself has only been reached after serious consideration.' In 1886 he writes to Chocquet, immediately after the break with Zola: 'I should have wished to possess the intellectual equilibrium that characterises you and allows you to achieve with certainty the desired end . . . Fate has not endowed me with an equal stability.' (These two letters are quoted at length on pages 95 and 98). The self-portraits that he paints and draws are truly of the many faces of one man and run the full range of moods from brooding introversion to a cavalier buoyancy (plates 29–32).

While something of this volatile fluctuation remains, the overall impression of his last thirty years is of maturing certainty and faith. The death of his father was obviously important as a psychological as well as financial relief. Outbursts in the 1890s became as extreme as: 'There is only one living painter—myself'; 'There are two thousand politicians in every legislature, but there is a Cézanne only every two centuries'; and, in a quieter mood, 'I have a lot of work to do; it is what happens to everyone who is someone.'

He lived out his stated ambition. Although I have referred to some already and shall use others in talking about his middle period of work, all of his important theoretical statements are late—after he had 'worked in silence'.

In some ways the early works of this middle period resume the flavour of his pre-Impressionist work. They are very direct in form with a stark, bald simplicity. Look at the haunted frozen skeleton of *The Pond at the Jas de Bouffan*, the frontal clarity of the still-lifes (plates 33, 34). The flattened heraldry of his wife's portrait (plate 88) looks very like the 1860s Empéraire image. Look, too, at the difference between the two portraits of Chocquet (plates 35, 90). He said later that 'it took me thirty years to realise that painting is not sculpture.' He certainly knew it in moving from the relatively tonal, modelled character of the first painting to the second, which is formalised like a Manet, flat in structure, jewel-like in colour (plate 3).

It is as if, in the seclusion of Provence, he consciously

Plate 33 Apples and Biscuits

1880–82 oil on canvas $17\frac{3}{4} \times 21\frac{3}{4}$ in (46 × 55 cm) V343 Louvre, Paris (Collection of Walter Guillaume)

Plate 34 **The Pond at the Jas de Bouffan** about 1878
oil on canvas $20\frac{5}{8} \times 22$ in $(52.5 \times 56$ cm)

V 164

Private collection

determined to impose his instinctive will, the stamp of his sense of order, on Impressionism and on nature. Compare those landscapes where we can still see him improvising with the lightness of marks that he had learnt from Impressionism—plates 36, 89—with others which have, on the face of it, little to do with Impressionism: the famous *Bridge at Maincy*, another rigid structure based on a mirror-image, or the *House in Provence* (plates 37, 38). Both have a brutally simple sense of surface, a very plastic sense of object-values. There is no hint of the melting diffusion of light. A hard, physical, almost metallic presence crowds out the surface, as if the two-dimensional plane of the canvas is inviolable.

In his painting he was more intellectually articulate than most Impressionists; so that while it was executed amid the same sort of surrender to visual sensations, he was more conscious of the nature of these and more free to alter, recompose, adjust. At this time he talks of his 'petite sensation', as if his vision was of a lucid, concrete, graspable idea. Later on he is to talk of 'confused

sensations': his vision becomes more fluid, ambiguous. The nature of the means he uses is a very conscious expression of these ideas. 'If the strong feeling for nature—and I certainly have that vividly—is the necessary basis for all artistic conception, on which rests the grandeur and beauty of all future work; the knowledge of the means of expressing our emotion is no less essential and is only to be acquired through very long experience' (letter to Louis Aureche, 25th January 1904).

The sort of liberties he takes with the motif-bending perspective, flattening, tilting-have led to a lot of confusion about Cézanne's 'fidelity to nature'. Usually this has been because both points are taken too literally. Basically what he was recognising was that painting is a dialogue between art and nature, with the artist acting as interpreter according to the limits of his resources. Sensations are subjective. The unique intricacy of each artist's sensations are the cause of the great diversity within and between paintings from nature. Although he uses the word 'logic', he

Plate 35

Portrait of Victor Chocquet Seated
about 1876-77
oil on canvas
18\frac{1}{8} \times 15 in (46 \times 38 cm)
V373

Columbus Gallery of Fine Arts, Columbus,
Ohio (Ferdinand Howald Fund)

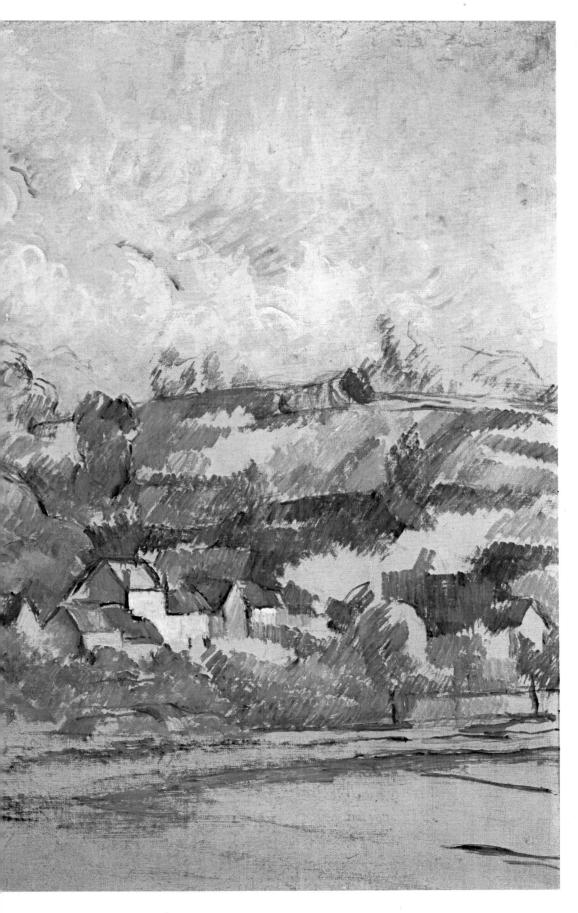

Plate 36 **Auvers from the Harmé Valley** 1879-82 oil on canvas $20\frac{7}{8} \times 32\frac{7}{8}$ in $(53 \times 83.5 \text{ cm})$ V315 Kunsthaus, Zürich (on loan from a private collection)

Plate 37 **Bridge at Maincy** 1882-85oil on canvas $23\frac{5}{8} \times 28\frac{3}{4}$ in $(60 \times 73 \text{ cm})$ V 396 Louvre, Paris

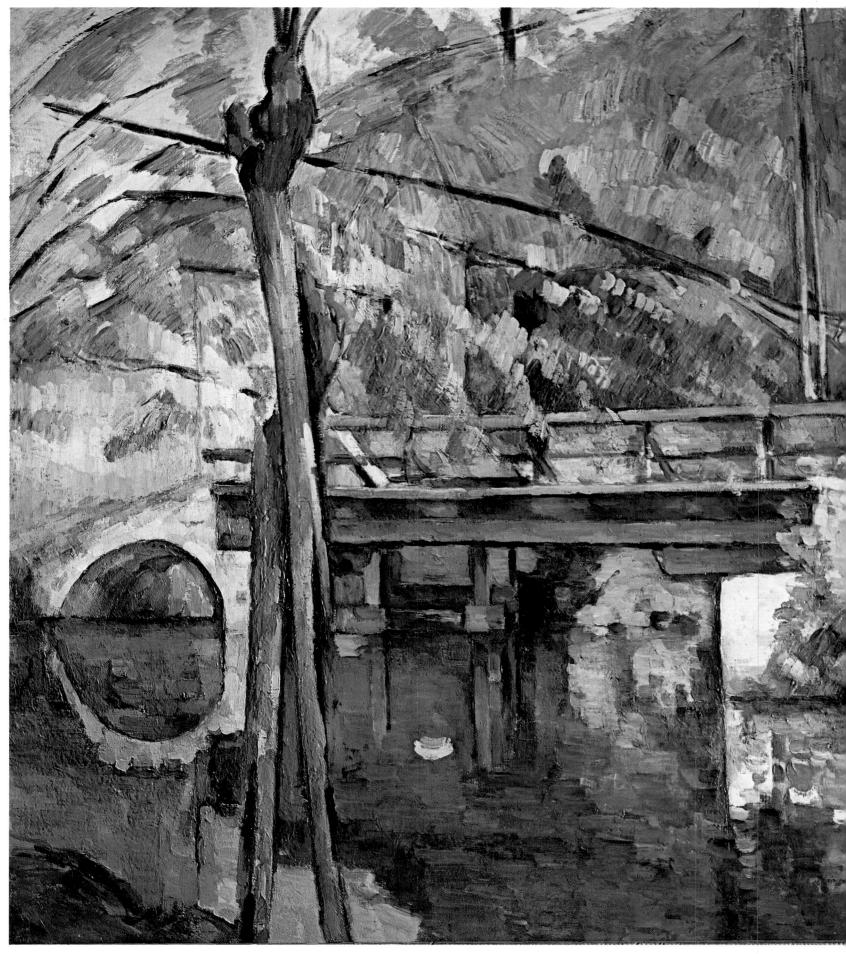

Plate 37 Bridge at Maincy see page 43

believed that a major part of logic was intuition and that sensations were largely beyond logic, outside of reason. It was a compulsive, internal logic that he obeyed. So he proposed a knife-edge balance or harmony between conscious control and intuitive response. The great artist, he thought, is the one with enough 'temperament', with sufficiently complex resources and sensibilities to respond to the irrational complexity of sensations in front of nature. 'Let us search to express ourselves following our personal temperament,' he says. The central axis of art is 'our temperament . . . in the presence of nature'.

In landscapes of the later 1880s, the inert mass of the surface is modified to admit more sensations of depth. The main motif of Aix, Rocky Landscape (plate 39) is clearly silhouetted in a loose ellipse. The hilltop contour links up with the foreground curve by echoing its colour and tone. This tends to flatten the image, contains it, controls the space. Between these two boundaries, relationships are more open and fluid. The eye moves from the mass of foreground rocks back through shifting foliage to muted, ambivalent hints of distant fields and houses. The polarity between the two is fairly exposed here. It was a period of free experiment, of exploration of 'the means of expression'. We can see in plates 40 and 41 how discriminate was his selection of the motif: the vertical/horizontal grid of Road Along a Lake, for instance. The curved road is flattened and contained by the tall shafts of trees, and the perspective recession is screened off first by the viaduct and then by the line of distant hills. It is a good example, too, of the structural integrity of a homogeneous fabric of brushmarks. Drawing and colour set up space, but the uniformity of the signs holds the screen intact.

In the evolution of his technical discipline and control, the great still-life paintings played a major role. Here, he was in control of the subject. There was a strong element of choice, the motif was arrangeable and, once arranged, was relatively stable. We know that he went to a great deal of trouble selecting and arranging the still-life first, composing relationships to create his motif. He was even prepared to resort to artificial fruit and paper flowers to outwit the passage of time and decay. Louis Le Bail describes the process: 'The cloth was draped very slightly upon the table, with innate taste; then Cézanne arranged the fruits, contrasting the tones of one against the other, making the complementaries vibrate, the greens against the reds, the yellows against the blues, tipping, turning, balancing the fruits as he wanted them to be, using coins of one or two sous for the purpose. He brought to this

task the greatest care and many precautions . . .'

So a lot of the odd features of the still-lifes-precariously balanced biscuits or piles of fruit as in the beautiful painting in New York (plate 43), disguised perspective lines, odd viewpoints, tipped-up plates, cups or dishes, controlled colour and so on-were actually contrived in the *reality* of what was in front of him. In the process of painting, the relationships were pushed further in intensifications of colour, adjustments of line, dramatised oppositions of form and shape. Much of this would come into his meaning of giving full force and variety to 'local values'.

Within the relatively inanimate genre of the still-life, he created a whole scale of images from the tight fugue-like plotting of counterpointed colours within a double row of apples (plate 33) to enormously generous Baroque symphonies.

In the earlier works there is the same assertive imposition of a regular technique, more or less at the expense of the motif's properties—e.g. *Still-Life with Compotier* (plate 44) which Gauguin owned (and plundered for stylistic ideas). In the later,

Plate 38 **House in Provence** about 1885-86oil on canvas $25\frac{5}{8} \times 31\frac{7}{8}$ in $(65.2 \times 81$ cm) V433 Indianapolis Museum of Art (Gift of Mrs J.W. Fester in memory of D.W. and E.C. Marmon)

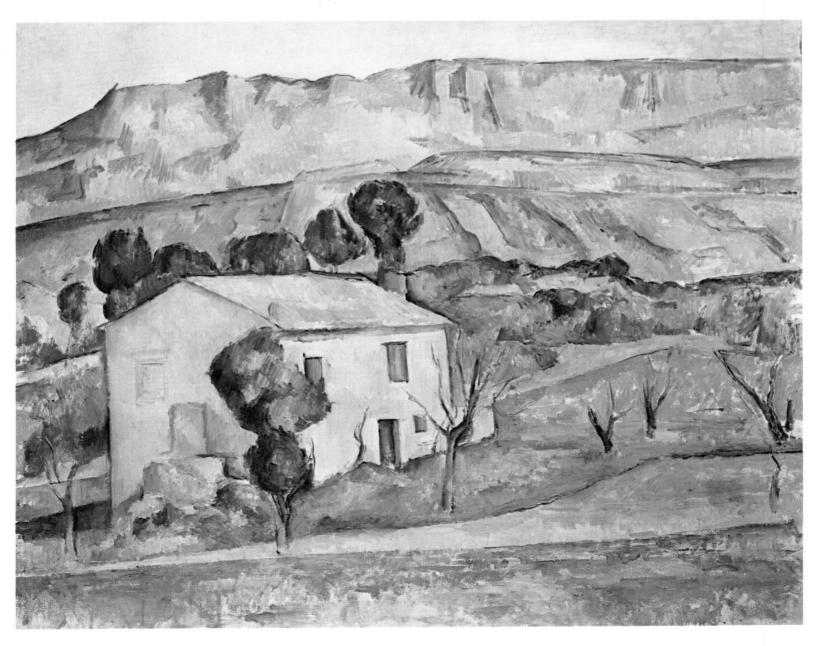

fuller works we are not only forcibly reminded of the intensity of local colours (of the absolute orange-ness of an orange, of the opposition between red and green apples) but also made aware of the particularity of the different objects. The painter of these images was not indifferent to the singular identity and sensuality of what he was painting. They are replete with such qualities: the contrasting silhouettes of pear and apple, the great bulging arc of a table top, the richness of patterned textiles, the virgin white of a tablecloth. But all of this richness is often expressed obliquely, essentially through the language and activity of painting and without compromising the integrity of paint. 'One must not reproduce nature, one must interpret it. By what means? By means of plastic equivalents and of colour.'

Kandinsky saw it this way: 'Cézanne made a living thing out of a teacup or, rather, in a teacup he realised the existence of something alive. He raised still-life to the point where it ceased to be inanimate. He painted things as he painted human beings, because he was endowed with the gift of divining the eternal life

Plate 39 **Aix, Rocky Landscape** about 1887 oil on canvas $25\frac{5}{8} \times 31\frac{7}{8}$ in $(65.1 \times 81$ cm) V491 National Gallery, London

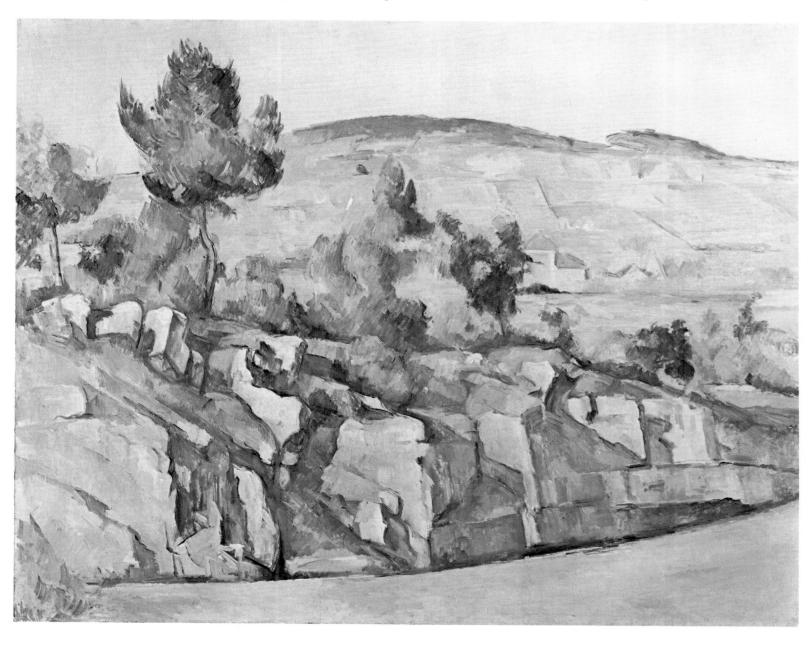

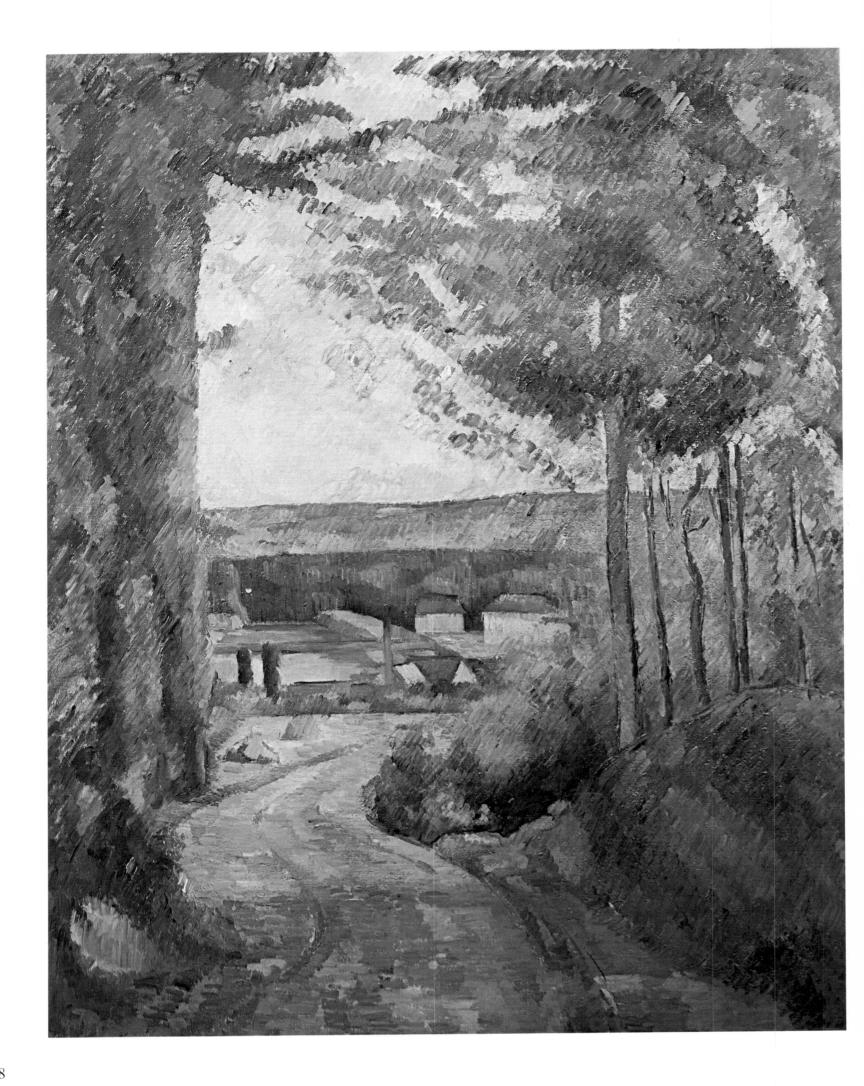

Plate 40 **Road Along a Lake** about 1879-82 oil on canvas $31\frac{7}{8} \times 23\frac{5}{8}$ in $(81 \times 60 \text{ cm})$ V 327 Rijksmuseum Kröller-Müller, Otterlo

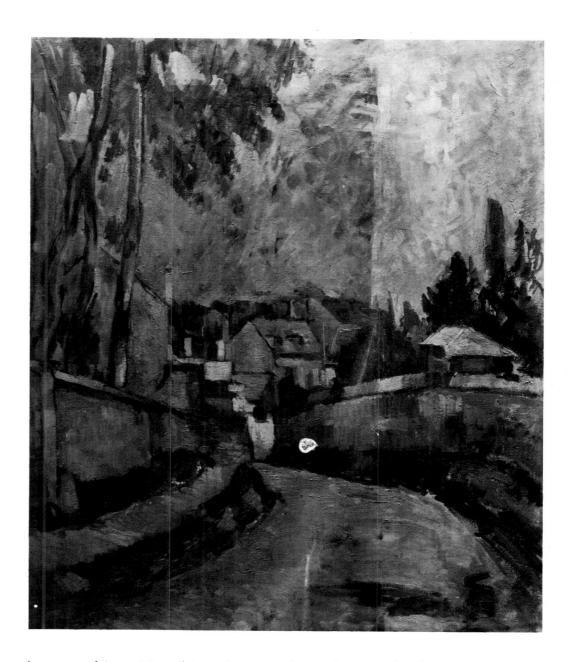

in everything. He achieved expressive colour and a form that harmonises this colour with an almost mathematical abstraction. A man, a tree, an apple are not represented but used by Cézanne in building up a painterly thing called "a picture".

In the same essay ('Concerning the Spiritual in Art', 1912), Kandinsky goes on to liken Cézanne's attitude to 'one of the greatest of young Frenchmen, Henri Matisse, [who] paints "pictures" and in these "pictures" endeavours to render the divine'. Matisse himself learnt much from Cézanne-he owned a small Bathers painting (plate 77)—not least from the still-lifes. He discusses Cézanne's work as a 'complex of energies', 'relationships of forces'. When in the later 1890s he was feeling his way into colour-painting, he produced a string of figure and still-life paintings that are directly descended from Cézanne, from Cézanne's dictum that 'painting is not the servile copying of

Plate 42 **Still-Life with Apples**about 1890-94oil on canvas $18\frac{5}{8} \times 21\frac{5}{8}$ in $(46 \times 54.9 \text{ cm})$ V621

Private collection

Plate 43 **Curtain, Pitcher and Fruit-Dish** 1893-94oil on canvas $23\frac{1}{4} \times 28\frac{1}{2}$ in $(58 \times 71$ cm) V601 Collection of Mr John Hay Whitney, New York

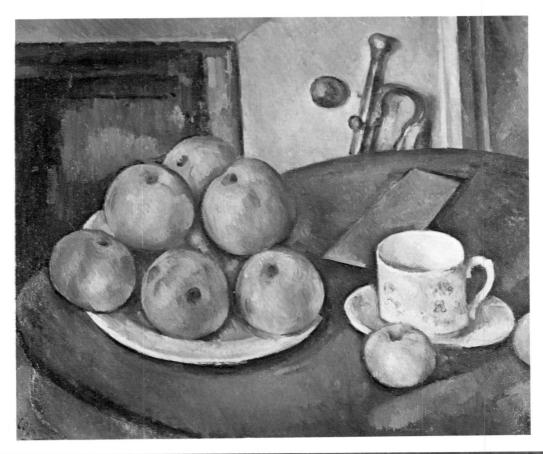

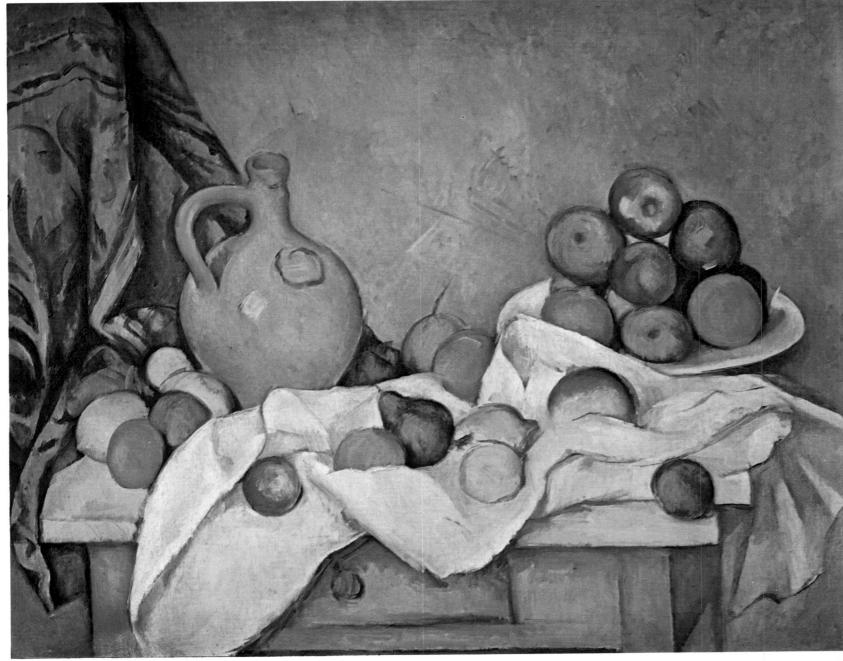

objects, but the discovery of harmony among numerous relationships'. A dictum of Matisse's, 'I want to reach that state of condensation of my sensations that constitutes a picture', might well have been Cézanne talking.

In the still-life paintings this discovery of relationships starts when he is setting up his motif, choosing, arranging, balancing. It is continued and concluded during the painting.

So the sort of eccentricity that we are faced by in a painting like the Still-Life with Cupid (plate 45) has a complicated origin. That the painting was an unusually programmatic play on realities, a real and a painted sculpture, a real and a painted still-life with the same fruit and drapery, is clear from the start. But the sort of ambiguity we see at our left between painting of drapery and painting of painted drapery as well as other liberties with the motif like the discontinuous edge of the canvas behind the Cupid's head or the apparently gigantic scale of the solitary green apple beyond (Formerly in Paul Gauguin's Collection) - this sort of event only emerged in the course of painting. The

Plate 44 Still-Life with Compotier about 1879-82 oil on canvas $18\frac{1}{8} \times 21\frac{5}{8}$ in $(46 \times 54.9 \text{ cm})$ V341 Private collection

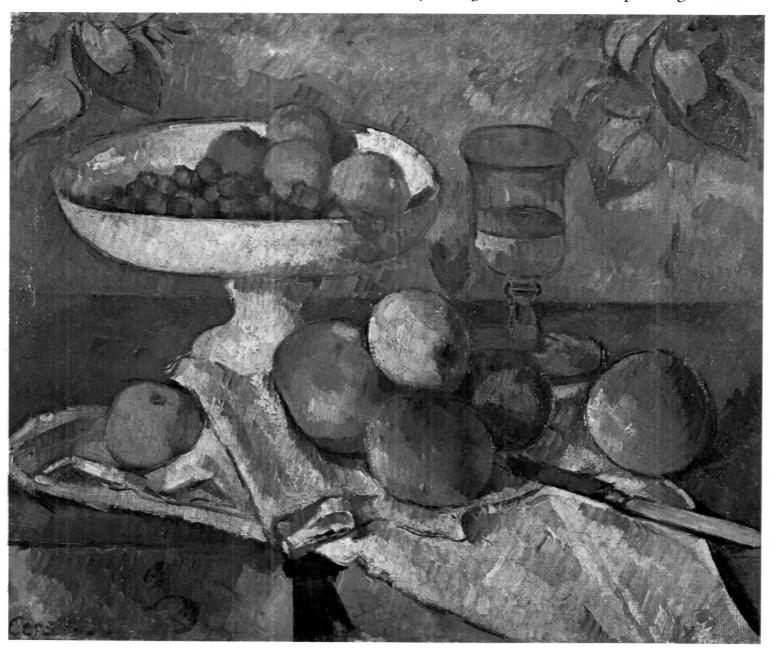

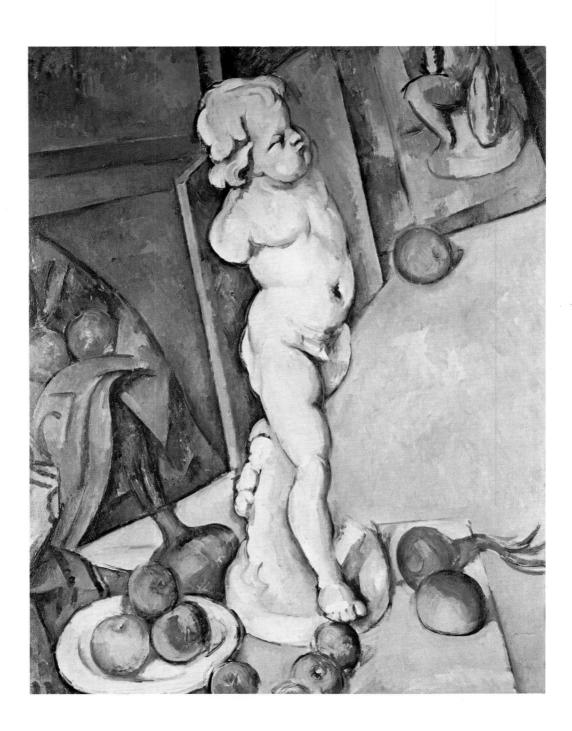

Plate 45 **Still-Life with Cupid**about 1895
oil on canvas
28 × 22½ in (71.1 × 57.1 cm)

Courtauld Institute Galleries, London

familiar trite explanation of distortions in Cézanne's work—that he was combining different viewpoints of the same object—is not by itself enough. Cézanne was in fact very particular about the uniqueness of viewpoint. He said on one occasion that if, while sitting on a stool in front of the landscape, he leant a little to the left or to the right, he would be looking at a different motif (see page 111).

The different angle at which the canvas edge meets the Cupid's head on the right compared to the left has to do not only with the intuitive need for a different encounter with each side of the figure's silhouette, but also with the part the two lines play in the whole climactic convergence of many lines towards the head.

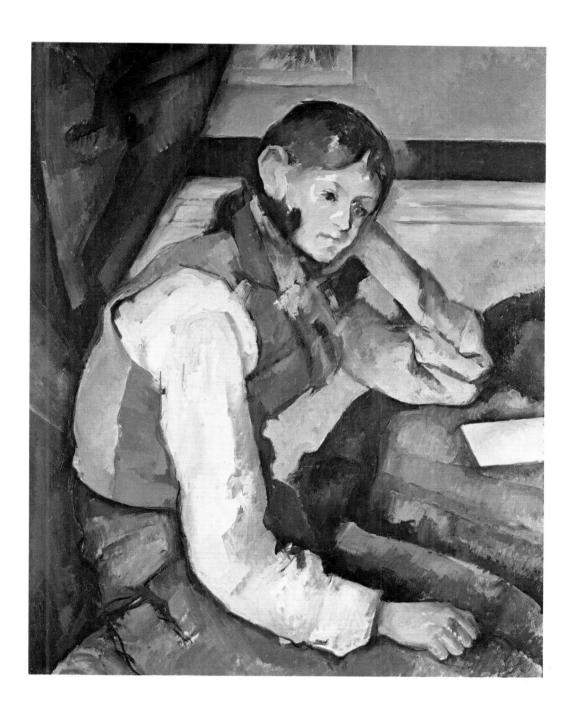

Plate 46 **Boy in a Red Waistcoat**about 1894-95oil on canvas $31\frac{3}{4} \times 25\frac{1}{8}$ in $(79.5 \times 64$ cm)
V681
Bührle Collection, Zürich

The same procedure and values are at work in a figure painting like Boy in a Red Waistcoat (plate 46) with its unnatural crook of the left arm and elongated right arm. These adjustments arise in part from an instinctive overstating of what the eye sees of the sitter, and in part from a deliberate sense of 'design' that is the mind's conception of the figure. The dragging of lighter tones across the dark horizontal band behind and to the left of the head lifts the head away from the background, whereas on the other side the merging of horizontal and hair holds the head back. The eye encounters such contradictions all the time. This is a painterly metaphor for seen reality, not an arbitrarily imposed manipulation. Each visual experience posed its own problems, demanded its own

Plate 47 **Woman with Coffee-Pot** about 1890-94oil on canvas $51\frac{1}{4} \times 38\frac{1}{4}$ in $(130 \times 97 \text{ cm})$ V 574 Louvre, Paris

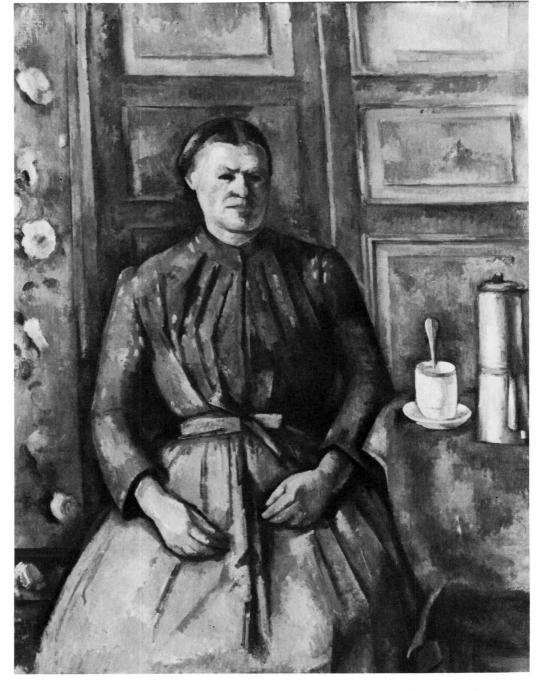

solutions. Each solution contributed to the next, or the one after next. The means of expression matured.

'There are two things in the painter,' Cézanne wrote, 'the eye and the brain. The two must cooperate; one must work for the development of both, but as a painter: of the eye through the outlook on nature, of the brain through the logic of organised sensations which provide the means of expression.' Note the 'but as a painter'. The logic is a felt more than a known certainty, the certainty of an experienced painter sitting looking at his motif in nature. Looking educated his way of painting. Painting educated the way he saw. Cézanne again: 'The painter must devote himself entirely to the study of nature . . . one is neither

Plate 48

Man Leaning on a Table
about 1895
oil on canvas $36\frac{1}{4} \times 28\frac{3}{4}$ in (92.5 × 73.5 cm)
V684
Städtische Kunsthalle, Mannheim

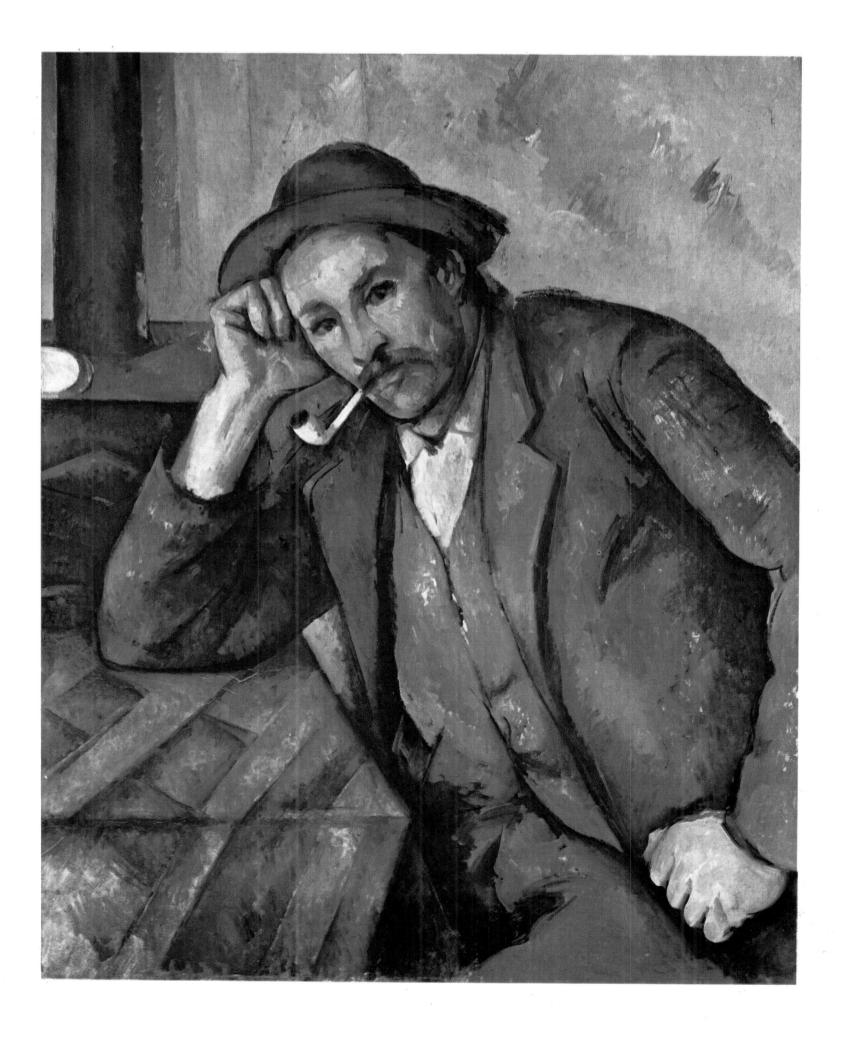

Plate 49 **Two Card Players** about 1890–92 oil on canvas $17\frac{3}{4} \times 22\frac{1}{2}$ in $(45 \times 57$ cm) V558 Louvre, Paris

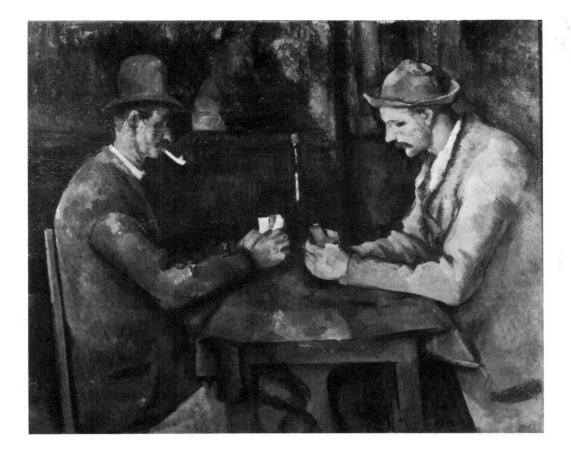

too scrupulous, nor too sincere nor too submissive to nature; but one is more or less master of one's model and above all of one's means of expression.

'Get to the heart of what is before you and continue to express yourself as logically as possible' (26th May 1904).

'To achieve progress nature alone counts, and the eye is trained by contact with her. It becomes concentric by looking and working' (25th July 1904).

Figure paintings like the Woman with Coffee-Pot or Man Leaning on a Table (plates 47, 48) show the figure used very much like a still-life motif. It is this sort of Cézanne painting that gave rise to the 'significant form' interpretation of his art, the legend of a man not concerned with the identity of persons, only with the more or less abstract formal construction. The woman is particularly passive in personality.

Gertrude Stein and her brother were once trying to decide whether to buy a male or a female portrait by Cézanne at Vollard's gallery: '. . . finally they chose the portrait of a woman. Vollard said of course ordinarily a portrait of a woman is always more expensive than a portrait of a man, but, said he looking at the picture very carefully, I suppose with Cézanne it doesn't make any difference' (Gertrude Stein, *The Autobiography of Alice B. Toklas*).

And of course Cézanne himself had very mixed feelings and

Plate 50 **Portrait of Gustave Geffroy** about 1895 oil on canvas $45\frac{5}{8} \times 35$ in (116 × 88.9 cm) V692 Private collection

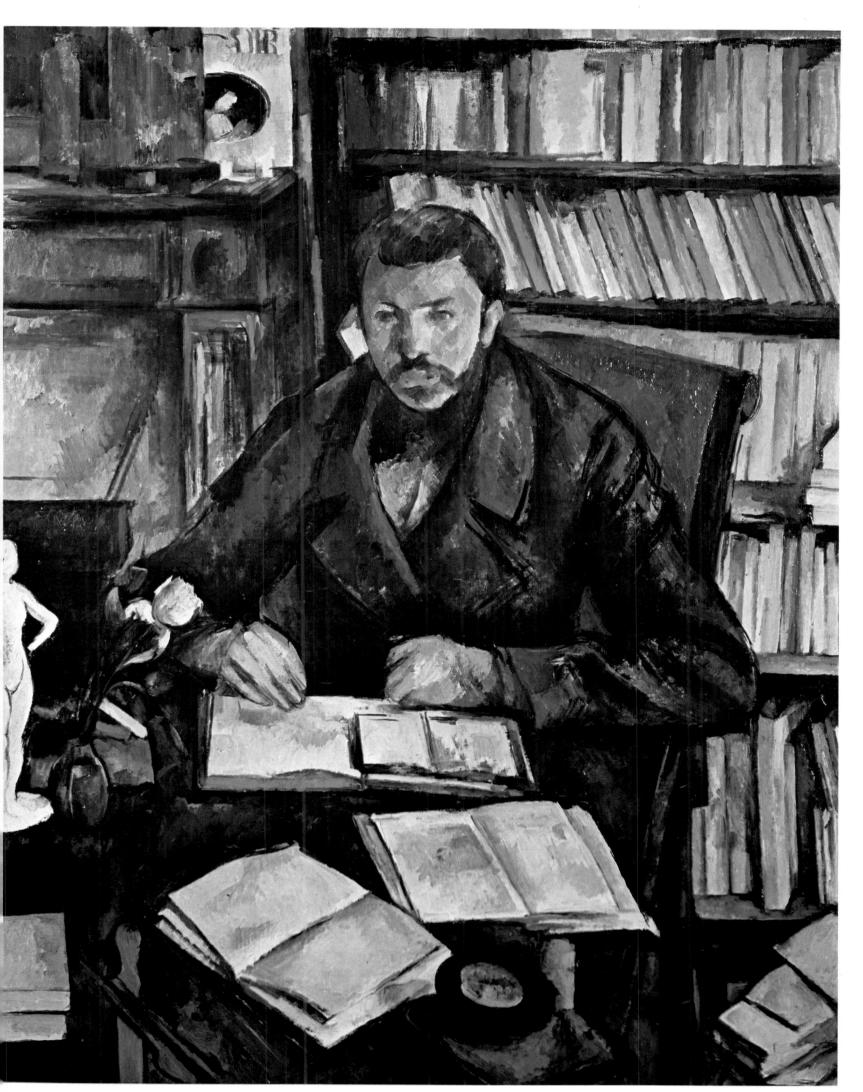

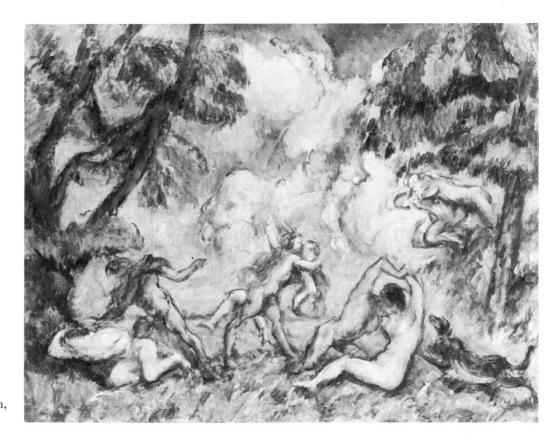

Plate 51
Bacchanale
(La Lutte d'Amour)

1875-80 oil on canvas $15 \times 18\frac{1}{8}$ in $(38 \times 46 \text{ cm})$ V 380 National Gallery of Art, Washington, DC (Gift of the W. Averell Harriman Foundation, in memory of Marie N. Harriman)

unhappy experience of women. Jean Renoir quotes him as saying: 'I paint still-lifes. Women models frighten me. The sluts are always watching you to catch you off your guard. You've got to be on the defensive all the time' (Jean Renoir, Renoir My Father).

In the selection of *Two Card Players* (plate 49) as a subject, Cézanne was obviously attracted by the inherent opposition of forms as some sort of symbol for a more profound opposition. This is one of several versions, some of which include two or three spectators. None of them is a narrative or a psychological drama: there is little conventional characterisation. But in all of them there is considerable tension of opposition. It is expressed as formal oppositions: contrasts of hat shape, of light and shadow, upright or hunched pose, shifts of colour, the shape between the knees, complementary creases each side of the tablecloth and so on. What it all amounts to is a powerfully charged confrontation between the two opponents, enclosed, silent and concentrated: in other words something very close to the heart of a serious game of cards.

The matter of each painting is things seen, acutely seen. The visual experiences are reconciled to a conscious sense of organisation in the interests of making a complete visual image of the total visual experience. In a sense Cézanne taught himself to see in a way that anticipated his sense of pictorial order.

The highly structured portrait of the critic Geffroy (plate 50)

Plate 52 **Five Bathers** about 1879-82oil on canvas $17 \times 20\frac{7}{8}$ in $(43 \times 53 \text{ cm})$ V₃85 Private collection

typifies this. It is an intricate fabric of looking, thinking, painting, (eye, brain, hand). Its angular composition, in which everything contributes to and converges upon the central figure-pyramid and ultimately on the head, comes very close to the character of early Cubist painting. There is the same basic certainty of a horizontalvertical grid, complemented by a whole range of diagonal variations. There is the same controlled colour-scale which gives full force to the occasional emphatic exception, such as the battery of orange books that again focuses towards the head. It is the whole fabric that makes it a great portrait, creating its mood, dignity, seriousness. It is an image of a writer surrounded by books, but beyond this basic definition everything is achieved without recourse to anything but painterly terms. Cézanne believed absolutely in the independent plastic reality of the work of art. He compares its 'concreteness' to the abstraction of literature (see page 107). Hence he was bound to be antipathetic to Gauguin, for instance, whom he called 'a maker of Japanese idols' (see letters etc., pages 122-123). He was bound to be against too much theory in art and over-intellectualisation. All of his own theory consists of fairly concrete explanation of practice: the discipline of looking is its watershed. So while we are more and more conscious of the proto-Cubist architecture in his works of the 1890s, it must not disguise the fact that for him the importance of looking never diminished.

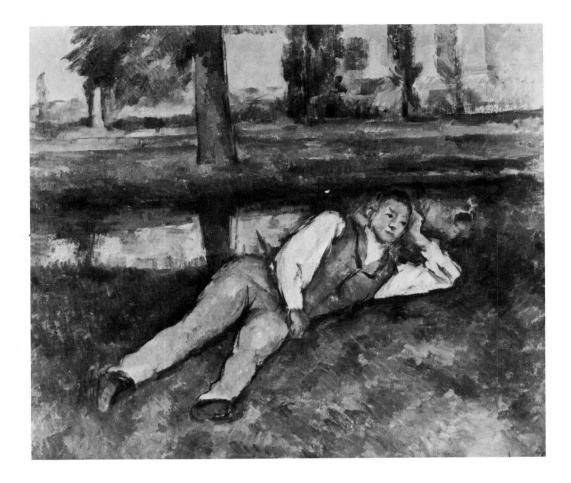

Plate 53 **Boy Lying Down** 1882-87oil on canvas $21\frac{1}{4} \times 25\frac{3}{4}$ in $(54 \times 65$ cm)

V391

Collection of Dr Armand Hammer

The stumbling block for this sort of interpretation of the figure in Cézanne's art is of course the great series of *Bathers* paintings. These and related subjects run intermittently all through his career. They are *not* painted from nature and, compared to the homogeneous corpus of his mature work just discussed, they may seem *not* to resolve vision with structure or form with content in the same harmonious manner.

From the way they are painted as well as from the subjects, they are obviously the closest links with his work of the 1860s. Through them the dream of great Baroque figure paintings and of an heroic Romantic art lives on in a very explicit form. Speaking of one of the big late *Bathers* compositions, Cézanne said: 'That one is in here', tapping his forehead (see letter of March 1904 to Emile Bernard, page 105).

The sources of the motifs are complex. One of his biographers, Gasquet, recalls Cézanne speaking of walking along a river bank watching soldiers bathing 'to see the contrasts, skin tones against the green'. The implication that his ambition was to lend the authority of his painting from nature to the great themes of his adolescence is an important one. But few of the paintings of the figure in landscape give any impression of being painted in situ. The *Boy Lying Down* (plate 53) is a possible exception.

His own neurotic attitude to women and his wife's disapproving provincial morality put the use of female nude models virtually

out of the question. We know that he used photographs. The monumental Standing Bather in New York (plate 54) is based on a photograph, and the same pose is also used in other versions. He copied reproductions from an album called Le Nu au Louvre; he copied some poses from his own early drawings; and above all he made extensive sketchbook studies in the Louvre after the great masters of the figure from history. His lifelong admiration of Delacoix has already been mentioned. There are accounts of Cézanne and Chocquet looking through Chocquet's collection of Delacroix watercolours with tears in their eyes. Of the others that he copies, he concentrates on the makers of generously opulent figure images, on muscular, curvilinear, highly physical art. Rubens is a repeated source, often the same pose over and over, and so are the more energetic sculptors, especially Puget and Michelangelo (plates 55, 56, 92). There is plenty to suggest that it was the study of such art in the museums that nurtured the rich

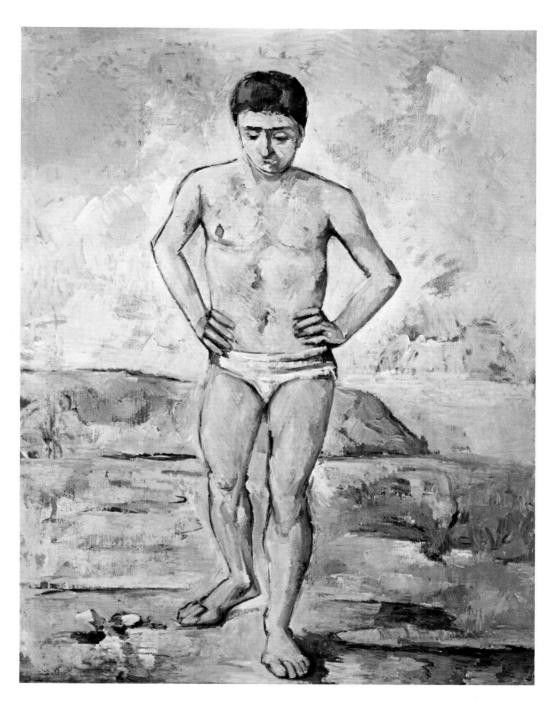

Plate 54 **Standing Bather**about 1885
oil on canvas $50 \times 38\frac{1}{8}$ in (126 × 95 cm)

V 548

Museum of Modern Art, New York
(Lillie P. Bliss Collection)

Plate 55 Milo of Crotona drawing after Puget's statue about 1880-83pencil $8\frac{5}{8} \times 5\frac{1}{8}$ in $(21.8 \times 13 \text{ cm})$ C 504 Kunsthalle, Bremen

Baroque drawing style of his later years. Compare it to the systematic plotting of landscape drawings from the 1870s. Again we see art educating his vision.

In the sketchbooks, these studies are intermixed with drawings from nature. This lends further incidental support to the suggested dual ambition motivating the *Bathers* paintings: he wanted to blend his respect for the great traditions of museum art, his awareness of the great Venetian painters of figure-in-landscape looking over his shoulder, with his mature resolution of the issue of landscape painting. He advised the young painter Charles Camoin to 'make . . . some studies after the great decorative masters Veronese and Rubens, *as you would from nature* [my italics]—a thing I was only able to do incompletely myself' (3rd February 1902. See page 104).

He writes to Bernard: 'I do not want to be right in theory but in front of nature. Ingres, in spite of his style, and his admirers, is only a very small painter. The greatest, you know them better than I; the Venetians and the Spaniards' (25th July 1904). And again in 1905: 'The Louvre is the book in which we learn to read. We must not, however, be satisfied with retaining the beautiful formulas of our illustrious predecessors. Let us go forth to study beautiful nature, let us try to free our minds from them, let us try to express ourselves according to our personal temperaments. Time and reflection, moreover, modify our vision little by little until at last comprehension comes to us.'

The best approach to an understanding of Cézanne's *Bathers* is to see them as an assimilation, little by little, of a type of painting to which he felt strong inner allegiance, but which in most respects lay outside his central concerns as a nature painter, into a final all-embracing 'comprehension'.

His treatment of the subject varies enormously. The *Bacchanales* of the 1870s echo the flavour of orgiastic violence of ten years earlier. There is still something of this in the loosely bulging figure drawing and sweeping composition of the late Chicago painting (plate 58). In others there is a more obvious attempt to contain the figures within the sort of systematic structure and brushwork by which he was ordering his landscape painting.

The Standing Bather is perhaps the clearest instance of this. The frontal centrality of the figure and its relationships outwards are wholly compatible with the Geffroy portrait for instance, or the Woman with Coffee-Pot. The flesh tones of the figure are echoed out into the ground plane, and the blues and violets of the background picked up in the figure. There is the same sort of changing emphasis in colour, tone or definition at different points

Plate 56 **The Dying Slave**Irawing after Michelange

lrawing after Michelangelo's statue bout 1884–87 bencil

 $8\frac{1}{8} \times 4\frac{7}{8}$ in (20.7 × 12.5 cm) C678

Collection of Robert von Hirsch, Basel

Plate 57 **The Bathers**about 1895

oil on canvas $8^{\frac{3}{2}} \times 26^{\frac{1}{2}}$ in (72 × 02 cm)

 $18\frac{3}{8} \times 36\frac{1}{4}$ in $(72 \times 92$ cm)

Ny Carlsberg Glyptothek, Copenhagen

around the figure's contour as we have seen in the still-lifes. In addition, a general consistency of brushwork links the whole canvas. The entire surface is positive and alive. The most dramatic colour incident, a great streak of cerulean blue among the greens, occurs in the 'background'.

In some of the later *Bathers* too, where there are many figures and where the expressive role of the figures is less passive, there is the same attempt to marry the figures with the painterly architecture of the landscape. The blue contour of the figures and the strong diagonal axis of their poses in the National Gallery painting (plate 60), link them to the generalised landscape setting. Many people find these the most disturbing and difficult to

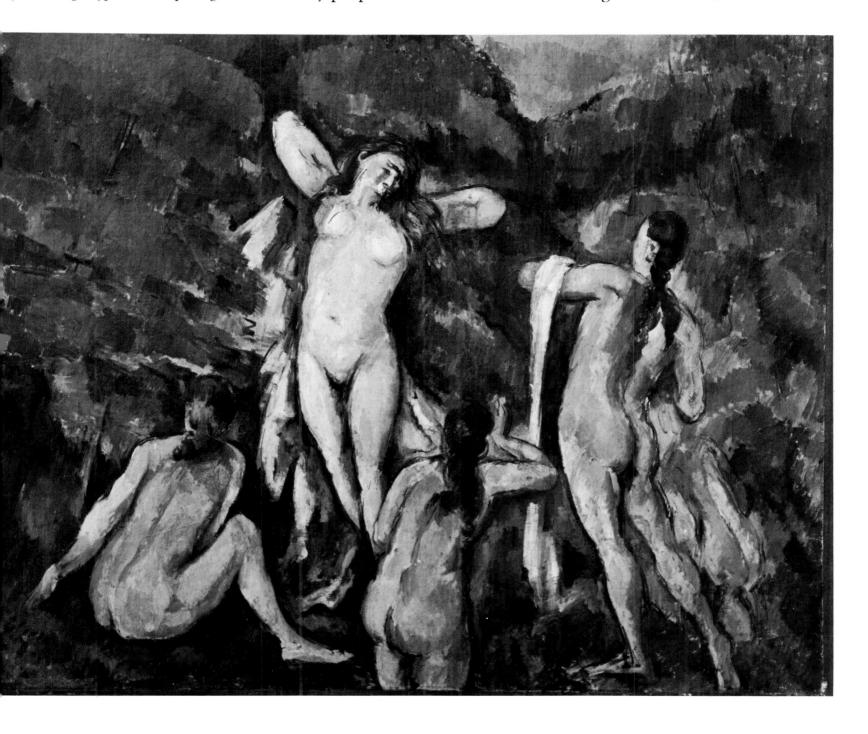

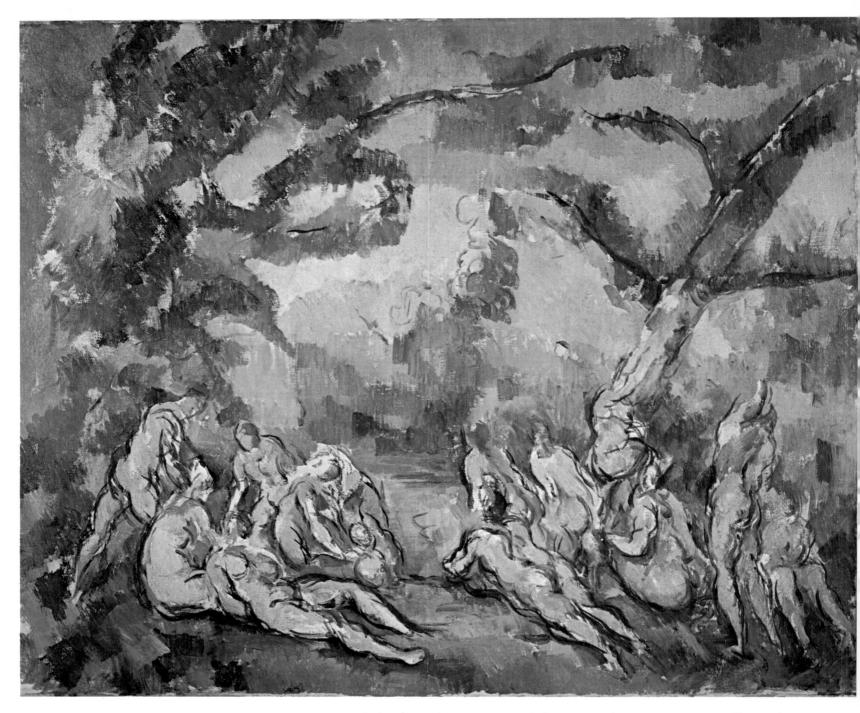

Plate 58 **The Bathers**about 1900
oil on canvas $19\frac{3}{4} \times 24$ in $(50 \times 61$ cm)
V722
Art Institute of Chicago
(The Amy McCormick Memorial Collection)

accept of Cézanne's paintings. The sometimes grotesque distortion of the imagined figures seems strident in the context of his otherwise classically harmonious mature work. The contrivance is restless and uneasy. It seems an embarrassment to the synthesis achieved in the landscape. What causes our discomfort—and Cézanne's presumably—is the instinctive and intimate sense of identification that we experience in looking at a figure image that we do not, for instance, in looking at a landscape or a still—life. The image of man or woman—particularly unclothed—we relate to: consciously or subconsciously it is an image of us. So we are instinctively more sensitive to distortion of the figure than we are to any liberties a painter might care to take with an apple or a treetrunk or a teapot or a building. The strange creature skulking through the undergrowth in the National Gallery *Bathers* makes an

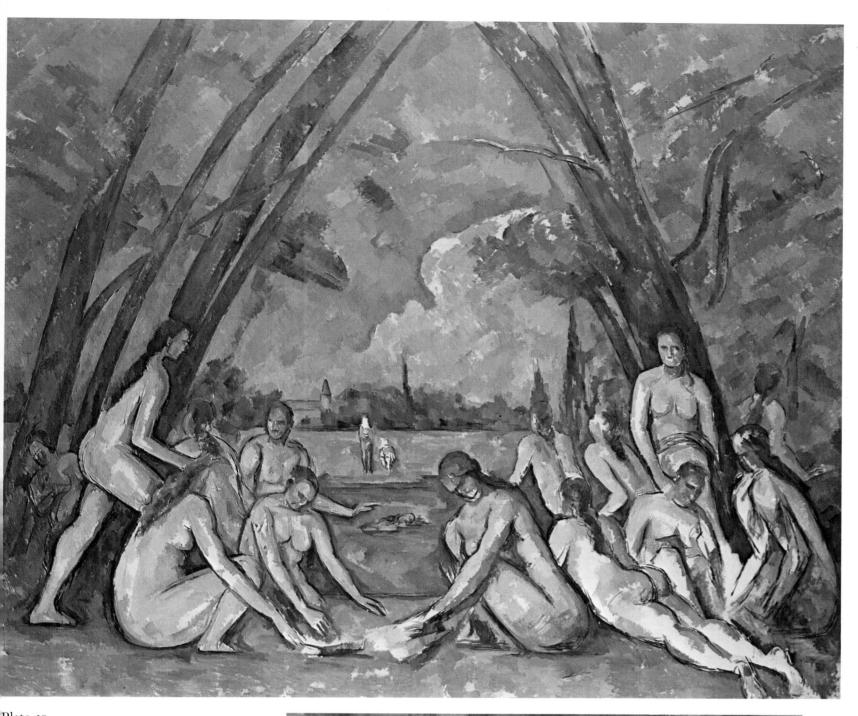

Plate 59 **Bathing Women**(The Large Bathers)
1898–1905
oil on canvas
82 × 99 in (208 × 249 cm)
V719
Philadelphia Museum of Art
(The W.P. Wilstach Collection)

Plate 60 **Les Grandes Baigneuses** about 1900–06 oil on canvas $50\frac{1}{8} \times 77\frac{1}{8}$ in (127 × 195 cm) V721 National Gallery, London

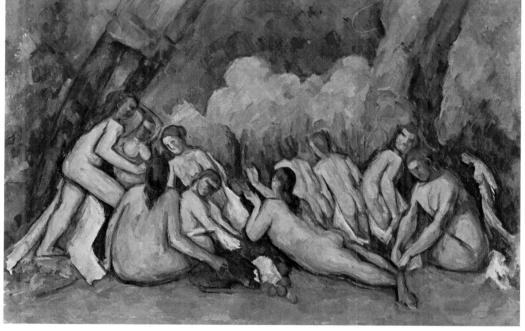

impact on our emotional responses. The lopsided carafe in *The Bottle of Peppermint* (plate 101) we can accept more readily.

In addition to this instinct, there is the degree to which our preconceptions of the figure in art are conditioned by the Classical ideal of physical beauty.

It is in the late landscapes that we witness, without inhibitions, the crowning achievements of Cézanne's art. We can sense the liberated richness and command that one associates with the late style of great artists. It was a period in which Cézanne himself at last felt real confidence, a confidence that could stand the test of contact with others, of public exhibition on a large scale and of defending 'in theory the results of my efforts'. 'I am beginning to see the promised land,' he writes. 'I have made some progress. Why so late? and with such difficulty? Is art really a priesthood that demands the pure in heart who must belong to it entirely?' (9th January 1903).

In 1890 he was invited to exhibit three paintings with the Belgian avant-garde group Les XX in Brussels. In 1895 two of his paintings entered the Luxembourg Museum in Paris with the bequest of the painter Caillebotte; in the same year he had his first one-man show in Paris. With Pissarro's encouragement, the dealer Ambroise Vollard put on an exhibition of about 150 of Cézanne's paintings. The silence was over (see Pissarro's letters of 1895, pages 118–119).

Vollard became Cézanne's dealer in Paris, and Cézanne also sent a few paintings to either the Salon des Indépendants or the Salon d'Automne almost every year for the rest of his life. Hè showed in Brussels again in 1901 and had a one-man show in Berlin in 1904.

During the same period, he was approached as a master by a number of younger painters and writers and established close friendships with some of them. They included Emile Bernard (who published a number of important articles and documents on Cézanne), Charles Camoin, Louis le Bail, Louis Aurenche, Joachim Gasquet, Maurice Denis, K. X. Roussel. It is largely in his correspondence and conversations with these men that his important theoretical statements were made. He admits to Vollard in March 1902 that 'It seems to me that it is difficult to disociate myself from the young people who have shown themselves to be so much in sympathy with me, and I do not think that I shall in any way harm the course of my studies by exhibiting.'

Something of this confident mood can be seen in the increased

Private collection

Plate 61 Château de Fontainebleau 1904-05 pencil and watercolour $17\frac{3}{8} \times 21\frac{5}{8}$ in $(44 \times 55$ cm) V925

> and different role of watercolour as a medium. He had used it intermittently all the time, but now it comes to the fore, and the late watercolours are among the most impressive and seductive works in a period of very great achievement generally.

In them we can see him confronting his problems very directly. The main problem was how to relate all of the chaos and disarray of perceptions from nature into a complete but truthful image. Watercolour does not allow scraping off and reworking: the discrimination involved in each mark is that much more acute. Where a decision to change occurs, it is left exposed. It stands stranded like the abandoned first statements of tree trunk in the Fontainebleau study of 1904-05 (plate 61).

In a sous-bois watercolour (i.e. a woodland scene) as early as the late 1880s (plate 62), it is clear how much the watercolours were to offer the late paintings. The motif is loosely set up in pencil drawing-this is almost always the case. Lines describe the motif and suggest the composition's principal lines of direction. The fullcharged brushstrokes of gentle cool colour amplify some of these and also break out into other areas, suggest other directions. The white paper blooms through the colour in varying degrees, according to the overlaid sequence of strokes. The more opaque passages link up with the density of the pencil marks. The bare passages between the marks tell strongly, making the measure for the subtle scale of values. Look at this continuous role of spaces in the 1890 Trees and Houses (plate 80). The scale is richer by the early 1900s (Plate 63). The fruity opulence of rippling restatements of

line is close to the late drawings from sculpture, as well as being evocative of shifting shadows, swaying branches, light filtering through trees.

A very late study takes this organic generosity to an extreme (plate 64). Coloured contours ripple across the paper, luminosity rises and falls as mark bleeds into mark. It is perhaps the most moving single statement of the poetry of 'confused sensations'.

Out of the watercolours came many elements in his late oil paintings, not least the fluency of mark and the way in which succulent colour becomes an open-armed embrace or celebration of nature.

Plate 62 **Sous-Bois** about 1887-89 watercolour and pencil $19\frac{1}{2} \times 12\frac{5}{8}$ in $(49.6 \times 32 \text{ cm})$ V1621 Victoria and Albert Museum, London

The white ground becomes more important, is often left exposed and is the basis for a thinner, more translucent use of colour. The relationship between coloured marks and broken, often repeated lines becomes a major dialogue in the late oil paintings. Look at the closeness in each of these respects between two of Cézanne's paintings of the gardener Vallier (plates 65, 66).

Although he spent some time in and around Paris, most of the last years were spent painting at Aix and in the neighbourhood. The most recurrent theme was the *Mont Sainte Victoire*, as obsessive a theme as the *Bathers*, comparable to the *Bathers* too, in that for him

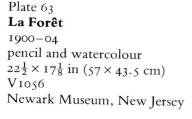

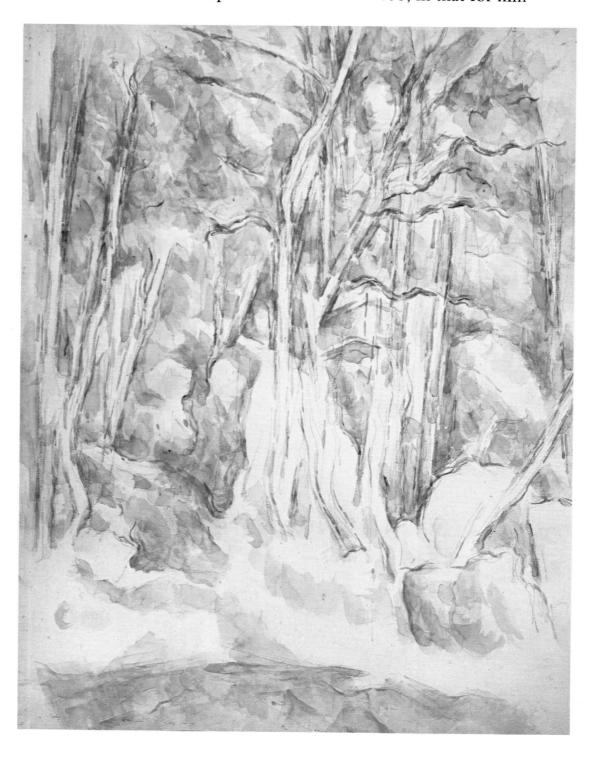

it seems to have stood as some sort of symbolic target. This is the mountain that dominates the plain outside Aix. He first mentions it in the letters in April 1878 to Zola as 'a stunning motif' seen from the train. It had already appeared in a painting of around 1870. This was the landscape of his youth and held very great emotional associations for him. 'When one was born down there, nothing else has much meaning.' It was here that he finally collapsed during a rainstorm and died a few days later, on 22nd October 1906.

You can already sense something of this emotional quality in *Le Grand Pin* of around 1889 (plate 67). Compared to the discipline of the early 1880s, it is a toweringly romantic image, sensual, luxuriant, rich in feeling.

The series of *Mont Sainte Victoire* images gather momentum. They are totally unlike the Impressionist concept of seriespaintings. Monet first resorted to a series of a single image in order to record its different aspects under changing conditions of light and atmosphere. For Cézanne the intention of each one was the

Plate 64 **The Cathedral at Aix**1904–06
pencil and watercolour $12\frac{1}{2} \times 18\frac{1}{2}$ in $(31.8 \times 47.1 \text{ cm})$ V 1077

Alex Hillman Family Foundation, New York

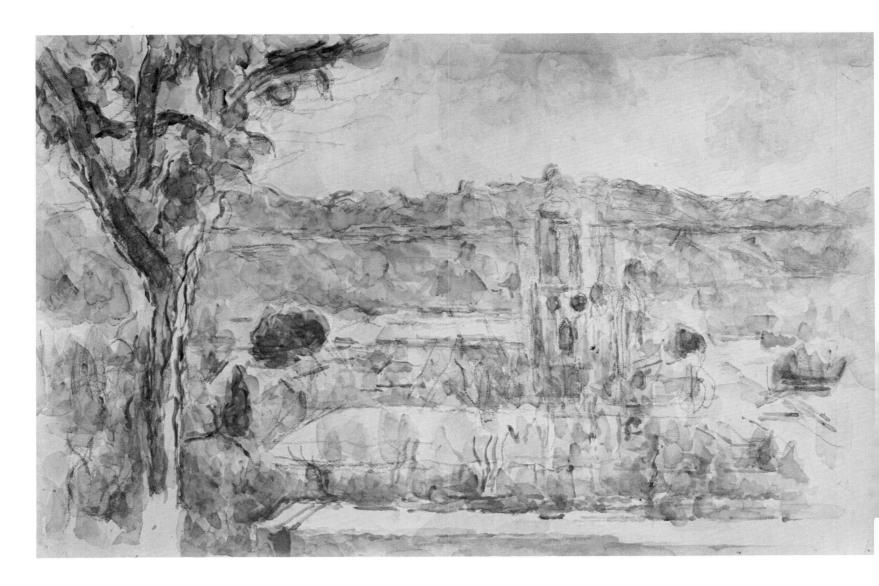

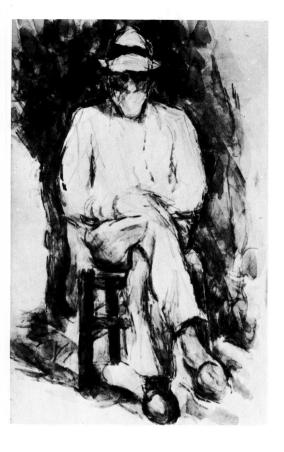

same. Each aspired to encompass a total knowledge of nature. The colossal silhouette of Mont Sainte Victoire seems to have stood for this.

Examples from the 1880s contain the grandeur of the motif and its sense of scale (plates 68, 69). In each he unrolls the vast plain from our feet out to the foothills of the mountain and uses devices to oppose that recession, to uphold the integrity of the painting's flat surface. His vision of nature is more complicated than the atmospheric illusion of space and distance. The New York painting is dominated by an elegant, isolated tree: its trunk runs from top to bottom, its foliage eats into the sky and breaks across the distant skyline. In the Courtauld painting, the foliage fills out the sky in vigorous arabesques, echoing the skyline. Again the nearest and furthest elements are engaged in a rapport that holds the picture space together. The solutions arise from what is in front of his eyes. 'The method of painting emerges in contact with nature. It is developed by circumstances. It consists . . . in organising sensations into a personal aesthetic.'

Plate 65 Portrait of Vallier

1902–06 watercolour and pencil $12\frac{3}{8} \times 18\frac{7}{8}$ in (31.5 × 48 cm) V1566 Private collection

Plate 66 **Portrait of Vallier**

1906 oil on canvas $25\frac{1}{2} \times 21\frac{1}{4}$ in $(65 \times 54 \text{ cm})$ V718 Collection of Mr and Mrs Leigh B. Block, Chicago

Plate 67 **Le Grand Pin** about 1889

oil on canvas $33\frac{1}{2} \times 36\frac{1}{4}$ in $(85 \times 92 \text{ cm})$ V669 Museu de Arte de São Paulo, Brazil

Plate 68 **Mont Sainte Victoire**

Note Sante Victore 1885-87oil on canvas $26 \times 36\frac{1}{4}$ in $(66 \times 92 \text{ cm})$ V454
Courtauld Institute Galleries, London

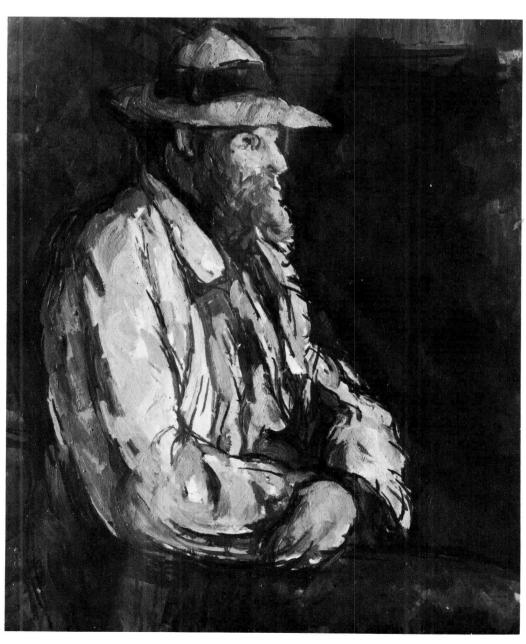

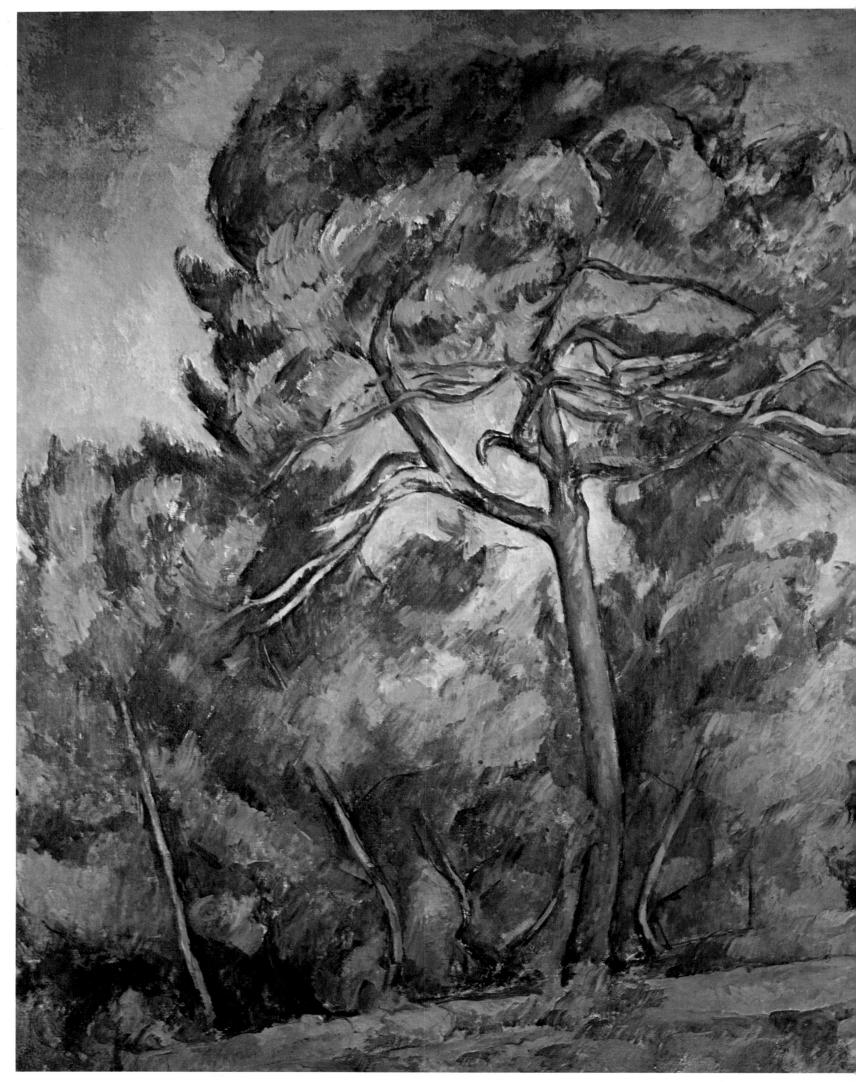

72

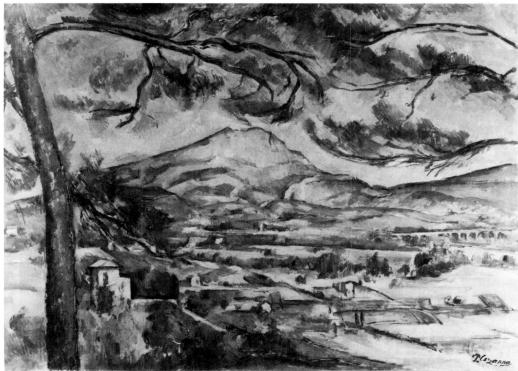

Plate 68 Mont Sainte Victoire see page 71

The later versions are masterpieces of his ultimate style. The same sort of picture structure is present, but the language has matured into a series of painterly notations. The expression of sensations is less literal, more abstract.

In one letter Cézanne wrote: 'Painting stands for no other end than itself. The painter paints an apple or a head; it is for him a pretext of lines and colours and nothing more.' He was almost certainly making a particular point for a particular reason. Out of context, it is too extreme to be characteristic. But it is precisely this sort of interpretation of his late work that was taken up by the Cubist generation of artists and critics. 'Cézanne is the Christopher Columbus of a new continent of form. He discovered methods and forms which have revealed a vista of possibilities to the end of which no man can see' (Clive Bell, 1914); '... however various the directions in which different groups are exploring the newlyformed regions of expressive forms, they all alike derive in some measure from the great originator of the whole idea, Cézanne' (Roger Fry, 1912). The painter Robert Delaunay talks of Cézanne 'who demolished all painting since its origins'. Fernand Léger calls him 'the only one of the Impressionists to lay his finger on the deeper nature of the plastic contrasts inherent in a work of art' (1914).

For most of the first generation who called Cézanne the father of modern art, it was the language that was most important. It was the control of plastic values in painting, the exposure of a pictorial

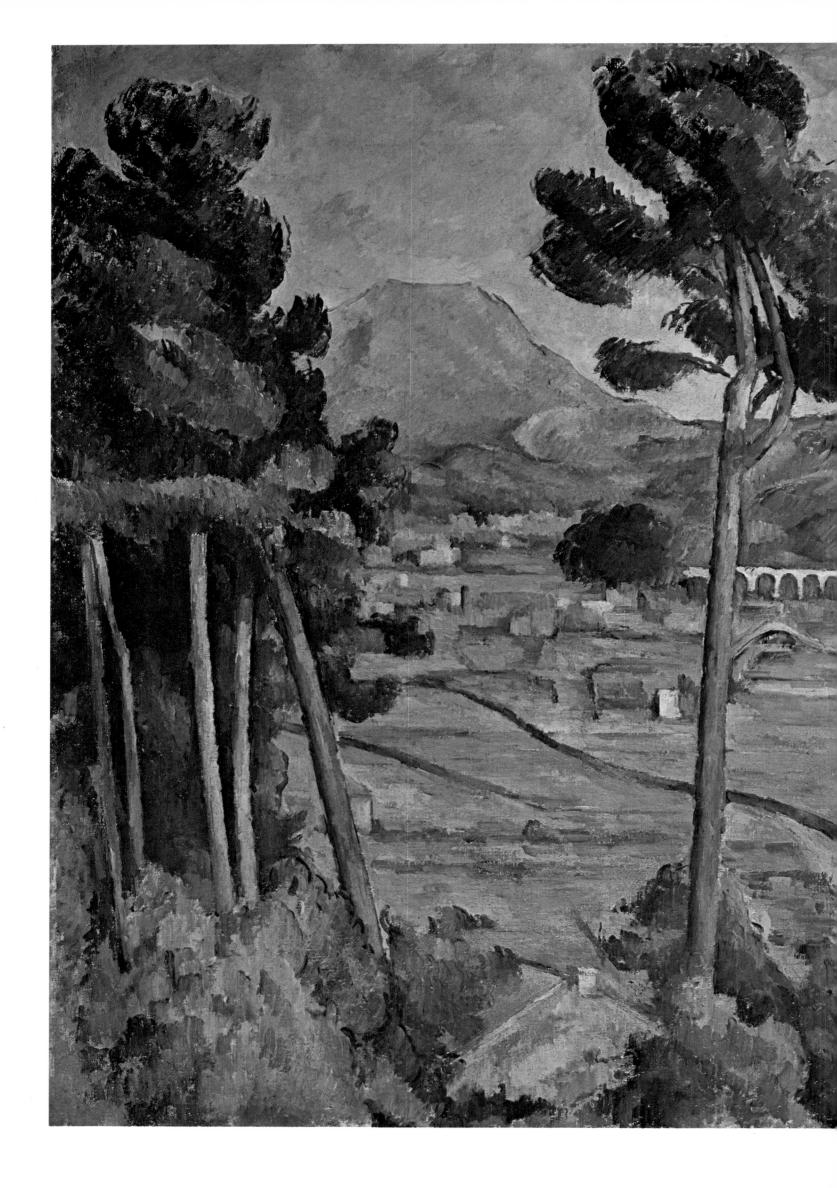

Plate 69

Mont Sainte Victoire
(Landscape with a Viaduct) 1885-87oil on canvas $25\frac{3}{4} \times 32\frac{1}{8}$ in $(65.4 \times 81.6$ cm)

V452

Metropolitan Museum of Art, New York
(Bequest of Mrs H.O. Havemeyer, 1929, H.O. Havemeyer Collection)

architecture bordering on abstraction, the way he built images as complex as the late *Mont Sainte Victoire* paintings and controlled the whole fabric by the relationship of contrasts and correspondences of colour, line and texture.

This he certainly did. But what this view of Cézanne overlooks

This he certainly did. But what this view of Cézanne overlooks is the religious devotion to the landscape, to nature, that comes so strongly through in the late work. Cézanne's historical importance and influence lie in establishing a fuller and purer emancipation of pictorial architecture than ever before, a new conception of it, an art of relationships. His greatness as a painter lies in the content that this was the vehicle for: in the fact that at the same time his imagery is abundant in qualities of immediate visual sensation (in the Impressionist sense) and in the associative qualities of his motifs.

It was probably nearing the turn of the century when he told

Plate 70 Mont Sainte Victoire about 1904–06 oil on canvas $23\frac{5}{8} \times 28\frac{3}{8}$ in $(60 \times 72$ cm) V1529 Kunstmuseum, Basel

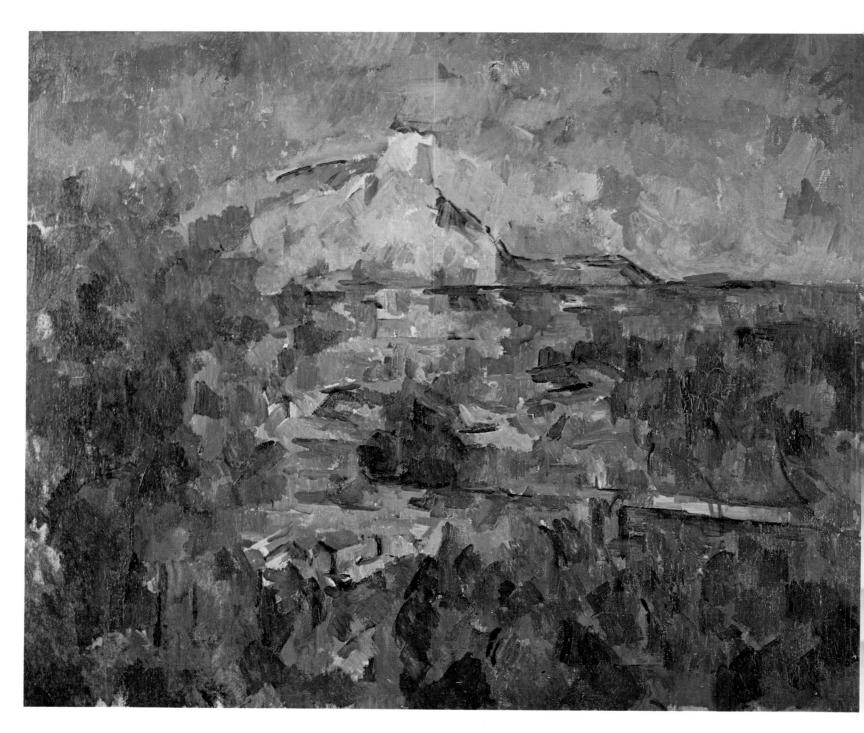

Gasquet that 'the blue smell of the pines . . . must be married to the green smell of the plains which are refreshed every morning, with the smell of stones, the perfume of distant marble from *Sainte Victoire*. I have not expressed it. It must be done. And by colours, not literature.'

The manner of the last paintings achieved this expressive eloquence. The technique is completely mastered: the fruits of sustained looking, thinking, painting. It was physical enough in its painterly substance to build a positive image of mountain and landscape and yet open enough to give off allusions as poetic as he described above.

Each mark was highly significant. The paintings were not rapidly executed. Each touch was considered. Patches of bare canvas are an integral part of the fabric as far as it has gone. When Cézanne was painting Vollard's portrait, the dealer, having

late 71 **Ionte Sainte Victoire**bout 1905–06
il on canvas $5\frac{5}{8} \times 31\frac{7}{8}$ in $(65 \times 81 \text{ cm})$ '802
rivate collection

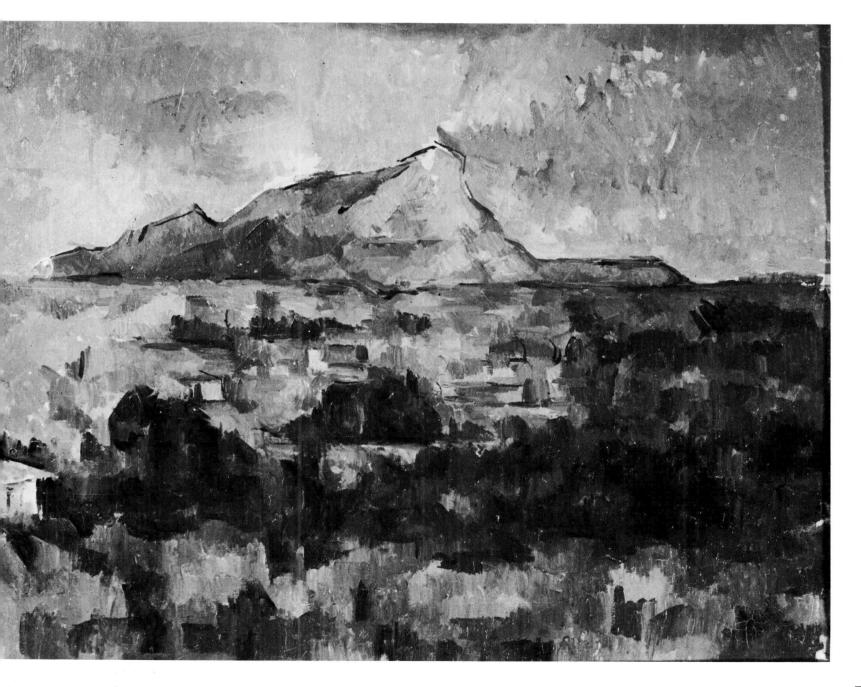

Plate 72 **Mont Sainte Victoire** about 1904–06 oil on canvas $25\frac{1}{8} \times 31$ in (63.8 × 78.7 cm) V799 Philadelphia Museum of Art (George W. Elkins Collection) endured many sittings in which few marks were made on canvas, asked about some unpainted parts of the hands of the portrait. 'Just understand,' Cézanne replied, 'that if I was to put something there at random I should be compelled to go over the whole picture again, starting at that spot.' The allegiance to the thing seen was intense: better to put no mark at all than one that did not satisfy the criteria of the eye. This binding discipline separates a Cézanne portrait from the great Cubist portraits by Picasso, with which there is such a close family resemblance (plates 98, 104). In the Cézanne there is little formal improvisation on a theme; in the Picasso there is no comparable commitment to nature.

The relationships within the sequence of marks of Cézanne's late manner are very elaborate. Their roughly rectangular regularity holds the whole together and lends to the occasional irregularity a

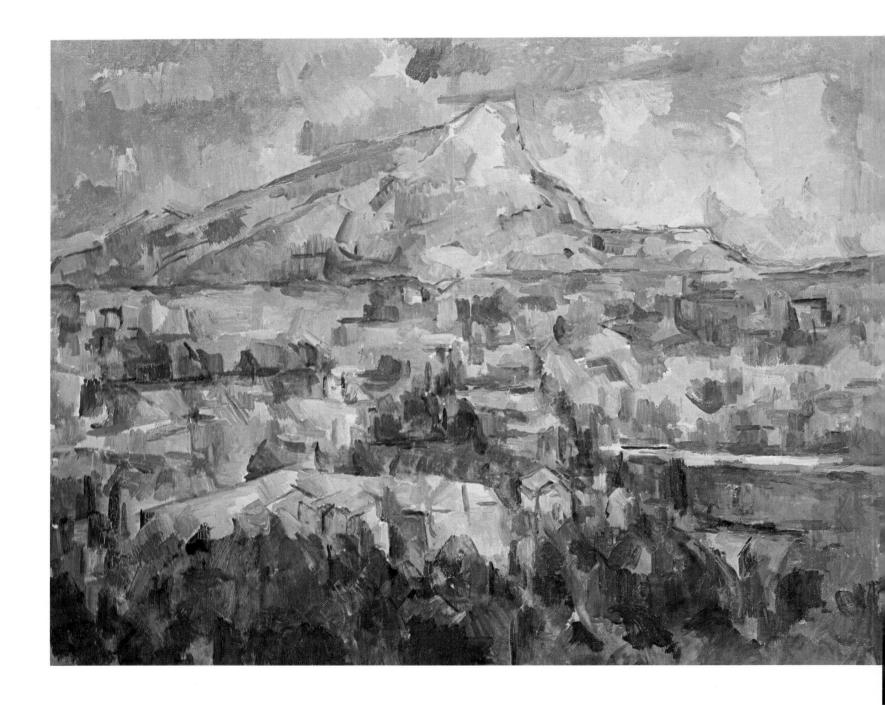

Plate 73 **Le Château Noir**1904–06
oil on canvas $27\frac{1}{2} \times 32\frac{1}{2}$ in $(70 \times 82$ cm)

Private collection

sense of event. The tipping of these shapes on to a diagonal (as in the *Château Noir* painting) suggests recession back into space, as does their overlapping. Insistently horizontal and vertical emphases echo the shape of the canvas and tend to hold the structure stable. Sequences that are built back through space by overlap or by change of tonal value are often held in check by a counter-sequence of colour, going from recessive blues to affirmative warm tones. In the sky of the Philadelphia *Mont Sainte Victoire* (plate 72) the strongest green of the plains makes a dramatic gestural appearance in the sky.

Line is used as a very free agent of emphasis or contrast, coinciding with the edge of colour planes only at points of major incident—the skyline in the *Château Noir* (plate 73), or the silhouette in the *Mont Sainte Victoire* paintings. More positive

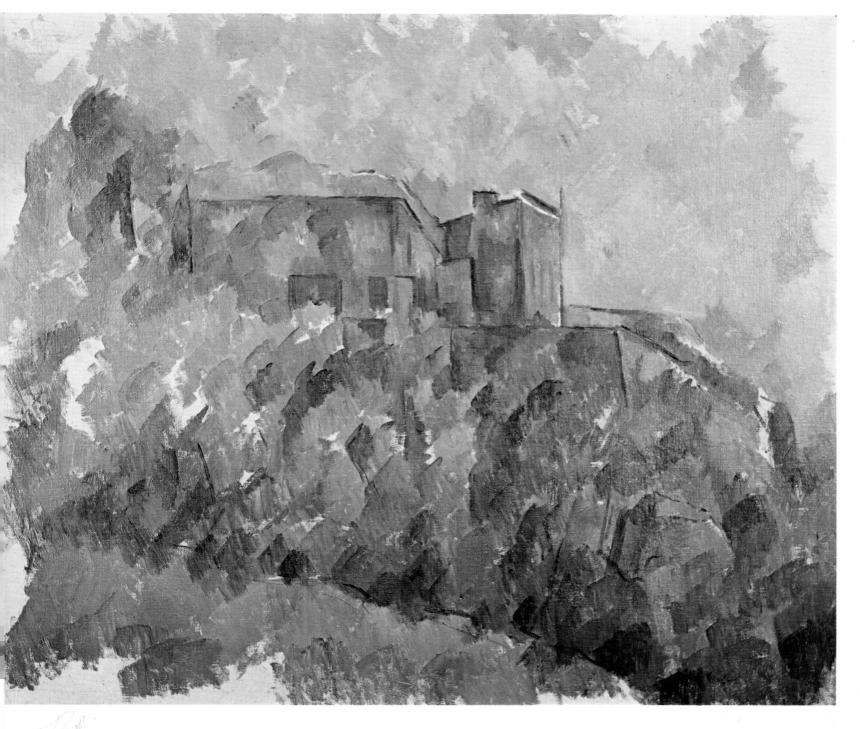

/9

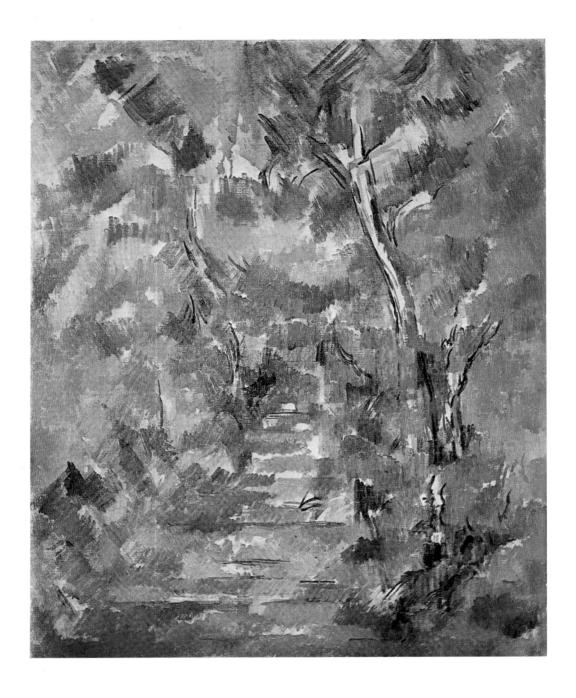

Plate 74 **Sous-Bois** about 1895-1900oil on canvas $31\frac{3}{4} \times 25\frac{1}{2}$ in $(81 \times 65$ cm) V1527 Galerie Beyeler, Basel

moments in the steps and the tree trunks of the two beautiful late sous-bois paintings (plates 74, 75) show the same coming together of line and colour.

Compare this shifting integrated role of line in his painting to the severe contour of his 1880s still-lifes or the uniform horizon boundary of *Houses at Bellevue* (plate 76). Now drawing and colour are as one. 'The more the colour harmonises, the more precise the drawing becomes.' The whole of each composition is animated by contrasts and unified by analogies.

This final quotation from Gasquet puts it all very clearly. Cézanne said to him, 'I have my motif . . . A motif you see is this . . .' and he joined his hands, fingers interlaced.

'What's that?' Gasquet asked, and Cézanne repeated the gesture,

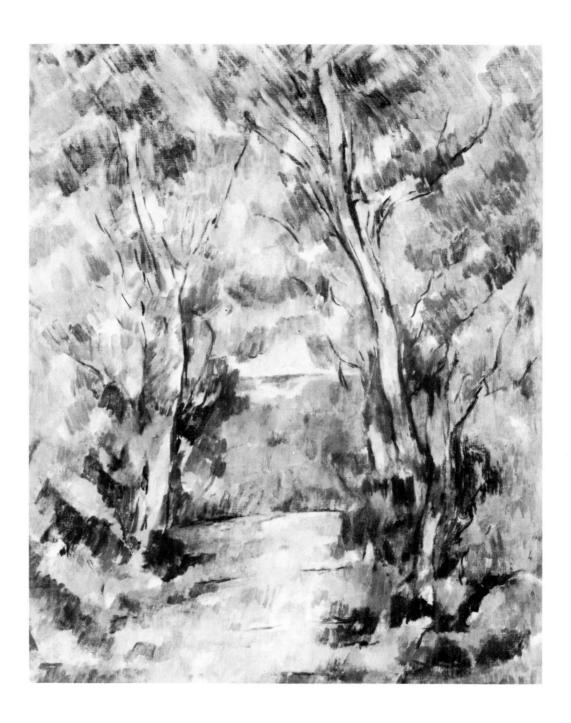

Plate 75 Landscape near Aix bout 1902–06 oil on canvas $2 \times 23\frac{1}{2}$ in $(81 \times 59.5$ cm)

drawing his hands apart, fingers spread out and then bringing them together again very slowly. Then he joined them, pressed them together and locked them tight, fingers interlaced.

'There you have it,' he said, 'that's what one must attain. If I pass too high or too low, all is ruined. There mustn't be a single link which is too loose, not a crevice through which may escape the emotion, the light, the truth. I advance, you understand, the whole of my canvas at one time, together. I bring together in the same spirit, the same faith, all that is scattered. All that we see disperses, vanishes; is it not so? Nature is always the same, but nothing remains of it, nothing of what comes to our sight. Our art ought to give the shimmer of its duration with the elements, the appearance of all its changes. It ought to make us taste it eternally. What is

underneath? Nothing perhaps. Perhaps everything. You understand?

'Thus I join these straying hands. I take them from left, from right, here, there, everywhere; tones, colours, shades. I fix them, I bring them together. They make lines. They become objects, rocks, trees, without my thinking about it. They acquire value.

'If these volumes, these values, correspond on my canvas, in my feeling, to the planes and patches of colour which are there before my eyes, very good! My canvas joins hands. It does not vacillate. It does not pass too high or too low. It is true. It is full. But if I feel the least distraction, the least weakness, above all, if I interpret too much one day, if today I am carried away by a theory which is contrary to that of the day before, if I think while painting, if I intervene, why then everything is lost.'

We tend to think of Cézanne as the last of the great landscape painters. It was essentially through his paintings of the Provençal landscape that he achieved his seemingly impossible ambition of reconciling the impermanence of nature's appearances to the permanence of great art. But his achievement is more broadly based than that. The fact that it has been so influential on artists right outside this genre confirms the wider implications of his originality. Maurice Denis saw him as 'the final outcome of the classic tradition and the product of the great crisis of liberty and light which has rejuvenated modern art. He is the Poussin of Impressionism' (*Théories*, Paris, 1912).

He seems to us to be both the giant figure of Post-Impressionism – that climactic seal on the heroic evolution of 19th-century painting—and the 'father of modern art'.

Why was it Cézanne who emerged so quickly in this role from among a generation of great French painters? There are a number of reasons. The prevailing mood of the young 1900s avant-garde was a restless questing for change, for an art whose concerns and whose language were explicitly of the moment, of the modern 20th-century world. There was a high premium on objective realism, on novelty, freedom and independence. The principles of traditional art were under suspicion. The disillusioned escapist retreat of so much 1890s art—Symbolism, the Aesthetic Movement, Art Nouveau—was passé. Its whole tendency towards decorative exoticism was discredited.

When the Cézanne memorial exhibitions—fifty-six paintings at the Salon d'Automne, seventy-nine watercolours at the Bernheim Jeune gallery—were launched on this *avant-garde* in 1907, the aims and achievements of his art seemed to satisfy most demands and to

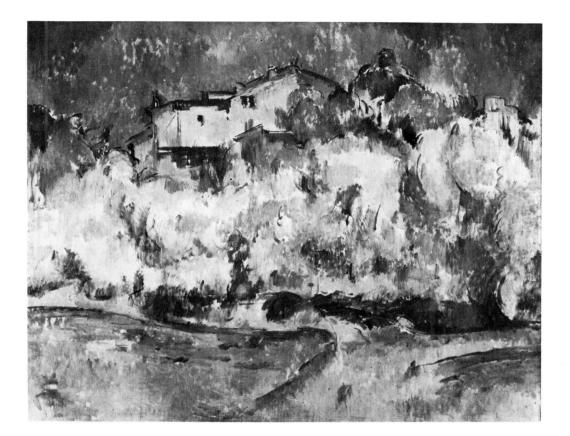

Plate 76 **Houses at Bellevue**about 1888–92

oil on canvas

12 × 25½ in (81.2 × 64.8 cm)

1651

Museum Folkwang, Essen

suffer few of the discrediting characteristics. (Publication by Emile Bernard of some of Cézanne's late letters lent further impact and authority to the revelation.)

While it bore profound affinities with the great picture-making traditions of the past, Cézanne's late art was also replete with freshness and originality, with dynamic and ruthless formal properties and with a vital, charged sense of colour. The principles of past art had been subsumed, digested deep into the fabric of a vitally new and experimental language. To the younger artists, this open, undated accessibility of painterly language offered the principles and the opportunity for an authoritative new start. Cézanne's art seemed to them to be free of the qualities of formula and stereotype that they perceived in Seurat's Neo-Impressionism; without the subjective idiosyncracies of Van Gogh; without the vulnerable, speculative empiricism of Gauguin. Cézanne arguably belonged to the great modern tradition of objective realism.

For Léger, Cézanne 'understood everything that was incomplete in traditional painting' (1913); 'his influence on me was so strong that to disentangle myself I had to go almost as far as abstraction.' For Delaunay, Cézanne had 'demolished all painting since its origins'. Gleizes and Metzinger saw in his art 'a profound reality, growing luminous as it forces the unknowable into retreat' (1913).

Respect for Cézanne among the Cubists finds its clearest expression in the degree to which early Cubism quotes, almost

Plate 77

Three Bathers

bout 1879–82

oil on canvas

9\frac{3}{4} \times 19\frac{3}{4} \times 160 \times 50 \text{ cm})

\$\sqrt{381}\$

Petit Palais, Paris

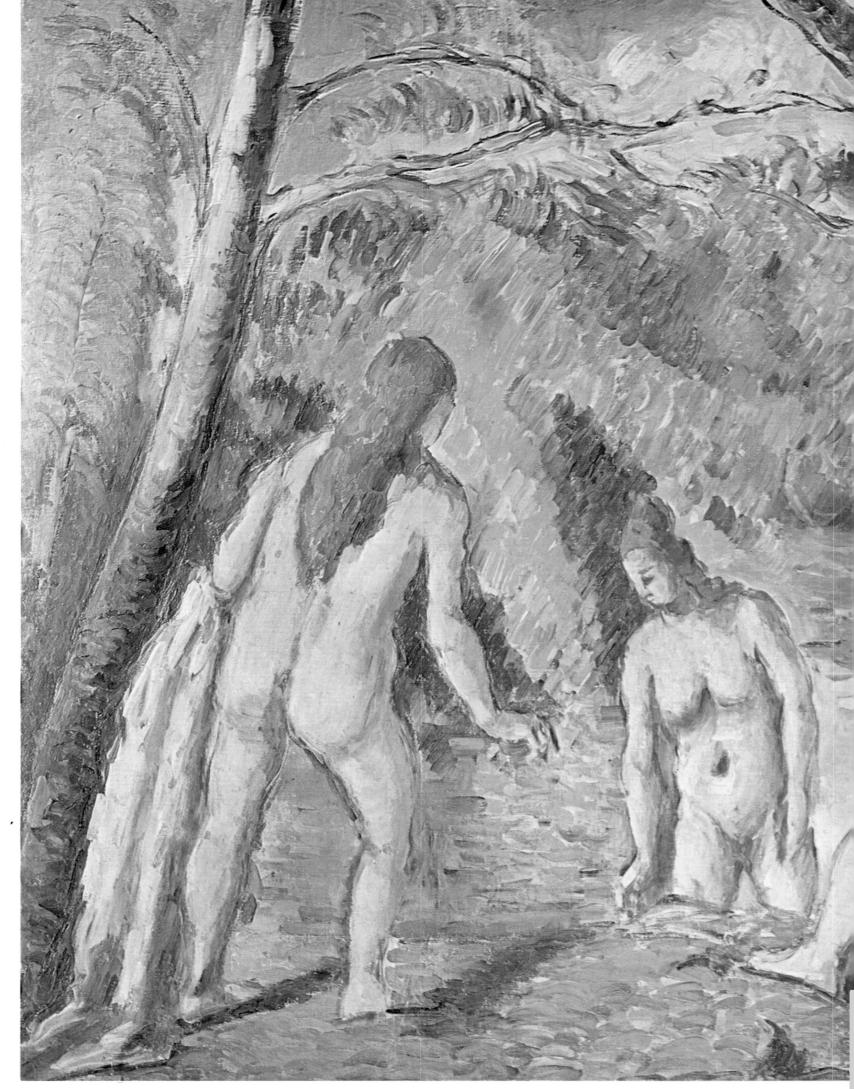

Plate 77 **Three Bathers** see page 83

verbatim, the style of Cézanne's late work. The motive behind Picasso's research into the paradoxes of illusionism and reality is largely attributable to Cézanne. The means with which he pursues it leaves no doubt of the relationship. Picasso's *Portrait of Vollard* (plate 104) is composed of the same homogeneous fabric of marks, the same sequence of contrast and analogy within it, the same shallow modulated space, the same delicate poise between identity of sitter and identity of the painting's internal harmony that we see in late Cézanne.

When, in the longer term, Cubism and modern art moved away from all Post-Impressionist systems of small-unit, or 'divisionist' structure, it was the wider implications of Cézanne's art that maintained his status as 'father of modern art'. Léger's recognition of a new dimension of plastic reality and Kandinsky's of a new pictorial sense of animation have already been mentioned (pages 49, 73). Matisse¹ saw him in similar terms. Asked if Cézanne had influenced his use of colour, Matisse replied: 'as to pure colour, absolutely pure colour, no. But Cézanne constructed by means of relations of forces, even with black and white.'

Right at the end of his life, Matisse felt sure that 'In modern art, it is indubitably to Cézanne that I owe the most' (1949), and it is through Matisse's writings that we get the clearest picture of the modern appreciation of Cézanne. When, in 1936, he presented his Cézanne painting *Three Bathers* (plate 77) to the Museum of the City of Paris, he wrote as follows to the Director:

'Allow me to tell you that this picture is of the first importance in the work of Cézanne because it is a very solid, very complete realisation of a composition that he carefully studied in several canvases, which, now in important collections, are only the studies that culminated in the present work.

'In the thirty-seven years that I have owned this canvas, I have come to know it quite well, I hope, though not entirely; it has sustained me morally in the critical moments of my venture as an artist; I have drawn from it my faith and my perseverance; for this reason, allow me to request that it be placed so that it may be seen to its best advantage. For this it needs both light and perspective. It is rich in colour and surface, and seen at a distance it is possible to appreciate the sweep of its lines and the exceptional sobriety of its relationships.

'I know that I do not have to tell you this, but nevertheless I think it is my duty to do so; please accept these remarks as the excusable testimony of my admiration for this work which has grown increasingly greater ever since I have owned it' (10th November 1936).

¹The Matisse quotations are from Jack D. Flam, *Matisse on Art*, Phaidon Press, 1973.

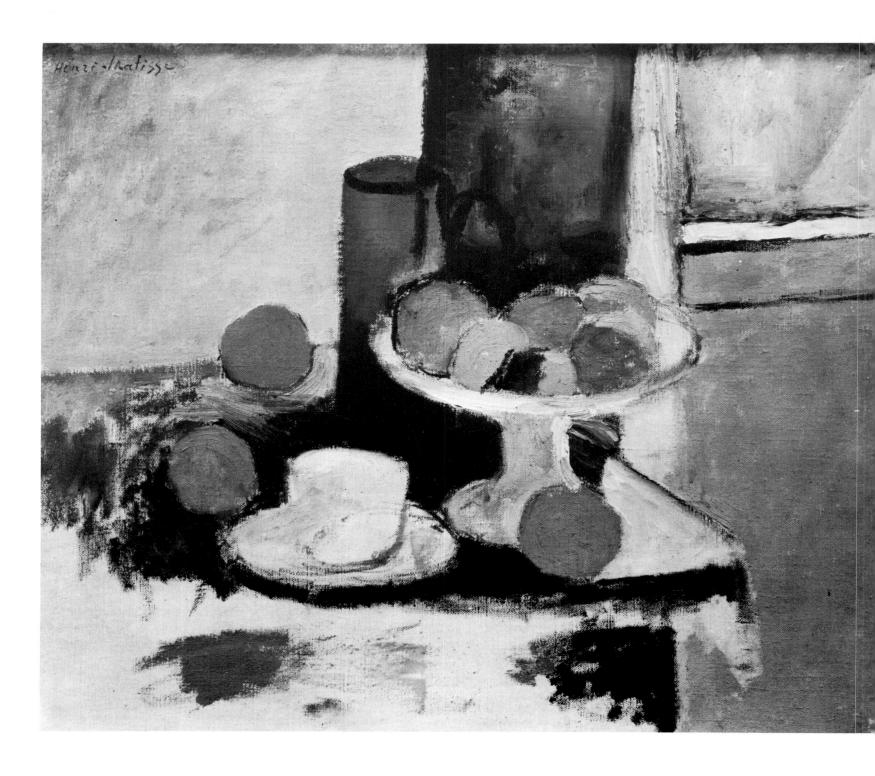

Plate 78
Henri Matisse
Still-Life with Oranges
about 1894
oil on canvas
18 × 20 in (45.7 × 50.8 cm)
Washington University Gallery of Art,
St Louis, Missouri

It was above all the clarity and order of Cézanne's art that he respected, the clear resolution of new and very complex possibilities. Thus in 1908:

'Look instead at one of Cézanne's pictures: all is so well arranged that no matter at what distance you stand or how many figures are represented you will always be able to distinguish each figure clearly and to know which limb belongs to which body. If there is order and clarity in the picture, it means that from the outset this same order and clarity existed in the mind of the painter, or that the painter was conscious of their necessity. Limbs may cross and intertwine, but in the eyes of the spectator they will

nevertheless remain attached to and help to articulate the right body: all confusion has disappeared' (*Notes of a Painter*, 1908).

And in 1925:

'If only you knew the moral strength, the encouragement that his remarkable example gave me all my life! In moments of doubt, when I was still searching for myself, frightened sometimes by my discoveries, I thought: "If Cézanne is right, I am right"; because I knew that Cézanne had made no mistake. There are, you see, constructional laws in the work of Cézanne which are useful to a young painter. He had, among his virtues, this merit of wanting the tones to be forces in a painting, giving the highest mission to his painting.

'We shouldn't be surprised that Cézanne hesitated so long and so constantly. For my part, each time I stand before my canvas, it seems that I am painting for the first time. There were so many possibilities in Cézanne that, more than anyone else, he had to organise his brain. Cézanne, you see, is a sort of god in painting' (interview with Jacques Guenne, published 15th September 1925).

We are tempted to wish that Cézanne could have known this—could have known that his personal logic, his methods of construction which had formed so slowly from accumulated observations, intuitions and theories, as a measure for himself alone in the isolation of Provence, were to become a yardstick of certainty for others. Matisse's identification with his lonely achievement reminds us forcibly how enormous was the task that Cézanne undertook, and makes more meaningful and poignant our reading of his letters—particularly the later ones to young artists. Their relentless insistence on certain principles that he had discovered express not so much the tyrannical patronage of an ageing master as a sincere feeling of responsibility for the future of painting and a determination not to lose the ground he had so laboriously gained.

Cézanne was not a raring revolutionary. He did not pull art apart to leave it in splendid disarray. In the context of painting from nature, he progressively exposed the very processes and nature of painting: possible roles of drawing, the related roles of marks, colours and tones, the magical dual presence of image and paint. His own standards of thoroughness and conclusiveness were demanding and exhaustive: we can see from the letters that, to the end, he allowed himself no let-up, no complacent sitting-back. The fruits of this incessant enquiry lie in the sense of order and self-contained logic of his painting. For this reason, his art presented later artists not with a ready-made closed solution, but with an accessible working range of possibilities for the future.

Extracts from Cézanne's letters

The following quotations from Cézanne's letters have been selected to give the flavour and mood of his writing as well as to emphasise its principal concerns. They are arranged chronologically. The translations are taken from John Rewald (ed.), *Paul Cézanne*, *Letters* (Bruno Cassirer, Oxford, 1941, new edition 1975), except one (to Emile Bernard, March 1904) from Goldwater and Treves (ed.), *Artists on Art* (New York, 1945, 3rd edition 1958).

The early letters to Zola and others show his adolescent extravagance and document his mood and working habits. Quotations from the 1870s and 1880s follow this practice, as well as picking up expressions of his shifting concerns as a painter.

The subject of the April 1866 letter is the official annual Salon. Cézanne insists on his right as an artist to exhibit, a right denied by the relatively 'closed shop' jury system (in which established academicians tended to select works by their own and each other's pupils and friends). The 'Salon des Refusés', which he proposes should be revived, refers to the unique occasion in 1863, when large numbers of rejected artists were given the option to exhibit their unacceptable paintings in a subsidiary exhibition. This letter gives the background to the independent exhibitions mounted by the Impressionist painters from 1874 onwards.

The letters from the last ten years of his life were written at a time when he was bubbling with comparative articulateness. (He writes to Emile Solari, 2nd September 1897: 'Your father came to spend the day with me—the unfortunate man, I saturated him with theories about painting. He must have a good constitution to have withstood it.') They express the happy coincidence of a new circle of admiring young correspondents with Cézanne's mature confidence in his own painting and in his understanding of art as a whole and the modern painter's place in it. Together they constitute a lucid exposé of his theory of art and the frame of mind in which he arrived at it.

In some major respects, he emerges as the natural successor to Gustave Courbet, spokesman for Realism. Courbet's position on the individual and tradition ('I simply wanted to draw forth, from

Plate 79 **Landscape at Médan** about 1879-82pencil and watercolour $13 \times 19\frac{1}{4}$ in $(33 \times 49$ cm) V847 Kunsthaus, Zürich

a complete acquaintance with tradition, the reasoned and independent consciousness of my own individuality,' 1855) finds repeated echoes as a main theme in Cézanne's thinking (see letters to Bernard of 1904–5). Similarly the issue of concreteness in art. Courbet wrote that 'painting is an essentially *concrete* art and can only consist in the representation of *real and existing* things. It is a completely physical language . . . an object which is *abstract*, not visible, non-existent, is not within the realm of painting' (1861). Compare this to Cézanne's letter to Bernard of 26th May 1904.

Cézanne's attitude to the younger painters is generously encouraging. Compare his talk of just 'a sense of art' or 'any feeling for nature whatever' being assets enough for a painter with the terrifying standards he sets for himself.

The central issue to emerge is that the problems of the painter are only soluble in confrontation with nature. Traditional art can provide valuable examples and supports (particularly the great colourists—Delacroix, Rubens, the Venetians), but only so far. He warns against too much subservience to the past, warns of its

Plate 80 **Trees and Houses**about 1890
watercolour and pencil $12\frac{3}{4} \times 19\frac{7}{8}$ in (32.4 × 50.5 cm)
V981
Museum Boymans-van Beuningen,
Rotterdam

threat to one's individuality, describes Emile Bernard as 'an intellectual crushed by the memory of the museums, but who does not look at nature enough'.

This faith in sensations in front of nature as the sole criterion for the painter was, of course, unprecedented. It was unshakeable. His confidence in his own ability to realise nature in art falters from time to time, but not this belief. This was the key to his originality.

To Emile Zola, 1858-59, from Aix

Since you left Aix, my dear fellow, dark sorrow has oppressed me; I am not lying, believe me. I no longer recognise myself, I am heavy, stupid and slow.

A certain inner sadness fills me and, dear God, I only dream of the woman I spoke to you about. I don't know who she is, I see her passing in the street sometimes . . . yes *you* are happy, but I, miserable wretch, I am withering in silence, my love (for love I feel) cannot find an outlet. A certain ennui accompanies me everywhere, and only for a moment do I forget my sorrow: when I have had a drop . . . I shall get drunk even more now!

My dear fellow, after having started this letter on 9th July, it is only right at least to finish it today, 14th, but alas, in my arid brain I do not perceive the least little idea, and yet how many subjects would I not have to discuss with you in person, hunting, fishing, swimming, what a variety of subjects there! and love (infandum, let us not broach that corrupting subject) . . .

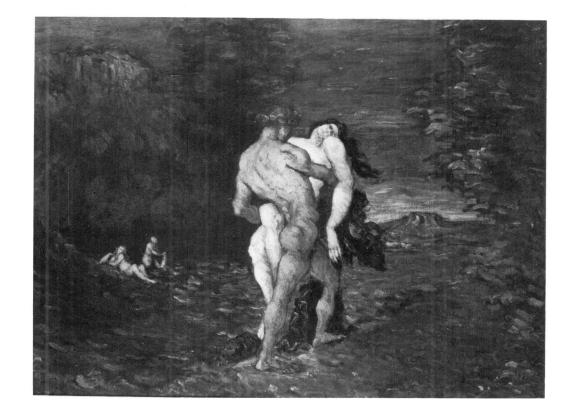

Plate 81

L'Enlèvement

1867
oil on canvas

35½ × 46 in (90.5 × 117 cm)

V101

Trustees of the late Lord Keynes

I have conceived the idea of a drama in 5 acts which we (you and I) will call: 'Henry VIII of England'. We will do it together in the holidays (July 1858).

I have had a passionate love for a certain Justine who is really 'very fine' . . . I am not happy, and yet I must say that I run the risk of meeting her three or four times a day. And better still, my dear: one fine day a young man accosted me, he is a first year student like myself, it is in fact Seymard whom you know. 'My dear,' he said, taking my hand, then hanging himself on my arm and continuing to walk towards the rue d'Italie; 'I am,' he continued, 'about to show you a sweet little thing whom I love and who loves me.' I confess that instantly a cloud seemed to pass before my eyes, I had, as it were, a presentiment that I didn't have a chance, and I was not mistaken, for midday having just struck, Justine emerged from the salon where she works, and upon my word, the moment I caught sight of her in the distance, Seymard, gave me a signal: 'There she is,' he said. At this point I saw nothing more, my head was spinning, but Seymard dragging me along with him, I brushed against the little one's frock . . .

Nearly every day since then I have seen her and often Seymard was following her . . . Ah! what dreams I have built up, and the most foolish ones, at that, but you see, it's like this: I said to myself, if she did not detest me we should go to Paris together, there I would make myself an artist, we should be happy. I dreamt of the pictures, a studio on the 4th floor, you with me, then how we should have laughed! I didn't ask to be rich, you

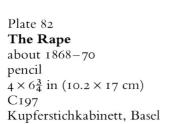

know what I'm like, me, with a few hundred francs I thought we could live contentedly, but, by God, that was a great dream, that one, and now I, who am so lazy, I am content only when I have had something to drink, I can scarcely go on, I am an inert body, good for nothing.

My word, old man, your cigars are excellent . . . (20th June 1859).

Thus before my eyes there sometimes appear Radiant beings with voices divine, During the night. Dear friend, one might say that dawn With its fresh sweet lustre colours them zealously. They seem to smile at me and I stretch out my hand, But in vain I approach, all at once they are gone; They mount to the heavens borne along by the breeze With a tender glance which seems to say Farewell! I strive to approach them again, And I try to touch them in vain, They are no more—the transparent gauze No longer designs their bodies and forms divine. My dreams disappearing reality comes Which finds me groaning, my heart heavy within, And I see before my eyes a phantom arise Horrible, monstrous, it's the LAW as it's called. [part of a poem, July 1859]

To Joseph Huot, 4th June 1861, from Paris

I fritter away my petty existence to right and to left. 'Suisse' [the Académie Suisse] keeps me busy from 6 am to 11 am . . .

I thought that by leaving Aix I should leave behind the boredom that pursues me . . . I have left my parents, my friends, some of my habits, that's all. Yet I admit that I roam about aimlessly nearly all day. I have seen, naive thing to say, the Louvre and the Luxembourg and Versailles. You know them, the pot-boilers which these admirable monuments enclose . . .

I have also seen the Salon. For a young heart, for a child born for art, who says what he thinks, I believe that is what is really best because all tastes, all styles meet there and clash.

To Numa Coste, 5th January 1863, from Paris

As in the past . . . I go to 'Suisse' in the morning from 8 till I o'clock and in the evening from 7 till 10. I work calmly and eat and sleep likewise.

To the Superintendent of the Beaux Arts, M. de Nieuwerkerke, Paris, 19th April 1866 Sir,

Recently I had the honour to write to you about the 2 pictures that the jury has just turned down.

As you have not answered me yet, I feel I must remain firm about the motives which led me to apply to you. Moreover, as you have certainly received my letter there is no need for me to repeat the arguments that I thought necessary to submit to you. I content

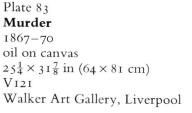

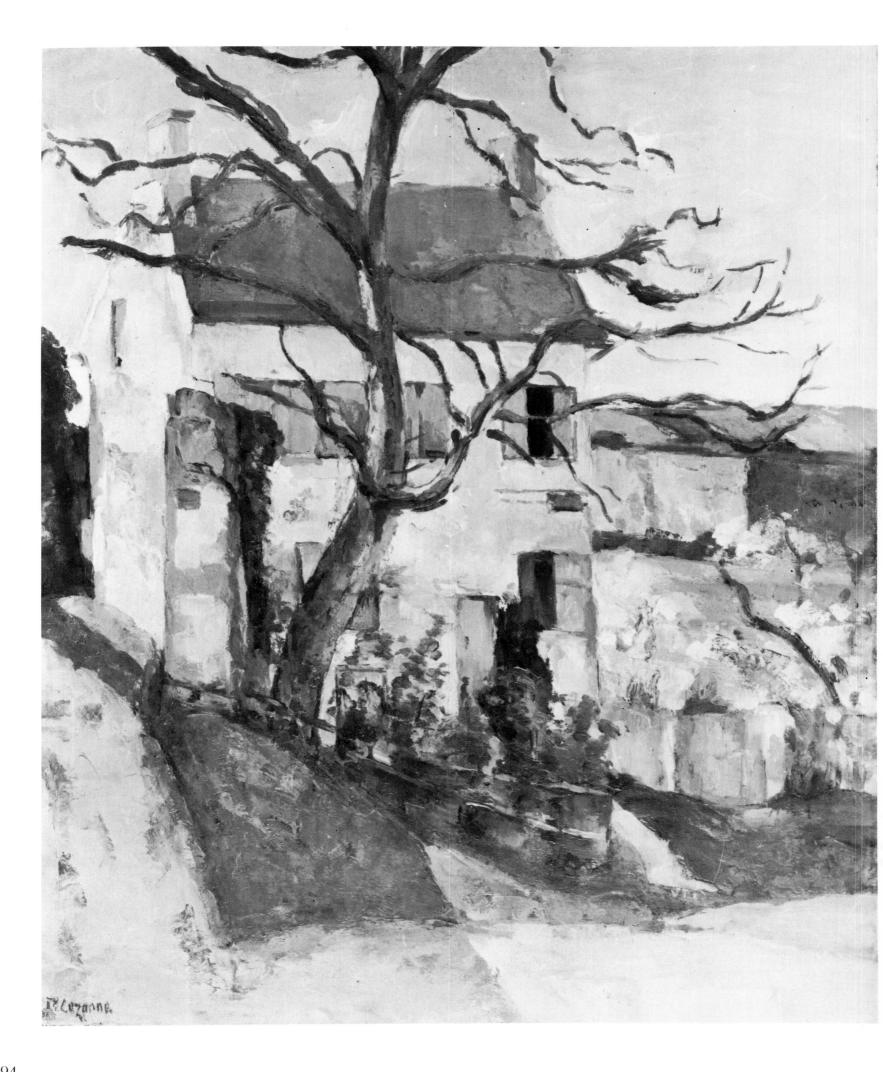

Plate 84 **Dr Gachet's House at Auvers**

oil on canvas $26 \times 21\frac{5}{8}$ in (66 × 55 cm) V 142 myself with saying again that I cannot accept the unauthorised judgement of colleagues whom I myself have not given the task of appraising me.

I am therefore writing to you to insist on my petition. I wish to appeal to the public and to be exhibited at all costs. My wish appears to me not at all exorbitant and, if you were to interrogate all the painters who find themselves in my position, they would all reply that they disown the Jury and that they wish to participate in one way or another in an exhibition which would perforce be open to all serious workers.

Therefore let the Salon des Refusés be re-established. Even were I to be there alone, I should still ardently wish that people should at least know that I no more want to be mixed up with those gentlemen of the Jury than they seem to want to be mixed up with me. I trust, Monsieur, that you will not continue to keep silent. It seems to me that every decent letter deserves a reply.

Please accept etc.

To Camille Pissarro, 23rd October 1866, from Aix

You are perfectly right to speak of grey, for grey alone reigns in nature, but it is terrifyingly hard to catch.

To his parents, probably 1874, from Paris

You ask me in your last letter why I am not yet returning to Aix. I have already told you in that respect that it is more agreeable for me than you can possibly think to be with you, but that once at Aix I am no longer free and when I want to return to Paris this always means a struggle for me; and although your opposition to my return is not absolute, I am very much troubled by the resistance I can feel on your part. I greatly desire that my liberty of action should not be impeded and I shall then have all the more pleasure in hastening my return.

I ask Papa to give me 200 fr. a month, that will permit me to make a long stay at Aix.

To Pissarro, 24th June 1874, from Aix

Recently I saw the director of the Musée d'Aix . . . and when I told him, for instance, that you replaced modelling by the study of tones, and was trying to make him understand this nature, he closed his eyes and turned his back.

To his mother, 26th September 1874, from Paris

... but I know that he [Pissarro] has a good opinion of me, who has a very strong opinion of myself. I am beginning to consider

Plate 85 Camille Pissarro **The Hermitage at Pontoise** about 1867 oil on canvas $59\frac{1}{8} \times 78\frac{3}{4}$ in (150 × 200 cm) Guggenheim Museum, New York

(Thannhauser Foundation)

The Bay of Marseille seen from l'Estaque 1882-85 oil on canvas

 $22\frac{3}{4} \times 28\frac{1}{4}$ in $(58 \times 72$ cm)

V428 Louvre, Paris

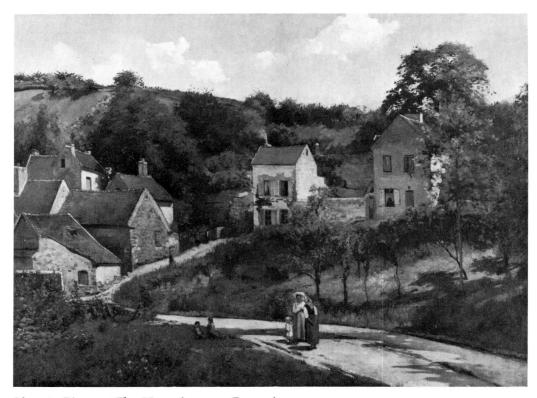

Plate 85 Pissarro The Hermitage at Pontoise see page 95

myself stronger than all those around me, and you know that the good opinion I have of myself has only been reached after serious consideration. I have to work all the time, not to reach that final perfection, which earns the appreciation of imbeciles—and this thing which is commonly appreciated so much is merely the effect of craftsmanship and renders all work resulting from it inartistic and common. I must strive after perfection only for the satisfaction of becoming truer and wiser. And believe me, the hour always comes when one breaks through and has admirers far more fervent and convinced than those who are only attracted by an empty surface.

To Pissarro, 2nd July 1876, from l'Estaque

It's like a playing-card. Red roofs over the blue sea . . . The sun here is so tremendous that it seems to me as if the objects were silhouetted not only in black and white, but in blue, red, brown and violet. I may be mistaken, but this seems to me to be the opposite of modelling.

To Zola, 23rd March 1878, from l'Estaque

The situation between my father and myself is becoming very strained and I am threatened with the loss of my whole allowance. A letter that Monsieur Chocquet wrote to me, and in which he spoke of Madame Cézanne and of little Paul, has definitely

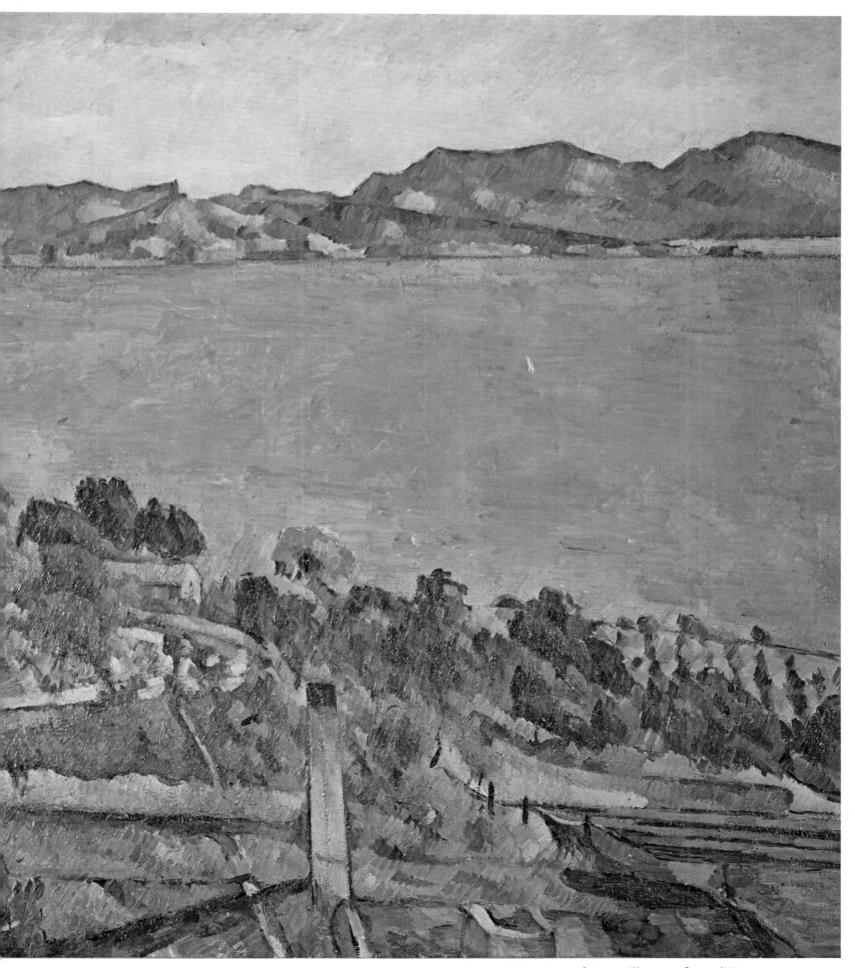

Plate 86 The Bay of Marseille seen from l'Estaque see page 95

Plate 87 **Two Studies of the Artist's Son Paul** about 1877
pencil
4 × 8 in (10.1 × 20.3 cm)

C703

Art Institute, Chicago

Plate 88

Madame Cézanne in a Red Armchair about 1877 oil on canvas $28\frac{1}{2} \times 22$ in $(72.5 \times 56 \text{ cm})$ V292

Museum of Fine Arts, Boston, Massachusetts (Bequest of R.T. Paine II)

revealed my position to my father, who by the way was already suspicious and on the watch.

To Zola, 24th May 1883, from l'Estaque

I have rented a little house and garden at l'Estaque just above the station and at the foot of the hill where behind me rise the rocks and the pines.

I am still busy painting.—I have here some beautiful views but they do not quite make motifs.—Nevertheless, climbing the hills as the sun goes down one has a glorious view of Marseille in the background and the islands, all enveloped towards evening to a very decorative effect.

To Zola, 27th November 1884, from Aix

I have not much news to give you about the good old town where I saw the light of day. Only (but this doubtless will not affect you much), art is changing terribly in its outer appearance, putting on too much of a small, very mean form, while at the same time the ignorance of harmony reveals itself more and more through the discord of the colours and, what is even worse, in the aphony of the tone.

After groaning, let us cry Vive le Soleil, which gives us such a beautiful light.

Rough draft (incomplete) of a letter to an unknown woman, Spring 1885

I saw you and you allowed me to kiss you; from that moment a profound emotion has not stopped exciting me. You will excuse the liberty that a friend, tortured by anxiety, takes in writing to you. I do not know how to explain to you this liberty that you may find so great, but could I have remained under this burden that oppresses me? Is it not better to give expression to a sentiment rather than to conceal it?

Why, I said to myself, suppress the cause of your agony? Is it not a relief granted to suffering, to be allowed to express itself? And if physical pain seems to find relief in the cries of the afflicted, is it not natural, Madame, that moral sadness seeks some consolation in the confession made to an adored?

I know well that this letter, the hasty and premature sending of which may appear indiscreet, has nothing to recommend me to you but the goodness of . . .

To Victor Chocquet, 11th May 1886, from Gardanne

Now I do not want to weigh too heavily on you, I mean morally,

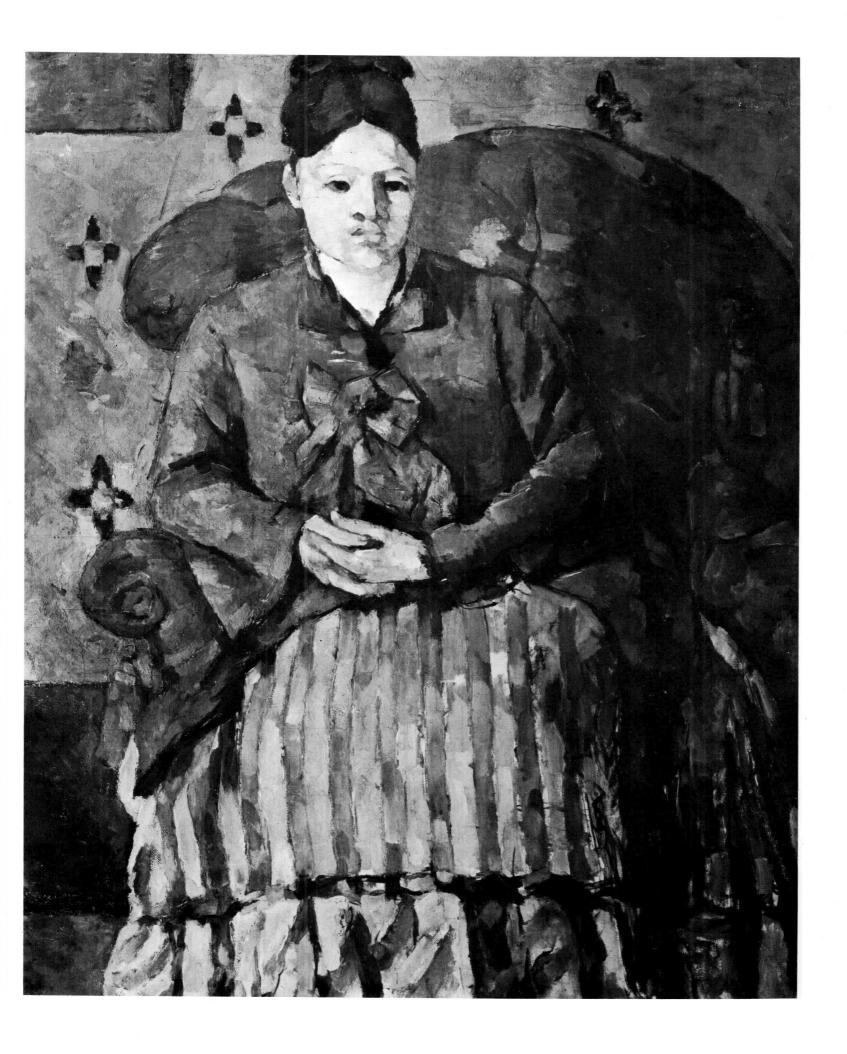

Plate 89 **Landscape in Provence**about 1878-83oil on canvas $19\frac{3}{4} \times 23\frac{7}{8}$ in $(50 \times 61 \text{ cm})$ V297

National Gallery of Art, Washington, DC (Chester Dale Collection)

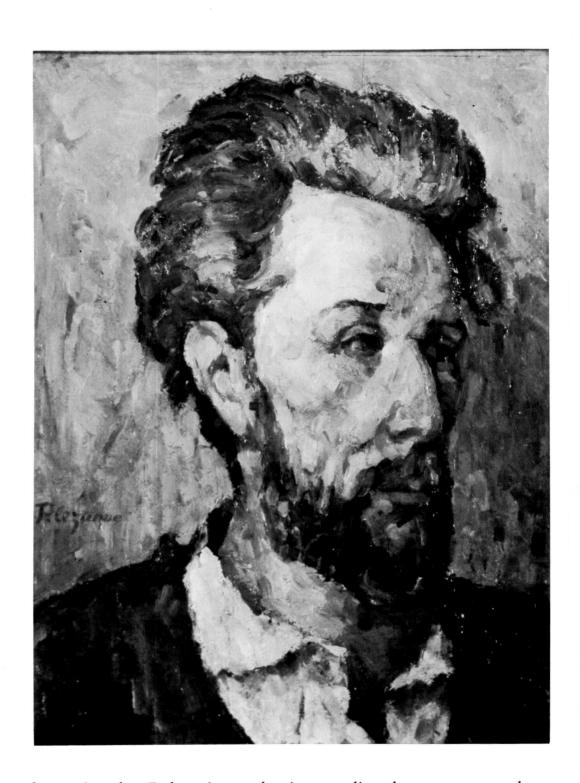

Plate 90 **Portrait of Victor Chocquet** about 1876-77oil on canvas $18\frac{1}{8} \times 14\frac{1}{8}$ in $(46 \times 36 \text{ cm})$ V283 Private collection

but seeing that Delacroix acted as intermediary between you and me, I will allow myself to say this: that I should have wished to possess the intellectual equilibrium that characterises you and allows you to achieve with certainty the desired end. Your good letter which was enclosed with the one from Madame Choquet, bears witness to a great equilibrium of vital faculties . . . Fate has not favoured me with an equal stability, that is the only regret I have about the things of this earth. As for the rest, I have nothing to complain of. Always the sky, the boundless things of nature, attract me and give me the chance to look with pleasure . . .

To conclude I must tell you that I am still occupied with my painting and that there are treasures to be taken away from this country, which has not yet found an interpreter equal to the abundance of riches which it displays.

To Claude Monet, 6th July 1895, from Aix

I was forced to abandon for the time being the study [see plate 50] that I had started at the house of Geffroy, who had placed himself so generously at my disposal, and I am a little upset at the meagre result I obtained, especially after so many sittings and successive bursts of enthusiasm and despair. So here I am then, landed again in the South from which I should, perhaps, never have separated, in order to fling myself into the chimerical pursuit of art.

To end, may I tell you how happy I was about the moral support I received from you, which served as a stimulus for my painting.

To Joachim Gasquet, 30th April 1896, from Aix

I met you this evening . . . If I am not mistaken you appeared to be very angry with me.

Could you see inside me, the man within, you would be so no longer. You don't see then to what a sad state I am reduced. Not master of myself, a man who does not exist . . .? But I curse the Geffroys and the few characters who, for the sake of writing an article for 50 francs, have drawn the attention of the public to me. All my life I have worked to be able to earn my living, but I thought that one could do good painting without attracting attention to one's private life. Certainly an artist wishes to raise himself intellectually as much as possible, but the man must remain

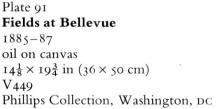

Plate 92 **Three Naiads**drawing after Rubens's
'Marie de Médicis landing at Marseille' 1876-79pencil $12\frac{1}{4} \times 17\frac{3}{4}$ in $(31 \times 45 \text{ cm})$ C455
Collection of Marianne Feilchenfeldt, Zürich

obscure. The pleasure must be found in the work. If it had been given to me to realise my aim, I should have remained in my corner with the few studio companions with whom we used to go out for a drink. I still have a good friend from that time, well, he has not been successful, which does not prevent him from being a bloody sight better painter than all the daubers with their medals and decorations which bring one out in a sweat, and you want me at my age to believe in anything? Anyway I am as good as dead. You are young, and I can understand that you wish to succeed. But for me, what is there left for me to do in my situation; only to sing small? and were it not that I am deeply in love with the landscape of my country, I should not be here.

To Charles Camoin, 3rd February 1902

Since you are now in Paris and the masters of the Louvre attract you, if it appeals to you make some studies after the great decorative masters Veronese and Rubens, but as you would do from nature—a thing I was only able to do inadequately myself. But you do well above all to study from nature.

Thank you for the very brotherly way in which you regard my efforts to express myself lucidly in painting.

To Joachim Gasquet, 8th July 1902, from Aix

I despise all living painters exeept Monet and Renoir.

To Ambroise Vollard, 9th January 1903

I am working doggedly, for I am beginning to see the promised land. Shall I be like the great Hebrew leader or shall I be able to enter? . . .

I have made some progress. Why so late and with such difficulty? Is art really a priesthood that demands the pure in heart who must belong to it entirely? I am sorry about the distance which separates us, for more than once I should have turned to you to give me a little moral support. I live alone, the——the——are unspeakable, it is the clan of intellectuals and, good God, of what a brand! If I am still alive we will talk about all this again.

To Charles Camoin, 22nd February 1903

Everything, especially in art, is theory developed and applied in contact with nature.

To Charles Camoin, 13th September 1903

I thought I had mentioned to you that Monet lived at Giverny; I hope that the artistic influence which this master cannot fail to have on his more or less immediate circle, may make itself felt to the strictly necessary degree, which it can and ought to have on a young artist willing to work. Couture used to say to his pupils: 'Keep good company, that is: Go to the Louvre. But after having seen the great masters who repose there, we must hasten out and by contact with nature revive within ourselves the instincts, the artistic sensations which live in us.' . . .

If you meet the master whom we both admire [Monet], remember me to him. He does not, I believe, much like being bothered, but in view of the sincerity he may relax a little.

To Louis Aurenche, 29th January 1904

After a whole day working to overcome the difficulties of producing after nature, I feel, when the evening comes, the need to take some rest, and my mind has not then the freedom of spirit necessary to write letters.

To Emile Bernard, March 1904

As you know, I have often made sketches of male and female bathers which I should have liked to execute on a large scale and from nature; the lack of models has forced me to limit myself to these rough sketches. There were obstacles in my way; for example, how to find the proper setting for my picture, a setting which would not differ much from the one I visualised in my mind; how to gather together the necessary number of people;

Plate 93

Amour en Plâtre

drawing after the statue attributed to Puget about 1890
pencil $19\frac{1}{2} \times 12\frac{1}{2}$ in $(49.7 \times 31.9 \text{ cm})$ V1462, C988
British Museum, London

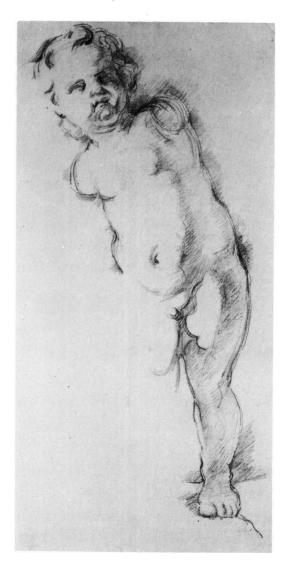

how to find men and women willing to undress and remain motionless in the poses I had determined. Moreover there was the difficulty of carrying about a large canvas, and the thousand difficulties of favourable and unfavourable weather, of a suitable spot in which to work, of the supplies necessary for the execution of such a large work. So I was obliged to give up my project of doing Poussin over entirely from nature, and not constructed piece-meal from notes, drawings and fragments of studies, in short, of painting a living Poussin in the open air, with colour and light, instead of one of those works imagined in a studio, where everything has the brown colouring of feeble daylight without reflections from the sky and the sun.

To Emile Bernard, 15th April 1904

May I repeat what I told you here: treat nature by means of the cylinder, the sphere, the cone, everything brought into proper perspective so that each side of an object or plane is directed towards a central point. Lines parallel to the horizon give breadth, whether it is a section of nature, or, if you prefer, of the spectacle which the *Pater Omnipotens Aeterne Deus* spreads out before our eyes. Lines perpendicular to this horizon give depth. But nature for us men is more depth than surface, whence the need to introduce into our light vibrations, represented by the reds and yellows, a sufficient amount of blue-ness to give the feel of air.

I must tell you that I had another look at the study you made in the lower floor of the studio, it is good. You have only to continue in this way I think. You have the understanding of what must be done and you will soon turn your back on the Gauguins and Van Goghs!

To Emile Bernard, 12th May 1904

I have already told you that I like Redon's talent enormously, and from my heart I agree with his feeling for and admiration of Delacroix. I do not know if my indifferent health will allow me ever to realize my dream of painting his apotheosis.

I progress very slowly, for nature reveals herself to me in very complex ways; and the progress needed is endless. One must look at the model correctly and feel very exactly; and also express oneself forcibly and with distinction.

Taste is the best judge. It is rare. Art addresses itself only to an excessively limited number of individuals.

The artist must scorn all judgement that is not based on an intelligent observation of character. He must beware of the literary spirit which so often causes the painter to deviate from his true

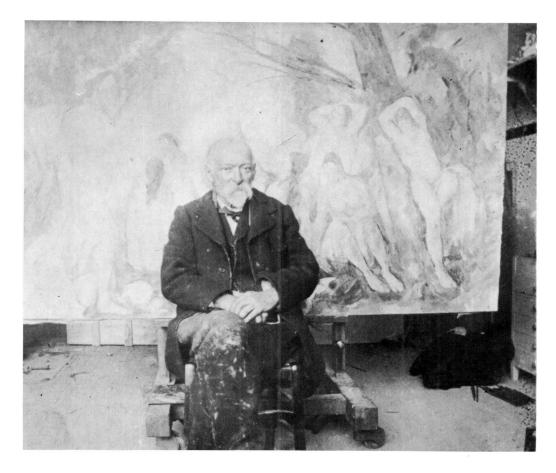

Plate 94 Photograph of Cézanne in 1904, sitting in front of one of his *Bathers* paintings

path—the concrete study of nature—to lose himself too long in intangible speculations.

The Louvre is a good book to consult but it must be only an intermediary. The real and immense study to be undertaken is the manifold picture of nature.

To Emile Bernard, 26th May 1904

I must always come back to this: painters must devote themselves entirely to the study of nature and try to produce pictures which will be an education. Talking about art is almost useless. The work which brings about progress in one's own craft is sufficient compensation for not being understood by the imbeciles.

The man of letters expresses himself in abstractions whereas a painter, by means of drawing and colour, gives concrete form to his sensations and perceptions. One is neither too scrupulous nor too sincere nor too submissive to nature; but one is more or less master of one's model and, above all, of the means of expression. Get to the heart of what is before you and continue to express yourself as logically as possible.

To Emile Bernard, 25th July 1904

I received the 'Revue Occidentale'. I can only thank you for what you wrote about me.

I am sorry that we cannot be side by side, for I do not want to be right in theory but in front of nature. Ingres, in spite of his style, and his admirers, is only a very small painter. The greatest, you know them better than I; the Venetians and the Spaniards.

In order to make progress, there is only nature, and the eye is trained through contact with her. It becomes concentric through looking and working. I mean to say that in an orange, an apple, a ball, a head, there is a culminating point; and this point is always—in spite of the tremendous effect; light and shade, colourful sensations—the closest to our eye; the edges of the objects flee towards a centre on our horizon. With a small temperament one can be very much of a painter. One can do good things without being very much of a harmonist or a colourist. It is sufficient to have a sense of art—and this is without doubt the horror of the bourgeois, this sense. Therefore institutions, pensions, honours can only be made for cretins, humbugs and rascals. Do not be an art critic, but paint, there lies salvation.

To Charles Camoin, 9th December 1904

Whoever the master may be whom you prefer this must be only guidance for you. Otherwise you will never be anything but a pasticheur. With any feeling for nature whatever, and some fortunate talents—and you have some—you should be able to dissociate yourself; advice, someone else's methods must not make you change your own way of feeling. Should you momentarily be under the influence of someone older than you, believe me, as soon as you begin to feel vividly, your own emotion will always emerge and win its place in the sun—gain the upper hand, confidence—what you must strive to attain is a good method of construction. Drawing is merely the outline of what you see.

Michelangelo is a constructor, and Raphael an artist who, great as he may be, is always tied to the model.—When he tries to become a thinker he sinks below his great rival.

To Emile Bernard, 23rd December 1904

Yes, I approve of your admiration for the strongest of the Venetians; we praise Tintoretto. Your need to find a moral, an intellectual point of support in works . . . will surely lead you, in front of nature, to your means of expression; and on the day you find them, be convinced that you will rediscover without effort and in front of nature, the means employed by the four or five great ones of Venice.

This is true without possible doubt-I am quite positive-an optical impression is produced in our organs of sight which allows

us to classify the planes represented by colour sensations as light or half-tone or quarter-tone. Light, therefore, does not exist for the painter. As long as we are forced to proceed in this way from black to white, making abstractions which from the start are simply points of support for the eye as much as for the mind, then we flounder and we do not succeed in becoming master of ourselves or in *possessing ourselves*. During this period (I am necessarily repeating myself a little) we turn towards the admirable works that have been handed down to us through the ages, where we find comfort, support, such as a plank provides for the bather.

To Louis Aurenche, 10th January 1905

I work all the time and that without paying any attention to criticism and the critics, as a real artist should. My work must prove that I am right.

Plate 95 Terraced Hills with Houses and Trees

about 1880-83 pencil $12\frac{3}{8} \times 18\frac{5}{8}$ in $(31.3 \times 47.3 \text{ cm})$ C798 Kupferstichkabinett, Basel

To Roger Marx, 23rd January 1905

My age and health will never allow me to realise the dream of art that I have been pursuing all my life . . . To my mind one does not put oneself in the place of the past, one only adds a new link.

To Emile Bernard, 1905

If the official Salons remain so inferior, the reason is that they encourage only more or less widely accepted methods. It would be better to bring more personal emotion, observation and character.

The Louvre is the book in which we learn to read. We must not, however, be satisfied with retaining the beautiful formulas of our illustrious predecessors. Let us go forth to study beautiful nature, let us try to free our minds from them, let us strive to express ourselves according to our personal temperament. Time and reflection, moreover, modify little by little our vision, and at last comprehension comes to us . . .

You will understand me better when we see each other again; study modifies our vision to such a degree that the humble and colossal Pissarro finds himself justified in his anarchist theories. Draw; but it is the reflection which envelops; light, through the general reflection, is the envelope. [CLXXXIII]

To Bernard, 23rd October 1905

Your letters are precious to me for a double reason, . . . for their arrival lifts me out of the monotony which is caused by the incessant pursuit of the sole and unique aim . . . Secondly I am able to reassess for you, undoubtedly rather too much, the obstinacy with which I pursue that part of nature, which, coming into our line of vision, gives the picture . . . we must render the image of what we see, forgetting everything that existed before us.

... Now, being old, nearly 70 years, the sensations of colour, which give the light, are for me the reason for the abstractions which prevent me from either covering my canvas or continuing the delimitation of the objects where their points of contact are fine and delicate; from which it results that my image or picture is incomplete.

... neo-Impressionism circumscribes the contours with a black line, a fault which must be fought at all costs. But nature, if consulted, gives us the means of attaining this end.

To his son, 3rd August 1906

I get up in the early morning, and live my ordinary life only between 5 and 8 o'clock. By that time the heat becomes stupefying and exerts such a strong cerebral depression that I can't even think of painting . . .

It is unfortunate that I cannot make many proofs of my ideas and sensations, long live the Goncourts, Pissarro and all those who have the impulse towards colour, representing light and air.

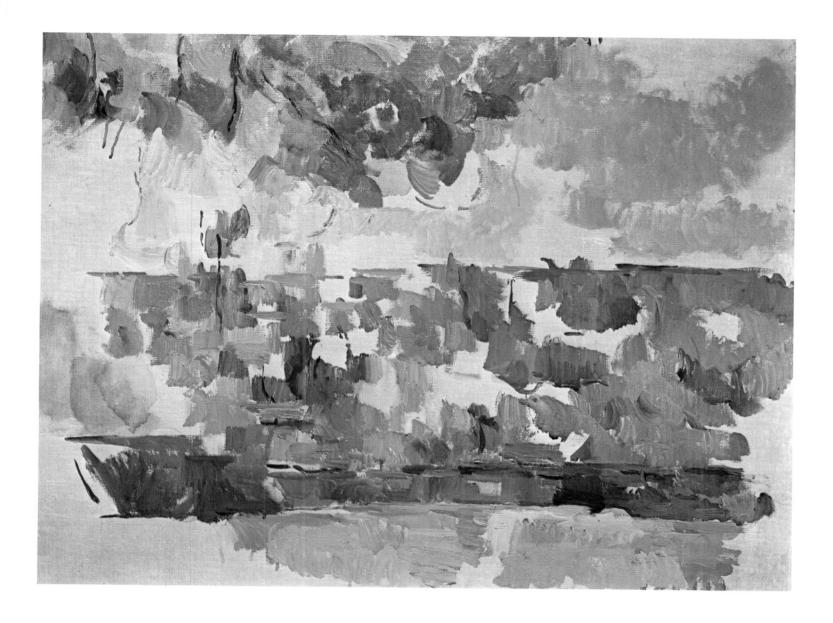

Plate 96

Jardins, Les Lauves

1904–06
oil on canvas $25\frac{3}{4} \times 30\frac{5}{8}$ in $(65.4 \times 77.8 \text{ cm})$ V1610

Phillips Collection, Washington, DC

To his son, 12th August 1906

At St Sauveur Cathedral an idiot of an abbé has succeeded the old choirmaster Poncet, he works the organ and plays wrong. In such a manner that I can no longer go to mass, his manner of playing makes me positively ill.

I think that to be a Catholic one must be devoid of all sense of justice, but have a good eye for one's interests.

To his son, 8th September 1906

Finally I must tell you that as a painter I am becoming more clear-sighted before nature, but that with me the realisation of my sensations is always painful. I cannot attain the intensity that is unfolded before my senses. I have not the magnificent richness of colouring that animates nature. Here on the bank of the river, the motifs multiply, the same subject seen from different angles gives a subject for study of the most powerful interest and so varied that I think I could occupy myself for months without changing my place, simply bending a little more to the right or left.

To his son, 13th September 1906

... Emile Bernard, one of the most distinguished aesthetes. I am sorry not to have him under my thumb so as to instil into him the idea so sane, so comforting and the only correct one, of a development of art through contact with nature. I can scarcely read his letter, but I think he is right, though the good man absolutely turns his back on what he expounds in his writings; in his drawings he produces nothing but old-fashioned rubbish which smacks of his artistic dreams, based not on the emotional experience of nature but on what he has been able to see in the museums, and more still on a philosophic attitude of mind which comes from his excessive knowledge of the master he admires.

P.S. One of the strong ones is Baudelaire, his 'Art Romantique' is magnificent, and he makes no mistake in the artist he admires.

To Bernard, 21st September 1906

Will I ever attain the end for which I have striven so much and so long? I hope so, but as long as it is not attained a vague state of uneasiness persists which will not disappear until I have reached port, that is until I have realised something which develops better than in the past, and thereby can prove the theories—which in themselves are always easy; it is only giving proof of what one thinks that raises serious obstacles. So I continue to study.

To his son, 26th September 1906

He [Camoin] showed me a photograph of a figure by the unfortunate Emile Bernard; we are agreed on this point, that he is an intellectual constipated by recollections of museums, but who does not look enough at nature, and that is the great thing, to make himself free from the school and indeed from all schools.— So that Pissarro was not mistaken, though he went a little too far, when he said that all the necropolises of art should be burned down.

To his son, 13th October 1906

My nervous sytem is very weak, only oil painting can keep me up. I must carry on. I simply must produce after nature.—Sketches, pictures, if I were to do any, would be merely constructions after nature, based on method, sensations, and developments suggested by the model, but I always say the same thing.

To his son, 15th October 1906

All my compatriots are arseholes beside me . . . I think the younger painters are much more intelligent than the others, the old ones see in me only a disastrous rival.

Cézanne in contemporary writings

A critic

[The following hostile review of paintings from Zola's collection (auctioned after his death) was partly anti-Zola polemics, but it was this sort of critical writing that prompted the constant condemnations of all art critics, 'intellectuals', 'talks on art', etc., strewn through Cézanne's late letters. The excerpt starts with a discussion of an early Cézanne portrait.]

The crowd was particular amused by the head of a man, dark and bearded, whose cheeks were sculptured with a trowel and who seemed to be the prey of an eczema. The other paintings by the same artist all had an air of defying, no less directly, Corot, Théodore Rousseau, and also Hobbema and Ruysdael.

Pissarro, Claude Monet, and the other eccentric painters of the plein-air and of pointillism-those who have been called 'confetti painters'-are academicians, almost members of the Institute, by comparison with this strange Cézanne whose productions Zola had picked up.

The experts in charge of the sale themselves experienced a certain embarrassment, in cataloguing these fantastic things, and attached this reticent note to each one of them: 'Work of earliest youth!'

If M. Cézanne was still being nursed when he committed these daubs, we have nothing to say; but what is to be thought of the head of a literary school, as the squire of Médan considered himself to be, who propagates such pictorial madness? And he wrote Salon reviews in which he pretended to rule French art!

Had the unfortunate man never seen a Rembrandt, a Velasquez, a Rubens, or a Goya? For if Cézanne is right, then all those great brushes were wrong . . .

Henri Rochefort, in L'Intransigeant, Paris, 9th March 1903 (translation from Rewald, Cézanne: see Bibliography)

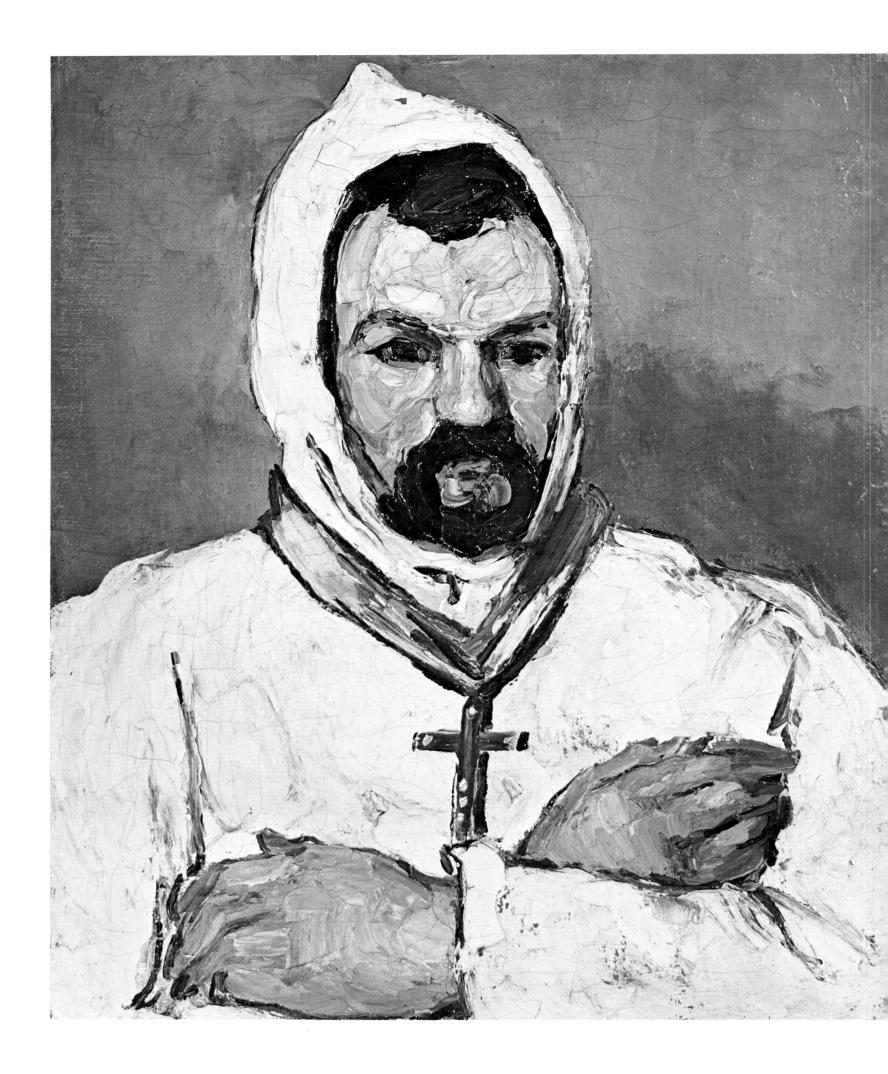

Plate 97

Uncle Dominique

Portrait de Moine) 1865-67oil on canvas $15\frac{5}{8} \times 21\frac{1}{4}$ in $(65 \times 54$ cm)

V72

Collection of Mrs Enid A. Haupt

Ambroise Vollard

[Vollard, quoting a sensational incident reported in a newspaper, was stopped by Cézanne. After Vollard's maid had left the room, the following exchange took place:]

'I stopped you,' said Cézanne, 'because what you were saying wasn't proper for a young girl to hear.'

'What young girl?' I asked in astonishment.

'Why! Your maid!'

'But she knows all about that sort of thing! You may even be sure she knows more than we do.'

'That may be. But I prefer to think she doesn't.'

Ambroise Vollard, Recollections of a Picture Dealer, 1936

Mary Cassatt

[Mary Cassatt, the American painter, member of the Impressionist group and friend of Degas, first met Cézanne in Giverny in the autumn of 1894. The following description of Cézanne is from a letter of around that date.]

The circle has been increased by a celebrity in the person of the first Impressionist, Monsieur Cézanne . . . Monsieur Cézanne is from Provence and is like the man from the Midi whom Daudet describes: 'When I first saw him I thought he looked like a cutthroat with large red eyeballs standing out from his head in a most ferocious manner, a rather fierce-looking pointed beard, quite grey, and an excited way of talking that positively made the dishes rattle.' I found later on that I had misjudged his appearance, for far from being fierce or a cut-throat, he has the gentlest nature possible, 'comme un enfant' as he would say. His manners at first rather startled me-he scrapes his soup plate, then lifts it and pours the remaining drops in the spoon; he even takes his chop in his fingers and pulls the meat from the bone. He eats with his knife and accompanies every gesture, every movement of his hand, with that implement, which he grasps firmly when he commences his meal and never puts down until he leaves the table. Yet in spite of the total disregard of the dictionary of manners, he shows a politeness towards us which no other man here would have shown. He will not allow Louise to serve him before us in the usual order of succession at the table; he is even deferential to that stupid maid, and he pulls off the old tam-o'-shanter, which he wears to protect his bald head, when he enters the room. I am gradually learning that appearances are not to be relied upon over here . . .

The conversation at lunch and at dinner is principally on art and cooking. Cézanne is one of the most liberal artists I have ever seen.

Plate 98

Portrait of Ambroise Vollard 1899
oil on canvas $39\frac{7}{8} \times 31\frac{7}{8}$ in (101.3 × 81 cm)
V696
Petit Palais, Paris

He prefaces every remark with: 'Pour moi' it is so and so, but he grants that everyone may be as honest and as true to nature from their convictions; he doesn't believe that everyone should see alike.'

Quoted by A. D. Breeskin, The Graphic Work of Mary Cassatt, 1948

George Moore

[Compare the tone of Mary Cassatt's description with the widely held picture of Cézanne painted by George Moore, who had never met Cézanne.]

We used to hear about him-he used to be met on the outskirts of Paris wandering about the hillsides in jack-boots. As no-one took the least interest in his pictures, he left them in the fields . . .

It would be untrue to say that he had no talent, but whereas the intention of Manet and of Monet and of Degas was always to paint, the intention of Cézanne was, I am afraid, never very clear to himself. His work may be described as the anarchy of painting, as art in delirium.

George Moore, Reminiscences of the Impressionist Painters, Dublin, 1906

Camille Pissarro

[Pissarro is the only other Impressionist painter from whom we have a substantial volume of correspondence—mostly the letters to his son, Lucien. Although these do not start early enough to say much of the days in 1872-74 when Pissarro and Cézanne worked together in Pontoise and Auvers, references from the 1880s onwards fill out our picture of Cézanne's moods and reputation. Cézanne's faith in Pissarro lost ground in the 1880s, probably because of the latter's association with Seurat and Neo-Impressionism, for which Cézanne had no sympathy. Towards the end of his life, Cézanne told Louis Le Bail that 'Perhaps we all come from Pissarro, as early as 1865 he eliminated black, dark brown and ochres, this is a fact' and 'if he'd continued to paint as he did in 1870, Pissarro would now be the strongest of us all.' The secondhand references to Cézanne's criticisms of him that Pissarro complains of below are also compensated by Cézanne's description of himself as 'pupil of Pissarro' in the captions to paintings exhibited in Aix in 1902 and 1906.

With the exception of the first, all of the following quotations from Pissarro are taken from his letters to Lucien (John Rewald, ed., Camille Pissarro, Letters to his Son Lucien, translated by Lionel Abel, Pantheon Books (a division of Random House Inc.), New York, 1943).]

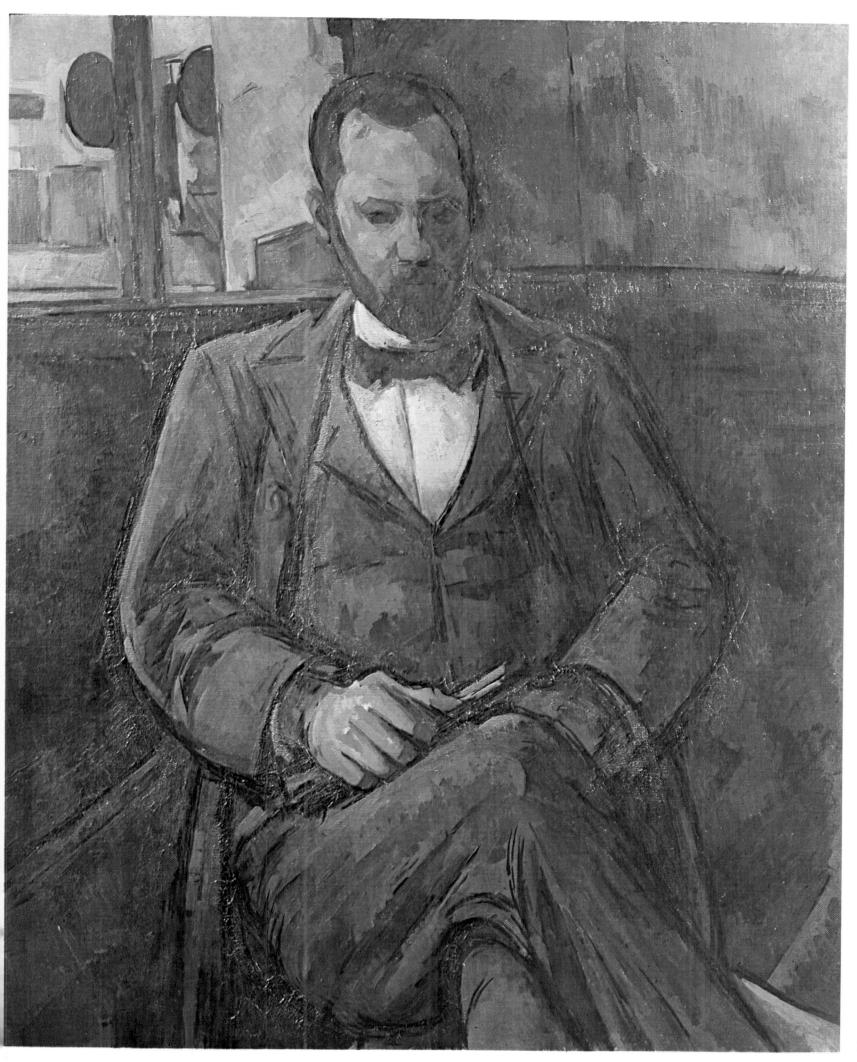

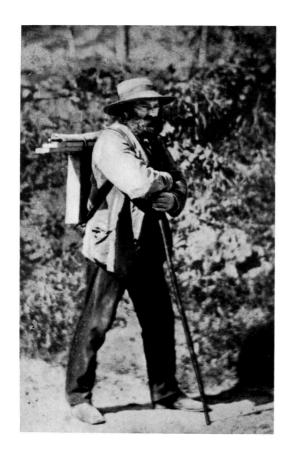

Plate 99 Photograph of Cézanne on his way to work, near Pontoise in about 1873

Our friend Cézanne raises our expectations and I have seen, and have at home, a painting of remarkable vigour and power. If, as I hope, he stays some time at Auvers, where he is going to live, he will astonish a lot of artists who were in too great haste to condemn him.

To Antoine Guillemet, September 1872

You can't see a Cézanne by holding it against your nose.

March 1884

I sent you with the etchings an issue of Les Hommes d'Aujourd'hui which has a portrait of Cézanne by me and a critical note by Bernard. This ignorant fool claims that Cézanne for a time was under the influence of Monet. That's the limit, no? However, Gauguin knows all about the Cézanne studies done in Auvers, Pontoise and elsewhere! Zola himself noted and, as I see it, correctly noted, by whom Cézanne was influenced!

7th May 1891

At Vollard's there is an extraordinary exhibition of Cézanne's works. Still-lifes of astonishing perfection and some unfinished works, really extraordinary for their fierceness and character. I don't imagine they will be understood.

13th November 1895

... I also thought of Cézanne's show in which there were exquisite things, still-lifes of irreproachable perfection, others *much worked on* and yet unfinished, of even greater beauty, landscapes, nudes and heads that are unfinished but yet grandiose, and so *painted*, so supple . . . Why? Sensation is there!

disconcerting aspect of Cézanne, familiar to me for many years, Renoir arrived. But my enthusiasm was nothing compared to Renoir's. Degas himself is seduced by the charm of this refined savage, Monet, all of us . . . Are we mistaken? I don't think so. The only ones who are not subject to the charm of Cézanne are precisely those artist or collectors who have shown by their errors that their sensibilities are defective. They properly point out the faults we all see, which leap to the eye, but the charm—that they do not see. As Renoir said so well, these paintings have I do not know what quality, like the things of Pompeii, so crude and so admirable! . . .

Nothing of the Académie Julian! [The Académie Julian was currently a centre of Symbolism, meeting place of the Nabis.] Degas and Monet have bought some marvellous Cézannes, I

exchanged a poor sketch of Louveciennes for an admirable small canvas of bathers and one of his self-portraits.

21st November 1895

You wouldn't believe how difficult it is for me to make certain collectors, who are friends of the impressionists, understand how precious Cézanne's qualities are. I suppose centuries will pass before they are appreciated. Degas and Renoir are enthusiastic about Cézanne's works. Vollard showed me a drawing of some fruit, which they both wanted to acquire; they drew straws to determine the lucky one. Degas so mad about Cézanne's sketches—what do you think of that!

4th December 1895

Before leaving Paris I saw our friend Oller, who told me of some extraordinary things that befell him with Cézanne and that indicate that the latter is really unbalanced . . .

After numerous tokens of affection and southern warmth, Oller was confident that he could follow his friend Cézanne to Aix-en-Provence. It was arranged to meet the next day on the P.L.M. [Paris-Lyon-Marseille] train. 'In the third class compartment,' said friend Cézanne. So on the next day, Oller was on the platform, straining his eyes, peering everywhere. No sign of Cézanne! The trains pass! Nobody! Finally Oller said to himself, 'He has gone, thinking I left already', made a rapid decision and took the train. Arrived in Lyon, he had 500 francs stolen from his purse at the hotel. Not knowing what to do, he sent a telegram to Cézanne just in case. And Cézanne was, indeed, at home. He had left in a first class compartment! . . .

Oller received one of those letters that you have to read to form an idea of what they are like. He forbade him the house, asked if he took him for an imbecile, etc. In short an atrocious letter. This incident is simply a variation of what happened to Renoir. It seems he is furious with all of us:

'Pissarro is an old fool, Monet a cunning fellow, they have nothing in them . . . I am the only one with temperament, I am the only one who can make a red! . . . '.

Aguiard has been present at scenes of this kind; speaking as a doctor, he assured Oller that Cézanne was sick, that the incident couldn't be taken seriously since he was not responsible. Is it not sad and a pity that a man endowed with such a beautiful temperament should have so little balance?

20th January 1896

[Cézanne's letter to Oller was as follows:]

Plate 100 **Pissarro Going Off to Paint** 1874–77 pencil $7\frac{3}{4} \times 4\frac{1}{2}$ in (21.3 × 12.9 cm) V1235, C300 Cabinet des Dessins, Louvre, Paris

Monsieur,

The high-handed manner you have adopted towards me recently and the rather brusque tone you permitted yourself to use at the moment of your departure, are not calculated to please me.

I am determined not to receive you in my father's house.

The lessons that you take the liberty of giving me will thus have borne their fruits.

5th July 1895

Lecomte tells me that Cézanne, who is now doing Geffroy's portrait, is running me down to him. Now that's nice! I, who for thirty years defended him with so much energy and conviction! It would take too long to tell the whole story. But it is things like this that give rise to silence and doubts (when my name comes up) . . . bah! Let us work hard and try to make dazzling greys! It will be better than running down the others in turn . . .

6th February 1896

Vincent Van Gogh

[Although Cézanne reveals about as much sympathy for Van Gogh as he does for Gauguin, Van Gogh seems to have regarded Cézanne as an ideal of truth and dignity, as both man and painter. He identified very closely with Cézanne in respect of truth to nature, the importance of colour and its relationship to drawing, the sheer physical effort of landscape painting and devoted commitment to the Provençal landscape in particular. They had in common a deep admiration for the Provençal painter Monticelli.

The following extracts are reprinted with the permission of New York Graphic Society from *The Complete Letters of Vincent Van Gogh*, copyright 1958. The references after each extract refer to this publication.]

If you saw my canvases, what would you say of them? You won't find the almost timid, conscientious brushstroke of Cézanne in them. But as I am now painting the same landscape, la Crau and Camargue—though at a slightly different spot—there may well remain certain connections in it in the matter of colour. What do I know about it? I couldn't help thinking of Cézanne from time to time, at exactly those moments when I realised how clumsy his touch in certain studies is—excuse the word clumsy—seeing he probably did these when the mistral was blowing. As half the time I am faced with the same difficulty, I get an idea of why Cézanne's touch is sometimes so sure, whereas at other times it appears awkward. It's his easel that's reeling.

B9, to Emile Bernard, June 1888, Arles

Plate 101

Still-Life
(The Bottle of Peppermint)
about 1890–94
oil on canvas
25\frac{5}{8} \times 31\frac{7}{8} in (65.1 \times 81 cm)
V625

National Gallery of Art, Washington, DC
(Chester Dale Collection)

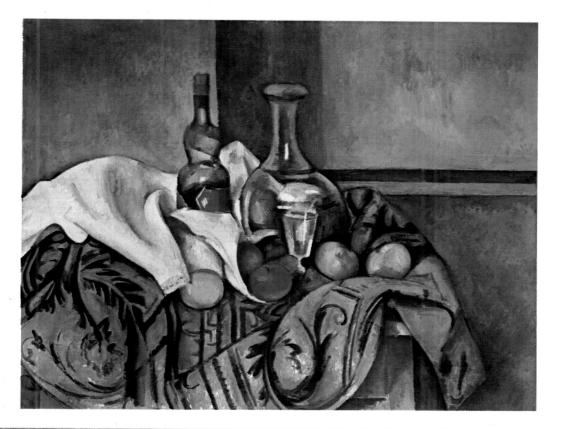

Plate 102 Still-Life with Apples and Oranges about 1895-1900 $28\frac{3}{4} \times 36\frac{1}{4}$ in $(73 \times 92.1$ cm) V732 Louvre, Paris

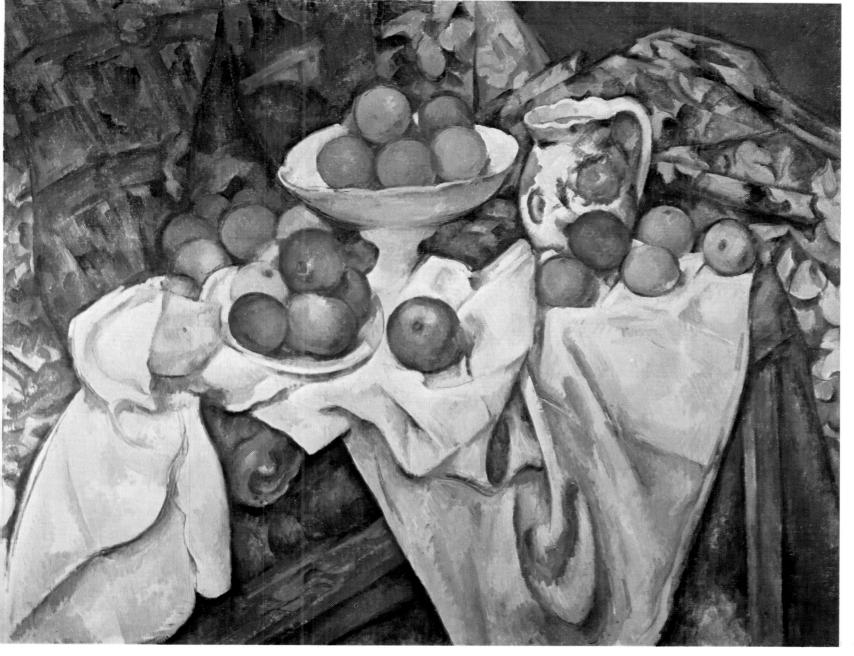

Plate 103
Paul Gauguin
Still-Life with Three Puppies
1888
oil on wood $36\frac{1}{8} \times 24\frac{5}{8}$ in (91.7 × 62.7 cm)
Museum of Modern Art, New York
(Mrs Simon Guggenheim Fund)

Instinctively these days I keep remembering what I have seen of Cézanne's, because he has rendered so forcibly . . . the harsh side of Provence . . .

I must manage to get the firmness of colouring that I got in the picture that kills the rest. I'm thinking of what Portier used to say, that seen by themselves his Cézannes didn't look anything, but put near other pictures, they washed the colour out of everything else.

. . . The country where Cézanne works is just the same as this, it is still la Crau. If coming home with my canvas I say to myself, 'Look! I've got the very tones of old Cézanne', I only mean that Cézanne, like Zola, is so absolutely part of the countryside and knows it so intimately that you must make the same calculations in your head to arrive at the same tones.

497, to his brother Theo, July 1888, Arles

I think that the continual wind must have something to do with the haggard look [my] painted studies have. Because you see it in Cézanne too.

512, to Theo, July 1888, Arles

As I know how much you like Cézanne, I thought these sketches of Provence might please you; not that there is much resemblance between a drawing of mine and one by Cézanne. Or for that matter, no more than there is between Monticelli and me! But I too love the country they have loved so much, and for the same reasons; the colour and the logical design.

B11, to Emile Bernard, late July 1888, Arles

Cézanne is a respectable married man just like the old Dutchmen; if there is plenty of male potency in his work it is because he does not let it evaporate in merrymaking.

B16, to Emile Bernard, August 1888, Arles

You must feel the whole of a country. Isn't that what distinguishes a Cézanne from anything else?

613, to Theo, 1889, St Rémy

Paul Gauguin

[Since the 1870s, Gauguin had been an admirer of Cézanne's painting and retained ownership of one (plate 44) even in times of great financial hardship. In the 1880s, the influence of Cézanne's technique played a major role in the formative period of Gauguin's mature art (see plate 103). Cézanne's furious reaction reflects partly

a jealously protective attitude to his own originality, but more significantly the distance between his own disciplined, nature-based objectivity, and the relatively speculative and abstract symbolism of Gauguin. Cézanne's antipathy was intense: 'Never mention Gauguin to Cézanne', Monet warned his friends.]

Has M. Cézanne found the exact formula for a work acceptable to everyone? If he discovers the prescription for compressing the intense expression of his sensations into a single and unique procedure, try to make him talk in his sleep by giving him one of those mysterious homeopathic drugs, and come immediately to Paris to share it with us.

Letter to Pissarro, summer 1881

[Cézanne's reactions to Gauguin and to his adoption of a Cézannesque technique are recorded first by Maurice Denis:]

This Gauguin! I had a *petite sensation*, and he stole it from me. He has taken it to Brittany, to Martinique, to Tahiti, yes, in all the steamships! This Gauguin.

Maurice Denis, Journal about 1894

[And in Cézanne letters to Emile Bernard of around 1904:]

Gauguin isn't a painter, he's only a maker of Japanese idols.

He misunderstood me . . . I have never wanted, nor could I ever accept the absence of modelling or gradation; that is nonsense.

You have the understanding of what must be done and you will soon turn your back on the Gauguins and Van Goghs.

[Gauguin's lasting respect for Cézanne is expressed in typical style in this anecdote from his *Intimate Journals*, written in Tahiti and the Marquesas Islands:]

Cézanne paints a brilliant landscape: ultramarine background, heavy greens, glistening ochres: a row of trees, their branches interlaced, allowing, however, a glimpse of the house of his friend Zola, with its vermilion shutters turned orange by the yellow reflected from the walls. The burst of emerald greens expresses the delicate verdure of the garden, while in contrast the deep note of the purple nettles in the foreground orchestrates the simple poem. It is at Médan.

A pretentious passer-by takes an astonished glance at what he thinks is some amateur's pitiful mess and, smiling like a professor, says to Cézanne: 'You paint?'

'Certainly, but not very much.'

'Oh, I can see that. Look here, I'm an old pupil of Corot's and, if you'll allow me, I can put that in its proper place for you with a few skilful touches. Values, values . . . that's the whole thing!'

And the vandal impudently spreads his imbecilities over the brilliant canvas. Dirty greys cover the Oriental silks.

'How happy you must be, Monsieur!' cries Cézanne. 'When you do a portrait I have no doubt you put the shine on the end of the nose as you do on the legs of the chair.'

Cézanne seizes his palette, and with his knife scrapes off all of Monsieur's dirty mud. Then, after a moment of silence, he lets a tremendous —— and, turning to Monsieur, says, 'Oh! what a relief.'

Intimate Journals, London, 1930, translated by Van Wyck Brooks

Picasso

[Picasso's allegiances to past art were wide-ranging and empirical: relevance to 'reality'—at many levels—was the most frequent yardstick. Cézanne's name seems to have often occurred to him in discussing general issues, as in the first quotation below. The other two quotations are more particularised and reveal a commitment and an esteem for Cézanne comparable to those of Matisse.]

It's not what the artist does that counts, but what he is. Cézanne would never have interested me a bit if he had lived and thought like Jacques Emile Blanche, even if the apple he painted had been ten times as beautiful. What forces our interest is Cézanne's anxiety—that's Cézanne's lesson; the torments of Van Gogh—that is the actual drama of the man. The rest is sham.

From Christian Zervos, Conversation avec Picasso, 1935, translation by Mfanwy Evans from Alfred H. Barr Jr, Picasso, 50 Years of His Life, New York, 1946

One doesn't pay enough attention. If Cézanne is Cézanne, it's precisely because of that: when he is before a tree he looks attentively at what he has before his eyes: he looks at if fixedly, like a hunter lining up the animal he wants to kill. If he has a leaf, he doesn't let go. Having the leaf, he has the branch. And the tree won't escape him. Even if he only had the leaf it is already something. A picture is often nothing but that . . . One must give

it all one's attention . . . Ah, if only everyone was capable of it.

From Jaime Sabartés, *Picasso*, *Documents Iconographiques*,
1954, translation by Dore Ashton from her *Picasso on Art*,
New York, 1972

As if I didn't know Cézanne! He was my one and only master! Don't you think I looked at his pictures? I spent years studying them . . . Cézanne! It was the same with all of us—he was like our father. It was he who protected us . . .

From G. H. Brassai, Picasso and Company, New York, 1966

Plate 104 Pablo Picasso **Portrait of Ambroise Vollard** 1909–10 oil on canvas $36\frac{1}{4} \times 25\frac{2}{3}$ in $(92 \times 65$ cm) Pushkin Museum, Moscow

Acknowledgments

Plates 10, 17, 24, 26, 28, 30, 58 and 87 are reproduced by courtesy of the Art Institute of Chicago; plates 2, 94 and 99 by courtesy of John Rewald; and plate 81 by courtesy of the Trustees of the late Lord Keynes.

Art Museum of the Ateneum, Helsinki 1; Arts Council of Great Britain, London 61; Bayerische Staatsgemäldesammlungen, Munich 31; Mr and Mrs Leigh B. Block, Chicago 66; Adrien Chappuis, Tresserve 8; Colorphoto Hinz, Basel 70; Columbus Gallery of Fine Arts, Columbus, Ohio 35; A. C. Cooper Ltd, London, 22; Courtauld Institute Galleries, London 45, 68; Editions d'Art Albert Skira, Geneva 21; Henry Ely, Aix 7; Fitzwilliam Museum, Cambridge 9; Fotostudio van Santvoort, Wuppertal 27; Solomon R. Guggenheim Museum, New York 85; Hamlyn Group (Franco Cianetti, Clohars-Carnoet, Finistère du Sud 73; Walter Dräyer, Zürich 20, 46, 92; John R. Freeman & Co. (Photographs) Ltd, London 93; Eric Pollitzer, New York 43; Rodney Todd-White & Son, London 65; John Webb, London 39, 60, 62, Liselotte Witzel, Essen 76); Hamlyn Group Picture Library 3, 6, 36, 37, 49, 59, 72, 77, 86, 90, 95, 96, 98; Dr Armand Hammer 53; Mrs Enid A. Haupt 97; Alex Hillman Family Foundation, New York 64; Robert von Hirsch, Basel 56; Indianapolis Museum of Art 38; Kröller-Müller Stichting, Otterlo 40; Kunsthalle, Basel 41; Kunsthalle, Bremen 55; Kunsthaus, Zürich 79; Kupferstichkabinett, Basel 82; Metropolitan Museum of Art, New York 4, 11, 69; Musées Nationaux, Paris 14, 15, 16, 18, 19, 33, 34, 44, 47, 50, 52, 100, 102; Museu de Arte de São Paulo, Brazil 67; Museum Boymans - van Beuningen, Rotterdam 80; Museum of Fine Arts, Boston, Massachusetts 13, 88; Museum of Modern Art, New York 54, 103; National Gallery, London 32; National Gallery of Art, Washington DC 5, 25, 51, 89, 101; Newark Museum, Newark, New Jersey 63; Ny Carlsberg Glyptotek, Copenhagen 57; Phillips Collection, Washington DC 91; Photographie Giraudon, Paris 104; St. Louis Art Museum, St. Louis, Missouri 12; Gustav Schwarz, Mannheim 48; Sotheby & Co, London 29, 74, 75, 84; Walker Art Gallery, Liverpool 83; Washington Gallery of Art, St. Louis, Missouri 78.

Bibliography

Emile Zola, L'Oeuvre, Paris 1886

Emile Bernard, 'Souvenirs sur Paul Cézanne et Lettres Inédites', *Mercure de France*, 1st and 16th October 1907, reprinted as *Souvenirs sur Paul Cézanne et Lettres*, Paris 1921 Ambroise Vollard, *Paul Cézanne*, Paris 1914, New York 1926

Emile Bernard, 'La Technique de Paul Cézanne', L'Amour de l'Art, Paris 1920, pp. 271-8 Joachim Gasquet, Paul Cézanne, Paris 1921

Lionello Venturi, Cézanne, Son Art, Son Oeuvre, Paris 1936

John Rewald (ed.), Paul Cézanne, Letters, Oxford 1941, revised edition 1975

John Rewald, History of Impressionism, New York 1946, London 1974

Adrian Stokes, Cézanne, London 1947

John Rewald, The Ordeal of Cézanne, London 1950

Meyer Schapiro, Cézanne, New York 1952

Lawrence Gowing, 'Cézanne', essay in Arts Council of Great Britain exhibition catalogue, Edinburgh and London 1954

Adrien Chappuis, Drawings of Paul Cézanne, Catalogue Raisonné, London 1973

Lawrence Gowing, 'Watercolours and Pencil Drawings by Cézanne', essay in Arts Council of Great Britain exhibition catalogue, Newcastle and London 1973

John Rewald (ed.), Camille Pissarro, Letters to his son Lucien, New York 1943

Jack D. Flam, Matisse on Art, London 1973

Index

Jumbers in bold type refer to illustrations

cadémie Julian 118 Chille Empéraire, Portrait of 20–21, 39, 15, 16 esthetic Movement 82 ix-en-Provence 7, 12, 13, 17, 18, 69, 70, 93, 104, 116, 119 Aix, Rocky Landscape 45, 39 Imour en Platre (after Puget) 61, 93 Ipples and Biscuits 33 Artists on Art 88 rt Nouveau 82 Art Romantique' by Baudelaire 112 shton, Dore 125 telier Suisse see under Paris urenche, Louis 41, 66 etters from Cézanne to 105, 109 lutobiography of Alice B. Toklas, The by Gertrude Stein 56 luvers from the Harmé Valley 40, 36 uvers-sur-Oise 29, 31, 116, 118 acchanale (La Lutte d'Amour) 62, 51 laille, Baptistin 7, 12, 16 arbizon school 6 arr, Alfred H., Jr 124 athers, The 62, 57, 58 athers series 49, 60, 61, 62, 63-65, 69, 105, 52, 54, 57, 58, 60, 94 and see individual titles athing Women (The Large Bathers) 59 audelaire, Charles 112 ay of Marseille seen from l'Estaque, The 86 ell, Clive 73 erlin, one-man show of 1904 66 ernard, Emile 13, 35, 60, 62, 66, 83, 88, 89, 90, 112, 118 letters from Cézanne to 105-110, 123 letters from Van Gogh to 120, 122 ernheim Jeune gallery, memorial exhibition 82 lack Clock, The 27, 31, 22 ottle of Peppermint 66, 101 oy in a Red Waistcoat 53, 46 oy Lying Down 60, 53 rassai, G. H. 125 ridge at Maincy 40, 37 rooks, Van Wyck 124 russels, exhibitions in 66 aillebotte, Gustave 66 'amille Pissarro, Letters to his Son Lucien, excerpts from 118-119, 120 amoin, Charles 62, 66, 112 etters from Cézanne to 104, 105, 106, 108 aravaggio 25 assatt, Mary 115-116 athedral at Aix, The 68, 64 atholicism 14, 111 lézanne by John Rewald, excerpts from 113, 115-116 ézanne, Louis-Auguste 12, 13, 27, 96 etter from Cézanne to 96 Portrait of 21, 5 ézanne memorial exhibition 82 ézanne, Paul (son) 29, 96 etters from Cézanne to 110-112 Two Studies of 87 ézanne's letters, publication by Emile Bernard of 83 excerpts from 90-113

Cézanne's mother 12, 13, 39 letter from Cézanne to 96 Cézanne's sister Marie, portrait of 12 Cézanne's wife 39, 60 portrait of 39, 88 and see Madame Cézanne in a Red Armchair Château de Fontainebleau 67, 61 Château Noir 79, 73 Chocquet, Victor 13, 39, 61 letter from Cézanne to 98-103 Portraits of 36, 39, 96, 35, 90 Complete Letters of Vincent Van Gogh, excerpts from 120-122 'Concerning the Spiritual in Art' by Vassily Kandinsky 49 Conversation avec Picasso by Christian Zervos 124 Coste, Numa, letter from Cézanne to 93 Courbet, Gustave 10, 11, 16, 19, 88-89 Couture, Thomas 105 Cubism, Cubists 59, 73, 83-85 Curtain, Pitcher and Fruit-Dish 46, 43 Daubigny, Charles François 6 Daumier, Honoré 10 Degas, Edgar 7, 115, 116, 118, 119 Delacroix, Eugène 11, 25, 26, 61, 90, 106

Daumier, Honore 10
Degas, Edgar 7, 115, 116, 118, 119
Delacroix, Eugène 11, 25, 26, 61, 90, 106
Delaunay, Robert 73, 83
de Musset, Alfred see Musset, Alfred de
Denis, Maurice 66, 82, 123
Dr Gachet's House at Auvers 84
Dying Slave, The (after Michelangelo) 56

Ecole des Beaux Arts see under Paris Enlèvement, L' **81** Estaque, l' 31, 96, 98

Fields at Bellevue 91
Fiquet, Hortense 12, 13, 27
Five Bathers 52
Forêt, La 63
Franco-Prussian war 28
Fry, Roger 73

Gardanne 102
Gasquet, Joachim 14, 60, 66, 77, 80
letter from Cézanne to 103–104, 106
Gauguin, Paul 7, 16, 46, 59, 83, 106, 118, 120,
122–124, 103
Geffroy, Gustave, Portrait of 58–59, 62, 103, 120, 50
Grandes Baigneuses, Les 63, 64–65, 60
Grand Pin, Le 70, 67
Grenouillère, La (Monet) 4
Group of Houses at l'Estaque 28
Guenne, Jacques 87
Guillemet, Antoine 16
letter from Pissarro to 116–118

Hermitage, Pontoise, The (Pissarro) 35, 27
Hernani 9
Hommes d'Aujourd'hui, Les 118
House by the Roadside 41
House in Provence 40, 38
House of Père Lacroix 25
Houses at Bellevue 80, 76
Hugo, Victor 8, 9, 11
Huot, Joseph, letter from Cézanne to 92–93

Impressionism, Impressionists 7, 10, 13, 18, 28, 29, 31, 35, 40, 70, 82, 88, 115

Impressionist exhibitions 35, 36

Intimate Journals by Paul Gauguin, excerpt from 123–124

Intransigeant, L' 113

Jardins, Les Lauves 96 Jas de Bouffan 12, 6

Kandinsky, Vassily 47, 49, 85

Landscape at l'Estaque 24 Landscape at Médan 79 Landscape in Provence 89 Landscape near Aix 80, 75 Le Bail, Louis 45, 66, 116 Léger, Fernand 73, 83, 85 Louvre see under Paris

Madame Cézanne in a Red Armchair 39, 88 Manet, Edouard 10, 11, 19, 20, 25, 35-36, 39, Man Leaning on a Table 56, 48 Marseille 98 Marx, Roger, letter from Cézanne to 109 Matisse, Henri 49, 51, 85, 87, 78 Maus, Octave 14 Melting Snow at l'Estaque 27, 23 Metzinger, Jean 83 Meurend, Victorine, Head of (Manet) 13 Michelangelo 61, 108 Milo of Crotona 55 Modern Olympia, A 25, 35-36, 19 Monet, Claude 6, 7, 10, 11, 13, 28, 31, 70, 105, 106, 113, 116, 118, 119, 123, 4 letter from Cézanne to 103 Monticelli, Adolphe 120, 122 Mont Sainte Victoire series 69-73, 76, 77, 79, 68, 69, 70, 71, 72 Moore, George 116 Murder 83 Musset, Alfred de 8, 9, 11

Nabis 118
Neo-Impressionism 83, 110, 116
Nieuwerkerke, M. de, letter from Cézanne to 93–95
Notes of a Painter by Henri Matisse 87
Nu au Louvre, Le 61

Oeuvre, L', by Emile Zola 13, 22 Oller, Francisco 119 letter from Cézanne to 120 Orgy, The 25, **18**

Paris 18, 36, 39, 66, 69, 104
Atelier Suisse 18, 31, 92
Ecole des Beaux Arts 18
Jeu de Paume 20
Louvre 93, 104, 105, 107, 110
Luxembourg Museum 66, 93
Museum of the City of 85
Salon 18, 19, 35, 36, 88, 93, 110
Salon d'Automne 66, 82
Salon des Indépendants 66
Salon des Refusés 19, 88, 95
Paul Cézanne, Letters 88
Picasso, Pablo 78, 85, 124–125, 104
Picasso and Company by G. H. Brassai, excerpt from 125

Picasso, Documents iconographiques by Jaime Sabartés, excerpt from 125 Picasso, 50 Years of his Life by Alfred H. Barr 124 Picasso on Art by Dore Ashton 125 Picnic, The 25, 21 Pissarro, Camille 11, 12, 13, 14, 18, 28, 29, 31, 66, 96, 110, 112, 113, 119, **85** letters from 116-120 letters from Cézanne to 95, 96 Pissarro, Lucien 116 letters from Camille Pissarro to 118–119, 120 Pissarro Going Off to Paint 100 Pond at the Jas de Bouffan, The 39, 34 Pontoise 29, 35, 116 Portrait of the Artist's Father Reading 'L'Evenement' 5 portraits see under name of sitters and individual titles Post-Impressionism 82, 85 Poussin, Nicolas 10, 82 Provence 39-40, 82, 87, 120 and see Aix-en-Provence Puget, Pierre 61, 93

Rape, The 82
Raphael 108
Recollections of a Picture Dealer by Ambroise Vollard
115
Redon, Odilon 106
Reminiscences of the Impressionist Painters by George
Moore, excerpts from 116
Renoir, Jean 58
Renoir, Pierre August 13, 31, 106, 118, 119
Renoir My Father by Jean Renoir 58
'Revue Occidentale' 107
Rewald, John 88, 113, 116, 118

Road Along a Lake 45, 40 Rochefort, Henri 113 Rousseau, Théodore 6, 113 Roussel, K.X. 66 Rubens, Peter Paul 25, 26, 61, 62, 90, 104 Ruy Blas 9

Sabartés, Jaime 125 Salon see under Paris Salon d'Automne see under Paris Salon des Indépendants see under Paris Salon des Refusés see under Paris Self-Portrait 29, 30, 31, 32 Seurat, Georges 7, 83, 116 Solari, Emile 88 Sous-Bois paintings 67, 80, 62, 74 Spanish school 26, 62, 108 Standing Bather 61, 62, 54 Stein, Gertrude 56 Still-Life with Apples 42 Still-Life with Apples and Oranges 102 Still-Life with Compotier 46-47, 44 Still-Life with Cupid 51-52, 45 Still-Life with Jar and Coffee-Pot 14, 14 Still-Life with Oranges (Matisse) 78 Still-Life with Three Puppies (Gauguin) 103 Symbolism 82, 118

Tanguy, Père 13, 39
Temptation of St Anthony, The 25, 20
Terraced Hills with Houses and Trees 95
Terrible Histoire, Une 22
Théories by Maurice Denis 82
Three Bathers 49, 85, 77

Three Naiads (after Rubens) 92 Tintoretto 108 Titian 25, 35 Trees and Houses 67–68, 80 Two Card Players 58, 49

Uncle Dominique 97 Uncle Dominique (The Man in the Blue Cap) 11

Vallier, Portraits of 69, 65, 66
Van Gogh, Theo, letters from Vincent Van Gogh to 122
Van Gogh, Vincent 7, 14, 83, 106
letters of 120–122
Venetian school 25, 26, 35, 62, 90, 108
Veronese 25, 62, 104
Viaduct at l'Estaque, The 1
View of the Village of Auvers 26
Vingt, Les see XX, Les
Vollard, Ambroise 56, 66, 113–115, 118, 119
letter from Cézanne to 104–105
Portrait of (Cézanne) 77–78, 98
Portrait of (Picasso) 85, 104

Woman Taken by Surprise 17 Woman with Coffee-Pot 56, 62, 47

XX, Les 66

Zervos, Christian 124 Zola, Emile 7, 9, 12, 13, 14, 17–18, 22, 26, 29, 39, 70, 88, 113, 118, 122, 123 letters from Cézanne to 90–92, 96, 98 Portrait of (Manet) 3